PHOTOGRAPHY BY
LES McCANN, LTD.

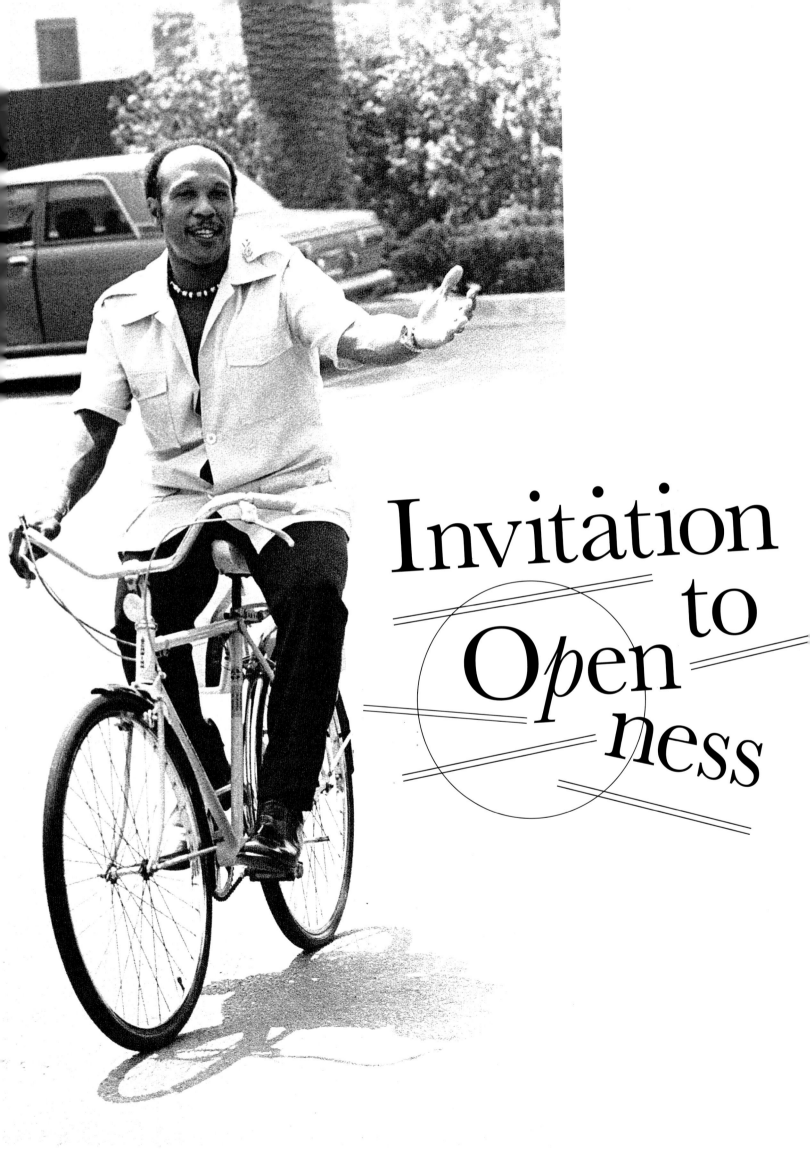

Invitation to Openness

BOY on a bicycle,
washington, d.c.

Publisher and Executive Editor: GARY "Antoine" GROTH
Art Direction and Design: JACOB COVEY
Photo Editors: PAT THOMAS, ALAN ABRAHAMS
Photo Restoration: PAUL BARESH
Senior Editor: J. MICHAEL CATRON
Copy Editor: KRISTY VALENTI
Associate Publisher: ERIC REYNOLDS

Film negative scanning: Kevin Duffy
Photo print and contact print scanning: Kevin Uehlein
Interview transcriptions: Katie Westhoff
Special thanks to: Zev Feldman and Graham Connah

Fantagraphics Books, Inc.
7563 Lake City Way NE
Seattle WA 98115
(800) 657-1100
www.Fantagraphics.com • Twitter: @fantagraphics • facebook.com/Fantagraphics

First Fantagraphics Books edition: March 2015
ISBN 978-1-60699-786-4
Library of Congress Control Number: 2014952339
Printed in China

Also by Pat Thomas:
Listen, Whitey! The Sights and Sounds of Black Power 1965–1975

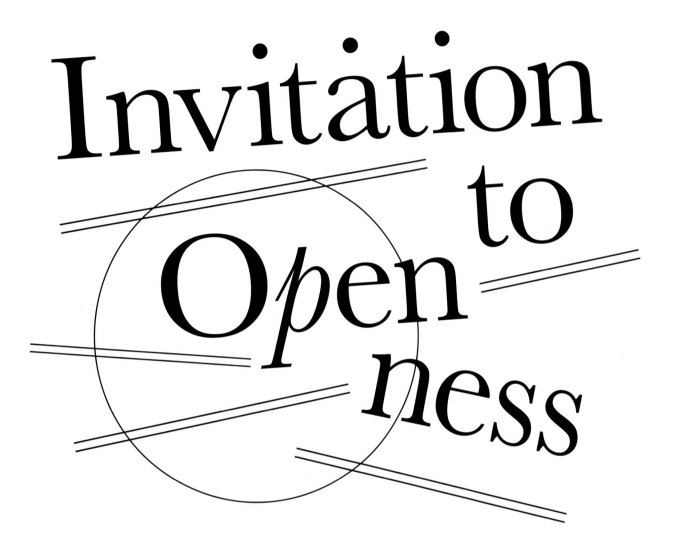

Invitation to Openness

The Jazz and Soul Photography of
Les McCann
1960–1980

Curated by Pat Thomas and Alan Abrahams

FANTAGRAPHICS BOOKS, SEATTLE, WA

THROUGH THE LENS SOULFULLY

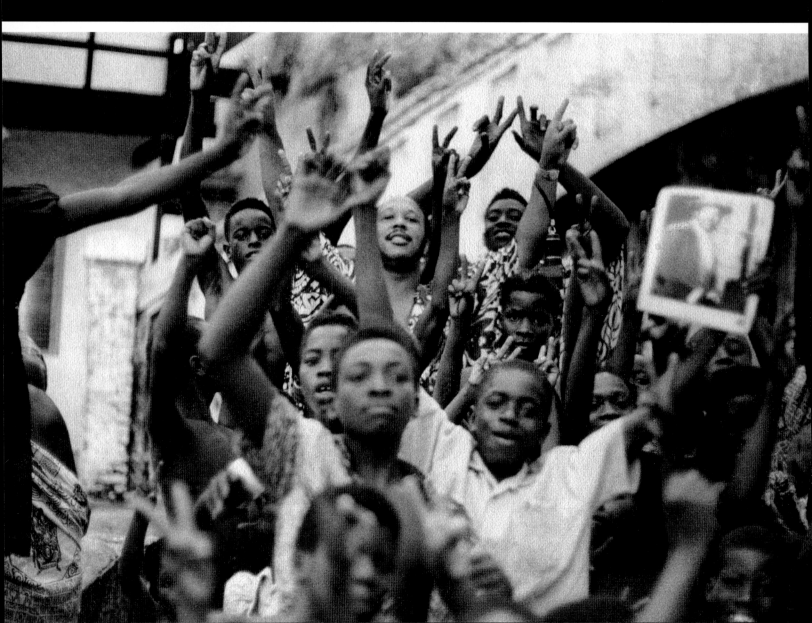

The eyes of Les McCann are windows into the world of a man who has lived his life soulfully, artfully — and long enough to share the tales. Les is easy to love. When you are with him you are in the presence of a stone soul giver. One listen to one of his recordings, one chance encounter, or one look at a few of the photographs in this book, and you can tell that this man, McCann, possesses sincere curiosity and compassion for "the soul" inside others. This is what feeds the bottomless well of soul Les McCann makes you feel: whenever, wherever, and however.

It started in Lexington, Kentucky, with his father, mother, grandmother, four brothers, a sister, and friends — all of whom he returns to lovingly and consistently in song. Those were times of cocooned warmth, play, and security while all around was the bitter, backward, entrenched hatred of the South: ecstasy amid the absurdity. Through it all, Les developed a third eye into his artistry. His voracious imagination was nourished by introspection and observation. Art, photography, music — he had a knack for them all, but music — the mistress bearing the most bodacious assets — put the lockdown on his heart.

This muse had been there for Les in the guise of his childhood home's piano, on which maybe 12 keys worked. In church, he discovered deeply inspiring music that would gently haunt him come bedtime. In school, Les huffed and puffed on the sousaphone — ever the boisterous male lead cheerleader, toting a tuba! And while serving in the Navy he played snare drum in the band, discovered Erroll Garner, and decided right then to step all the way off into jazz piano.

FOREWORD

A. SCOTT GALLOWAY

Straight outta the service, Les landed in California where he hustled to survive, becoming a prolific instrumental voice on the scene: adamantly expressing things his way, but always in an engaging manner that kept the people involved. At nightclubs, coffee houses, and anywhere he could draw an audience, Les was the one-man announcer, comedian, pianist, bandleader — all the while "learning the people" on many different levels. It was here that he perfected his root-down approach to jazz as funneled through the gospel, blues, country, and funked-up second-line marching band grooves of his youth — infectious, irresistible rhythms that kept toes tappin' and hands clappin'. Les's vibe was so tight that he played his piano-bass-drums trio like a symphony, massaging the people with dynamics that took them from hushed whispers to ribald hollers.

Les McCann's recorded output through the '60s, on the small World Pacific, Liberty, Sunset, and Limelight jazz labels, was plentiful: many times recorded "live" and, not surprisingly, often in the company of others that he clicked with so naturally. His free and open spirit earned him friends all over town — such as organist Richard "Groove" Holmes,

LES in africa, 1971

composer/arranger/conductor Gerald Wilson, and funky Gulf Coast brethren The Jazz Crusaders. Early on, Les would cut a classic in three hours — after hours — at the great Capitol Records Tower in Hollywood with a young man named Lou Rawls. But more on that later.

When Atlantic Records in New York came calling at the end of the '60s, Les was ready, hittin' 'em with the wittily titled *Much Les* LP. He scored a jukebox and jazz radio hit out of the box with the ballad "With These Hands" — *singing*. While in the Navy, Les won a talent contest resulting in an appearance on *The Ed Sullivan Show* crooning "Almost Like Being in Love," but Les had never really taken his singing seriously. That was about to change.

Paired with Chicago saxophonist and label mate Eddie Harris (who already had two million-sellers under his belt with "Exodus" on Vee-Jay and "Listen Here" on Atlantic), Les smoked his first joint and gave up the funk on an unrehearsed set at the Montreux Jazz Festival. He swore it was garbage, until producer Joel Dorn played him the tapes over the phone. With "production" basically consisting of re-sequencing the song order of the set, Atlantic billed them as "Les McCann & Eddie Harris" and issued the concert as *Swiss Movement*. It became an instant classic, fueled by Les's fire-and-brimstone reading of Eugene McDaniels's thunderous tongue-in-cheek protest song "Compared to What" and Eddie's sock-feet/stop-start boogie groove "Cold Duck Time." Overnight — after a decade — Les McCann was a star.

Of course, Atlantic wanted another Les & Eddie album *stat*, so, following solo LPs, they got back together, this time in the studio and reverse-billed as "Eddie Harris & Les McCann," for *Second Movement*. Fatefully, it did not live up to expectations but in hindsight was a damn good stab at unifying their singular directions. The duo was forever documented together in the all-star concert film *Soul to Soul*, shot in Ghana, Africa.

Obligations fulfilled, Les next did a 180-degree turn into a bold new direction of nuanced, open-ended mood recording. He called in three drummers, two guitarists, upright and electric bassists, two percussionists, a harpist, and winds master Yusef Lateef. *Invitation to Openness* featured Les on piano, Rhodes, Clavinet, ARP, and Moog synthesizer. Packaged in a gatefold LP jacket, it was presented as an experience ripe for headphones and high-end audio gear. This was Les at his most naked and intuitive, his earlier trio exponentially expanded for the spheres.

Les would go on to record many more albums, moving between instrumental and vocal projects. Ultimately, for a man who talks more than his fair share of shit, Les is a strong black man who has nakedly and consistently turned his attention to some of the most sensitive songs ever written: from "Everytime I See a Butterfly" to "Universal Prisoner." Though his classic "Sometimes I Cry" is an instrumental, Les McCann vocally cries like no other — cries of regret ("You Had to Know" by Donny Hathaway), cries for sanity ("Comment" by Charles Wright), cries of revelation ("The Price You Gotta Pay to Be Free" by a teenaged Nat Adderley, Jr.), cries of futility ("What's Going On" by Marvin Gaye), cries of romantic woe ("Seems So Long" by Stevie Wonder), cries of bliss ("Just the Way You Are" by Billy Joel), and cries for mercy ("Prince of Peace" written with Jon Hendricks). Les dropped tears on wax often, keeping his soul pure by purging the pain, maximizing his gift as a superior interpreter of great material by peers — past and present — whom he respects and admires.

In that sense, perusing the photographs in this book is not much different from listening to Les's music. The photos reveal another manner in which Les is able to capture intimate portraits of people and of the soul peeking out from the inside. With his camera, Les McCann honored entertainment pioneers from a fast-fading era while simultaneously catching the rising stars — snapping the hand-off from one generation to the next. Les documented his travels, his friends, and his ever-changing work environments. In so doing, he captured slices of history that only someone with his savoir faire and carte blanche access could nab.

Dig the way Les was able to get Average White Band members Steve Ferrone and Hamish Stuart horsing around with their ladies; Groove Holmes at the organ in the background photo-bombing Ben Webster (a sax legend) at the piano; Mama Cass of the folk-rock quartet The Mamas & the Papas clowning in a doorway; Duke Ellington deep in thought at the piano; Yusef Lateef tenderly holding his tenor sax; the ever-so-serious Roberta Flack perched comically on a heap of debris; Roebuck "Pops" Staples (patriarch singer/guitarist/guardian angel of The Staple Singers) fixing him with a decidedly non-Gospel-like glare; Gerald Wilson between takes on a coffee break, intense as ever; L.A. jazz DJ Tommy B (of late, lamented KBCA-FM) simply closing his car trunk, yet with a priceless expression on his face worth a thousand-word back announcement — all captured with Les's mystic eye and magic camera.

In front of Les's camera, everybody is a star, none more so than the children of the world. Most telling of all is a photo of kids — and Les in it with them! Note his studies of the people of Mexico — their dignity rendered in all its richness. Here's his grandmother, captioned as "The Original" Carrie Underwood, every line in her face a story to be told. Here, too, is his friend Ron Neal, who holds the distinction of being "the man who turned the man onto jazz." Here are those exhaustive shots of Tina Turner and The Ikettes in action — as if Les were trying desperately to will their salt shaker skirts to rise just a little bit higher. And here, too, are tasteful and candid shots of women well versed in sweet backrubs or who drove groovy li'l red Volkswagen cars — and who had no qualms about being nude before Les's appreciative lens. That's literally a whole 'nother book right there — but you get the drift. If Les had spent as much time behind a camera as he did behind the ivories …

Yet he surely wouldn't be as roundly adored and admired as he has been for his timeless music, the universal language in which he was born to communicate. He sure got through to the 5-year-old me via an 8-track of *Swiss Movement* and his infamous cuss-fussin' on "Compared to What," followed a few years later by the even more incendiary "Shorty Rides Again."

These two songs elevated Les McCann from mere mortal jazzman to mythical Black Godfather status among me and my childhood friends Eric and Anthony. As we came to imagine him, Les was initially that omniscient voice of most righteous conscience on your shoulder, trying to keep you from fuckin' up at whatever challenge lay before you. However, if you did fuck up, Les became all too real — the cosmos dialing him up direct on his Cadillac car phone and dispatching him your way — wheelin' around a corner on two driver's-side wheels, coming to a screeching halt in front of you, the back passenger window silently sliding down, an index finger beckoning you to come closer, followed by a big meaty mitt poppin' you upside your head — with a good "Goddamn it" or three (to grow on) — before the car lurched off toward other comeuppances.

In more introspective grown-folks times, with "The Blue Dot" and "Vallarta" as soundtracks, Les McCann morphed into one of the great musicians of my childhood dreams with whom I got to connect in very real ways and on multiple occasions. The first was after a great show at the old Birdland West in Long Beach where he took the time to thank every guest upon his or her departure at the door, including my lady Elise and me. I told him if we ever got married I wanted him to sing "With These Hands" at our ceremony. He complimented her beauty and my taste, and promised that he would — and we both could feel that he meant it. Several years later, he came to the Burbank office of Urban Network, where I interviewed him for his CD *Pump It Up*. He proceeded to charm everyone in the place, especially my friend and co-worker Tosha — to whom he took an exceptional liking thanks to her exceptional bosom.

Most profoundly, when I took on the task of writing the book for the video documentary *Down the Rhodes: The Fender Rhodes Story*, I insisted that Les be a part of both, interviewing him in the home of his manager and friend Alan Abrahams. There, Les spoke passionately about how the instrument was not just a keyboard, but an aural extension of his being — the warm reverberating sound of his very soul speaking. Before I left that night, I got to jam

with Les McCann — he downstairs on the Rhodes and me in an upstairs room on Alan's drums as we grooved down one of my favorites of his, "Shamading" (pronounced "shah mah DING"). The home was configured in such a way that we could not see each other, but we had no problem whatsoever communicating.

Les McCann thrives on conversation, connection, and communication — on intuition, improvisation, and interaction. Whether that be in a photograph of a weary Duke Ellington at the piano contemplating the perfect harmonic bridge that will complete the musical puzzle at hand or Les himself at the piano, closing out a quintessential take of "Willow Weep for Me" where Lou Rawls squeezes out and holds a floating blue note as Les wholeheartedly repeats a six-note trill — again — and again — and again. I know for a fact that George Duke received *that* message. It's spiritual, it's beautiful, and it's just the way Les likes to get right down and "talk to the people."

Hatred is a feeling
Love is a feeling
Let us hate all that does not allow us to love

Carry on, brother Les.
Carry on — full of love.

— A. SCOTT GALLOWAY

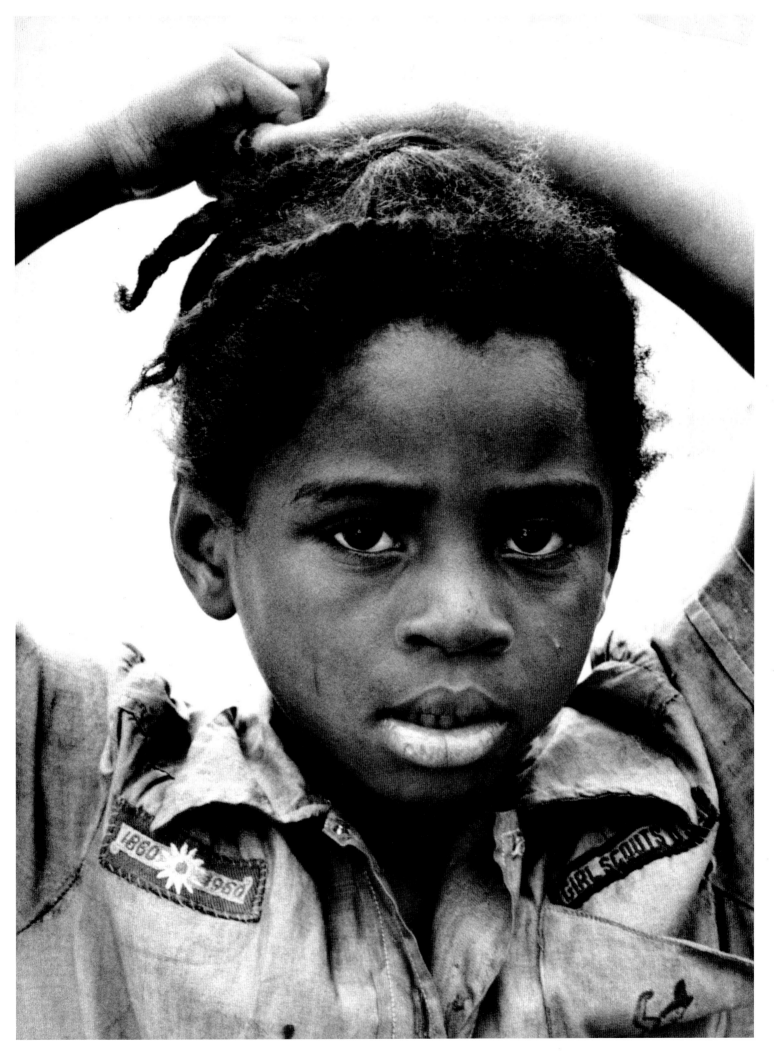

GIRL scout

February 17, 2014

INTERVIEW WITH

PAT THOMAS

Ifirst discovered Les McCann via his seminal 1969 album *Swiss Movement*. Knocked out by the incomparable song "Compared to What" featured on that record, I began tracking down the song's composer, Gene McDaniels. Along my journey, I assembled a vinyl LP reissue of *Swiss Movement*, including new liner notes by producer Joel Dorn. McDaniels's sociopolitical *Outlaw* album became another game-changer for me. I reissued that on CD and interviewed McDaniels for the liner notes. Its anti-establishment — yet celebratory — view of the United States recalled Allen Ginsberg's 1956 epic poem "America."

Noticing that other Les McCann classics were out of print, I telephoned the great man and organized a CD reissue of *Invitation to Openness*. That 1972 expressive instrumental work broke down considerable barriers. Here was "free form" jazz that also retained a groove (and a heart). Most free jazz is "head music" — McCann's take was soulful. Therefore, the album title, *Invitation to Openness*, was the perfect name for this photography book as well. It's a trademark of McCann's approach to art: casual, yet poignant.

It'd been about a decade since I'd last spoken to McCann, and I had never actually met him in person; so, with some encouragement from Gene's widow, Karen McDaniels, I called McCann out of the blue two years ago, inviting myself over. Needless to say, he was "open" to it.

We quickly bonded over some comedy tapes recorded by his former sparring partner, Eddie Harris — and, in fact (truth is always stranger than fiction), during our Harris listening party, the phone rang. McCann let the answering machine pick up, and a familiar voice beamed out: "Hey, it's Eddie. I'm back from the dead; let's get the old band back together!"

Perfect timing for an impromptu joke from one of McCann's former bass players — we still laugh about it.

It was during one of these visits that I discovered stacks of scratched-up photographs, boxes of dusty negatives, and piles of vintage contact sheets that had curled over time. I saw a book in McCann's massive archives and suggested taking the idea of a book to Fantagraphics. He agreed. Nearly none of the thousands of photos in his apartment had ever been published. All the major players in the world of jazz and soul were there (no need to list them, you've already bought the book) — along with images of Jimmy Carter, Angie Dickinson, Jack Lemmon, and several exotic ladies that McCann had encountered on the road. (By the way, if you're wondering why there are no specific dates or venue names attached to any of these photos — it's because the majority of the negs and contact sheets were undated and unmarked. So, despite McCann's best efforts, he simply can't remember — which proves, as the old cliché goes, that he really was there!) McCann's manager, producer, and comrade-in-arms Alan Abrahams was folded into the mix, and he invited me down to Baton Rouge — where he had stockpiled even more amazing photos taken by McCann during the better part of the '60s and '70s.

What you hold in your hands is very much like the making of the *Swiss Movement* album, back in the day: Les McCann and Eddie Harris were booked to play a gig together at the Montreux Jazz Festival, which was originally recorded merely as a "document" of the concert, not as a potentially stellar live album — it just happened to come out brilliantly. McCann carried a camera around for years, just to capture the wine, women, and song that he encountered. Thoughts of a book? No way! Decades later, it just happened to come out brilliantly. Maybe lightning occasionally does strike twice (without killing you either time).

These days, McCann leads a somewhat relaxed life: he enjoys phone calls and visits from friends, as well as the occasional medicinal joint, and dresses ultra-casual — lets it all hang out, so to speak. It was under these conditions that I recently conducted McCann's first ever interview focusing on his photography.

— **PAT THOMAS**

PAT THOMAS: *Tell me what your earliest memories of taking photos were.*

LES McCANN: All my brothers, I would say — I have one sister and four brothers — I grew up thinking that they were smart, and I wasn't quite … they could do things, and they did things. My younger brother, next to me, we all thought of him as a genius. He could make anything. To me, that was a marvel. I would go take piano lessons and he'd come for his lesson and he'd do twice as good as I did! Damn! But he didn't want to play no piano; that wasn't his thing, he's much brighter and smarter than that!

But then I noticed: the one thing the three of my brothers all had was a camera. We always had a camera in the family — a [Kodak] Brownie Hawkeye, I remember, which was a marvel, too: "How'd you do that?" — but just watching my brothers always taking pictures of a whole lot of things. When I got into the military, I talked to my other brother who was in the military. He was in charge of photography. He was hired by IBM to do the photography for the company. He built his own house in Austin, or wherever it is, and he retired doing all these things — so he was the one, my brother Bill, second to me.

When I got out here to L.A. and started hanging out, I was attracted to the art people, and all of them had cameras. I said, "At least what I can do is make a record, keep a record of things I've done, people I've met." So, I got more into it. I'd often carry a camera with me, but I wouldn't do nothing with it. After I got a fine camera, a Nikon, I liked it: 'cause if I ain't using that shit, then, what the fuck, you know? So I started taking pictures. And the more I took pictures, the more I got into it. As a musician, somebody onstage, there's always someone coming to give me a photograph, and I'd say, "What the fuck is that?"

"Well, that's a picture I took of you."

Oh, that's what he calls a photograph? "Oh, I like that one, that one's great." *[Laughs.]*

All my friends are photographers. Everybody I know that is related at least carries a camera. Now with these phones, oh God … I'm trying to think of what can I do now that a camera doesn't do, and the only thing that I've thought of is I now have a project of my photographs which are pictures of portions of my paintings. Not just of the paintings, but parts of them. So within one painting, I've got two thousand pictures. I call that "Photo Snippets."

Everywhere you go, everybody's got their hand up in the air with the camera. It's the new American look. I say, "I can tell you're American, because you've got your camera in the air." The camera's blocking the flag, which you're supposed to be standing up for!

How soon did you start developing your own stuff?

That happened in Hollywood after I went to school and got my education in journalism, and the radio/television classes I took. I was poor, I couldn't buy nothin'. But boy, I got a good camera, started hanging out. Shit! I stayed with this guy at least two or three years, going up to his house every night because I had a long-term gig I was playing at a coffeehouse. I'd get off of work, didn't matter what time it was, because he was up all night in the darkroom. Chester Maydole. Not Bernie Madoff. *[Laughter.]* I think that's a classic name. "My name is Bernie Madoff." Yeah, you made off with everybody's money, motherfucker!

So that was an eye-opening in the sense of — wow, what a beautiful thing to do, to watch the magic of how it felt: paper, racks of chemicals. It was science class, and all that. But there came a time when I started making money, and I got a house up in Hollywood. There was a baby room. So what we'll do with that is make that into a darkroom! And I did. It was fantastic; it was fantastic. I loved it. I spent many a night in there, especially when my wife and I were fighting with each other.

Yeah: a good way to get away from the bullshit.

Yeah, go and get them other fumes. *[Laughter.]* "Honey, what's the matter with you?"

"I don't know … you bitch!"

The beautiful thing about my wife is that she'd encourage me, because she really thought I had a talent more than just snapping snapshots of people I know just to say I was with Chet Baker. No. I really got into it. And now, even though my eyes are not what they were, I feel like I'm into it better than I ever was doing what I was just telling you about with the snippets, 'cause I see what I really am wanting to see and things that come out of nowhere. You go, "What the hell was that?" A product of whatever you were doing. You may not understand what it is, but I see things that I've only dreamed about.

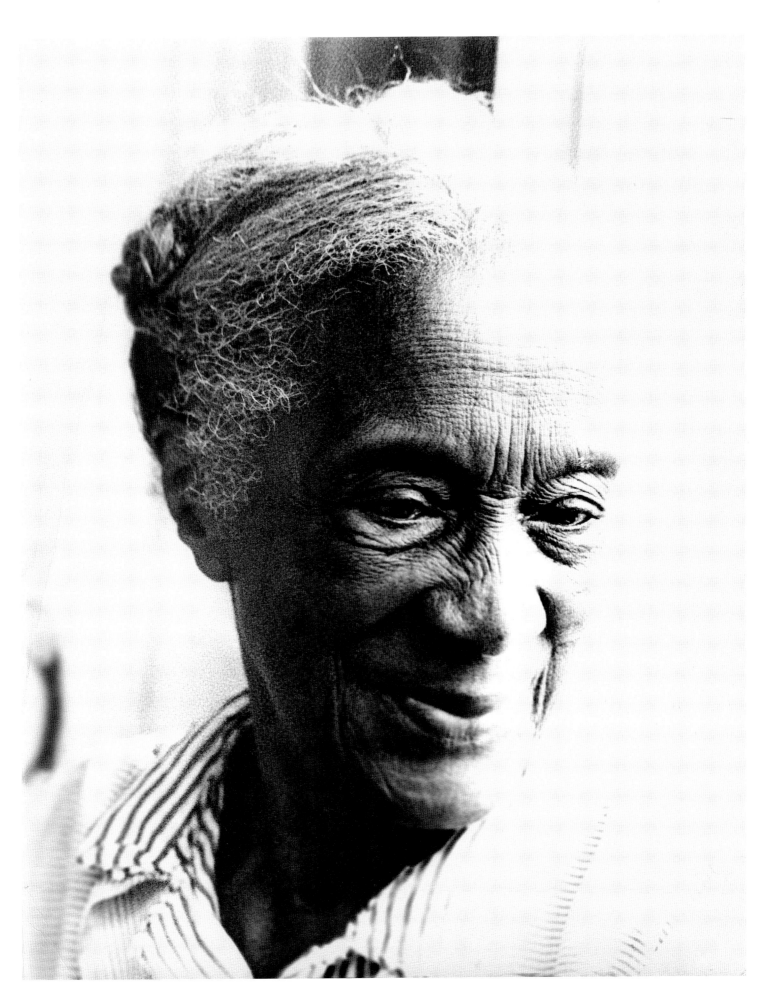

CARIE underwood (les's grandmother)

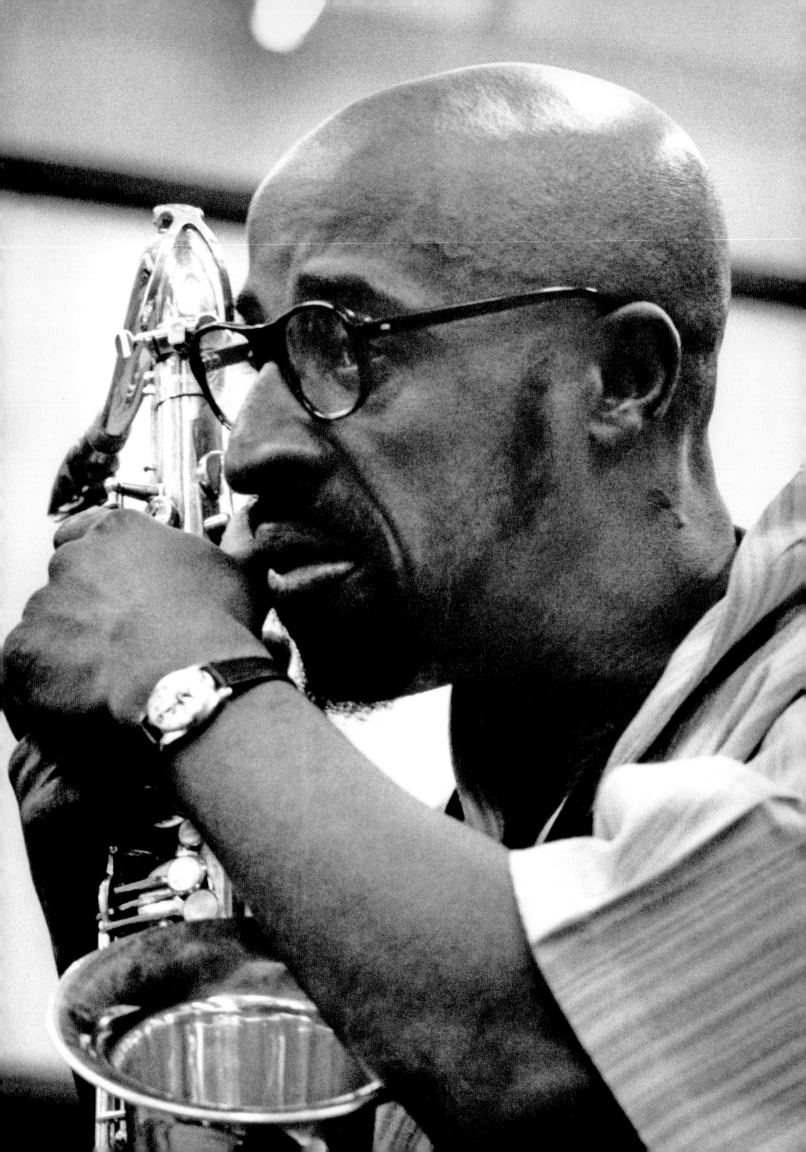

One of the things I love about your photos is they're very intimate. Because you know these people offstage, you're able to somehow capture them onstage.

Well, I trust my intuition, you see. That's the whole thing with all of this, I'm guided because I believe in my ability to do the great and good things I want to do in life. Assistance through mistakes, and learnings, and whatever you want to call it: to observe means to check it out, in many instances, and people plan. I'm better off when I just do what I do on the piano: play. I don't have to set it up and all that. I learned to be able to get good pictures. Maybe a lot of them are out of focus because you're trying to move a lot, but always within some of that is something special.

Your best music is like your best photography: it's spontaneous.

That's exactly what I'm saying. Which is my DNA. This is what I'm programmed to do, which is the most important thing in my life: to enjoy what I'm doing. And what I am is, "I do what I do." It's not just one thing. I see it the same as the music, same as the paintings. It's all connected.

You're very much a Renaissance man.

I don't think so. Really?

In the sense that you're a really good musician, a really good photographer —

People have to come to that level to realize they have that ability. We live in a society that often teaches you what you feel is wrong, so you have to learn this yourself. About two or three people I know, when they talk about learning, they talk about, "what I told them," and "what I did." OK, and when do you listen to this guy you keep talking about? You're wondering why you have all these problems, and you don't hear nothin'! My favorite thing is, we're not set upon this earth ill equipped to function.

Your photography is very much like your music. It's not only spontaneous but it's obviously improvisational and very freeing.

For me, the only time I get in trouble is when I plan something. Like, "I want to paint a football player." *[Laughs.]* Shut up and just play the piano. Bottom line is, I have to do what makes me happy, what I enjoy doing. I'm in bed for eight days now dying to get some paper over here but I have to learn to rest, too, which I've never done. First time ever! First time in my whole career have I ever canceled a gig. I don't look at it as bad. I don't look at it as good. I look at it as now I have time to recuperate 80 years — I don't know how the hell old I am, 78? — of doing what I do and enjoying it and never having to take a vacation. You gotta understand, this is what I am. If I go on vacation, I've got to have something that I can feel good about while I'm there.

One is a great photo of Cannonball Adderley offstage —

Smoking a cigarette! I think that was one of the first ones, when I started sending photographs out.

I love that photo because, again, it captures that intimacy. Because you're not a journalist, because you're a fellow musician, there's this incredible inside view you get in these photos.

I would never take out challenges. I don't mean that. One would say, "Well, you have to do, if you're into something." Go into it further, and don't just get caught up in just one thing and stay with that. That's good for some people, but I'm not like that. I can't put it in words, because I've never done it before, but keep creating at all times. First thing is, first-grade photography. Do not photograph all those things we've locked into our heads as "good" photographs. A "good" painting, a boat going down the river with the fall trees, and there's a farmhouse and some animals. We've already seen all of that! What we're taking pictures of is ten times better than what we're doing with the photograph! We're just looking at the same shit over and over.

If I'm going to take a picture of a musician playing a horn, let me see if I can capture something that he does when he's not playing, although he has his horn in his hand. That includes in the dressing room when he's got the horn sitting over there, waiting to be taken up on stage. Tying the artist to the instrument, even though he may not be playing because part of being a musician is taking care of your horn, traveling with it. So I'd take pictures of guys at the airport.

That's an angle that a journalist wouldn't understand because they don't play an instrument. You understand that the instrument and the musician are integral to each other.

YUSEF lateef

17

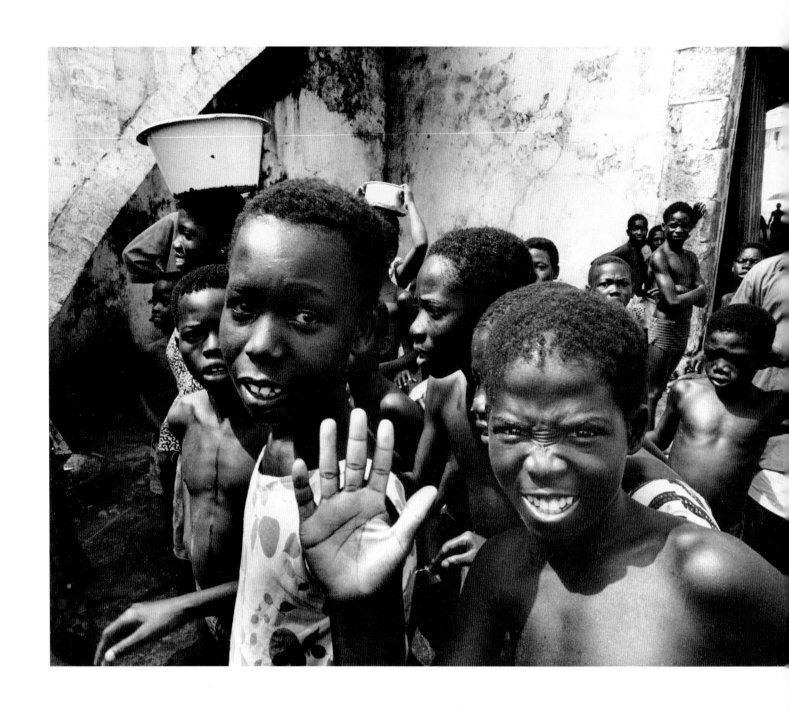

CHILDREN in africa

It's the same in all things. It's not just in what I do. We all have these abilities. What I'm saying is, "Use them! Get into it deeper! Go for it even more!"

The other thing I'm realizing as we're talking is that it's not just photography that inspires your photography, but it's obviously —
Life!

Life! Did you get into things like some of the beat generation guys like [Allen] Ginsberg, [Jack] Kerouac — did you read them?
Not really, but I was around. That's when I began to open up my eyes, because I wasn't into drugs or anything. My wife was much hipper than me.

But were there any writers that inspired you, black or white?
No.

Didn't do a lot of reading?
I kind of thought I couldn't read for a while, because my eyes have always done some other things.

So if you weren't doing much reading, were you going to a lot of movies?
No. I'm not a movie fan.

What I'm trying to say is, I was focused on life, nature, things that I had never seen before, but my focus was music. Period. Just music. That was A-1 during that period, on every level. Going to hear: try to stand outside if I could just hear the club, seeing the guy walk in or whatever. Totally taken … and by jazz! That was the kicker, because I had heard music, loved music, all my life, but to hear music where it's like, "What are *they* doing?"

Let's talk about jazz for a minute. When I started coming over here a couple months ago, one of the conversations I loved having with you is that a lot of people are jazz Nazis, right? It's like, "I only listen to bebop," or "I only listen to this," and I know you have a wide palate.
Only because of the fact that I've accepted that everything in this life was meant for good. I'm talking about my spiritual understanding of what I am as a non-human, so I'm putting them both together. I open myself to everything. Very few of it, as far as

human things, do I like, do I want to hear again, but I've learned to at least listen to it. I hear what it was. "Yeah, what is that?"

"This is the new cool, this is Justin Bieber," or whatever his name is.

OK, why is everyone makin' a fuss over him?

I know when Ornette Coleman starting playing, a lot of people said, "That's not jazz."
Same thing, same thing. Doesn't matter. People always got something to say no matter what you do, right or wrong. They call them the "haters" and the "lovers." It's OK; we need all that. These are all necessary components in living a life of discovery, because you're pushed forward by those who say no to you. Part of the human DNA. Too many people think somebody's a star or does something great. "Oh, you're so much greater than me."

You gotta keep it at home, where it really begins, which is us, our heart, connected to this whole thing. We created all of this. We're part of it and we are part of God.

I love in the Soul to Soul movie watching you go to Ghana. Is that the first time you'd been in Africa?
Yes.

I could see the look on your face as you — there was that slave building and —
Slave castle.

Slave castle, and you're walking through the streets and you're meeting — I'm just going to use the word "natives" because I can't think of a better word —
Motherfuckers. *[Thomas laughs.]* Black motherfuckers! *[Laughs.]*

Black motherfuckers, right: original black motherfuckers. I just want to talk about that for a moment, what that felt like to be over there.
Well, you've heard so many stories, and you hear so many stories. You already have images in your head: which, to me, I want to go over there with a blank palette. The way they treated us and the way it was, was fantastic. Could be frightening in some ways, 'cause the plane we went on alone was not a jet plane. We were going all the way from L.A.

to New York on this "Capitol Airline." Ain't no way it was no Capitol Airline! Shit. "No jet, what?! And we're going to fly to Africa on this motherfucker?" Shit.

Well, that plane ride alone, you've got Santana, Roberta [Flack], Eddie Harris, you, The Voices of East Harlem …

Well, we had to pick up on the East Coast group in New York. Santana, I think they came in on their own because they were traveling the world at the time. There was a whole contingent from L.A. and one of the main men involved was Dick [Richard] Bock. Another thing about him and his photography at the company: the first company that had ever put a photograph on a record cover. I forgot his name, but I learned a lot from him as well with Pacific Jazz and then he moved on to Liberty Records.

Because you have a photographic eye, did you get more involved than most artists in your record covers? Did you say, "I want this photo," or when it came to doing your album covers, did you have a lot of input in that?

Yeah, but only because that's the way we worked. My producer, Joel Dorn, my dear friend, he would never do something without talking about it and seeing how you felt about it. Often he tells you, "I got some idea, let me go with this." I loved him enough to trust whatever he said and that'd be cool.

So something like Layers —

That, I had nothing to do with that at all! What do you think that is on the cover there?

I'm not sure, but it works. Whatever the fuck that is, it works!

Exactly. So, that's the way Joel sees photography. He sees shapes; he sees color. You wouldn't believe his photographs. You ought to check him and his photographs out. I'm talking about him, he's dead now, but his photographs are un-fucking-believable. Who thinks of things like that?

You guys must've bonded on photos and music, then?

Brothers … brothers.

You guys bonded on everything?

I mean, I would go by what I call my Number 1, A group. People I can talk to without worrying about what words I have to say and hold back. He's one of three people I know.

Who are the other two?

Me.

[Laughs.] You said there's one of three!

That's right. I'm two and he's one.

OK, baby.

My wife and I, we're pretty cool, but that was it. I ain't never had a real girlfriend that I could totally be honest with except, you know, and that's the only kind of people I like to deal with. Tell me you're gonna do something, you do it! You ain't gonna show up in 20 minutes, I'm goin' to sleep! Bye, motherfucker!

Speaking of women, your photography of women is also really wonderful.

Oh, I wish I could find the book of when I first went to Europe and saw these four people in a camp in the mud in the rain. I saw this woman I couldn't believe. I walked over and said, "Sh-s-s-, j-j-jo-, d-d-d-, w-w-wa-," "What? OK." She joins. I picked her up and took her back to the hotel with me and I hadn't even checked in yet! Next day, I took pictures of her; you wouldn't believe these pictures!

Your photography of women is sensual, but not sexual.

That's what I wanted to show.

They're artistic. I've seen your photos of early '70s Mexico.

That's a whole set of books right there, even videos.

Did you take the album cover for Hustle to Survive? *Is that your photo on the front?*

Yeah. That was in Africa.

You're really capturing the humanity of people, whether it's in Mexico, whether it's in Africa, whether it's on the streets of Los Angeles.

If I had my way, I'd probably take pictures of everything, you know? 'Cause when I'm not looking at it and thinking of what it is, it's art to me. Colors, whatever it is.

CONTACT SHEET featuring ANGIE dickinson, others

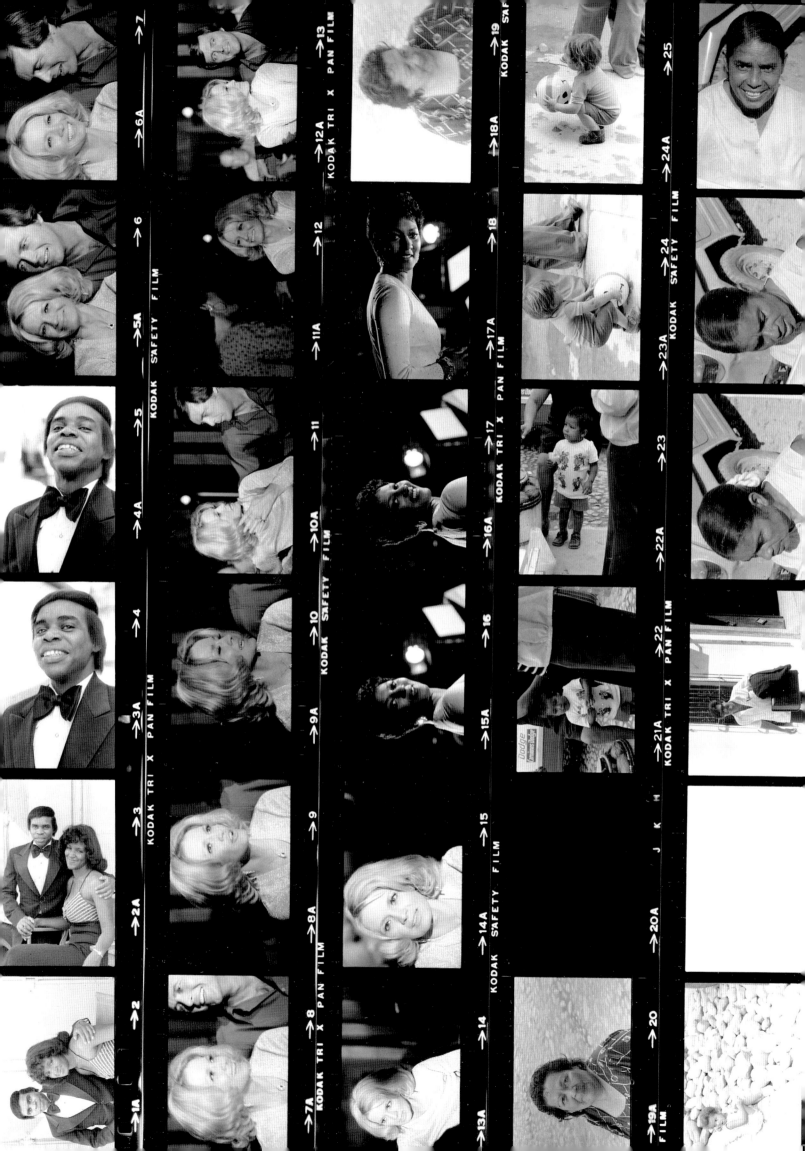

It keeps folding into that phrase "Invitation to Openness," right?
Well, it symbolizes what I am.

You're not filtering; you're letting those people into your life and they're letting you into theirs and it's very natural.
That's a good way to put it. See, that wasn't a statement for them, that's a statement. Period.

Which is very similar to me just coming over here, man. I remember the first time I came over here; you didn't know me from fucking Adam, so to speak, and we had a very freeing conversation. I think that's how you approach your whole life.
Yes. I trust my intuition, is what I'm saying. When I meet you, I feel you might be a jive motherfucker, but don't jive with me. If I can't play with you, I can't joke with you … everybody's different.

Did you have a good relationship with Roland Kirk?
No. I didn't know him. I just loved his music. Half the times when Joel and I did something, and he was saying, "Blah blah blah is here, why don't you put him up on stage with y'all? Let him come in and sit in with ya."

And I would do it. Same thing with that: "Roland Kirk wants to come up on stage with you."

"Well, bring the motherfucker up here! I ain't never liked them before, this might be my moment!"

Because I know you and Eddie Harris were totally different people, right?
Everybody's different. Roland Kirk had a camera on his chest everywhere he went.

That's not bad for a blind guy.
Exactly, he took pictures of everybody. "Hold it! Right there!" Took pictures. Flash. There you go.

How would you describe Eddie? What was his approach to life, if any?
His approach to life was the same thing I'm telling you about me, only ten times more involved. He's a genius, a frustrated genius: brilliant, reluctant, spiritual. He only thought he was human; everything is dissonance. I would try to show him there's more to life than what you know.

Was he more cynical?
He had every human quality that all the rest of us had. You can't be cynical, unless you try to learn something and cynical does teach us to whatever you get out of being cynical. We all have that.

Based on that album he made of jokes — you and I were listening to it here — you guys must have shared some sense of humor, because he seems like he had a pretty wild sense of humor.
He had an extremely wild sense of humor, but you never knew when he was joking! With me, everything he did was funny, but he was a very serious guy. You never know when he was joking, 'cause it was all the same delivery.

You had some of the same band members for years, right? Leroy Vinnegar, wasn't he with you for a long time?
No.

He was not?
He was a crook, a gangster. He'd get me going in the beginning. He was my next-door neighbor, and he was considered probably the best player of his time during that period. And he protected me because he knew I had something different going. I had a lot of critics, serious critics. Some *angry* critics, and he would say, "You fuck with Les? I promise you you won't be walking no more." And that was the other musicians, too.

The only other guy that I can think of at that time who was doing something like you were doing was Ramsey Lewis.
Right.

What kind of relationship did you have with him?
None at all.

You never really met him?
I met him and I've been on his television show.

It seems like you were doing in L.A. what he was doing in Chicago, right?
I hear that a lot, but I never knew him. Because each one of us, if we were to listen to each other, "I don't sound nothin' like that!"

No, I'm not saying you guys —
That's what we would say though, see: 'cause I've heard that a lot. I think what people liked was the fact that it was church-y, it was gospel-y, you know? It had the feel of the church.

That's the "soul" part of the soul jazz, right?
Well, they said they — my record company — considered me jazz, and wrapped the word "soul" into the musical vernacular because of me.

I see you as the father of soul jazz.
That's what they said. "Les McCann invented soul musical." What was Ray Charles doin'? What was B.B. King doin'? It's all just kind of a special area.

So this is your first book of photos, with hopefully many more to come. What are your thoughts as you start to hear me and Alan [Abrahams] talk about finally putting a book together?
I love it. I'm not so tied up with the music that I can now deal with it, hopefully. I can get up and find some of this stuff I've been looking for — I mean, I have this with everything. Photography, videos … you wouldn't believe the shit I have over there.

Why do you think it's taken so long to get a photograph book?
I've had many people say, "You ought to have a book," but I'm busy playing music. I can't get involved in it, that's why I have people who are my angels, I call them — like Alan — who are willing to do the work it takes, and he knows a lot. He's a great businessman. Of all the people I've had work with me, he's gotten me more money than anybody because he's looking out for *me*. He knows that I've gone through what we go through in life, and there have been periods when I had nothing, but that's part of my learning, too. ✳

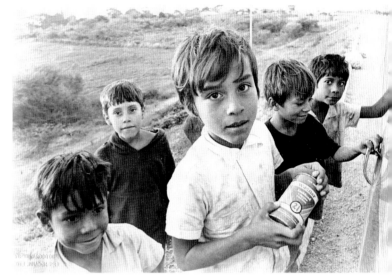

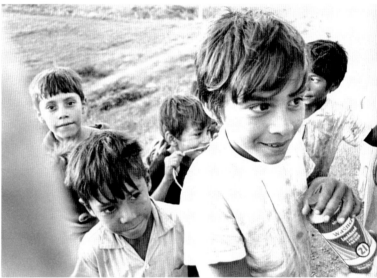

CHILDREN in mexico

God darn It!

"Les is about 'no rules.' To learn from Les is to be released from limitations that musicians, artists, and listeners may not even realize are holding them back."

INTRODUCTION

ALAN ABRAHAMS

I was at the *Playboy* Jazz Festival for the first time in the very early 1980s with my friend and partner in all things soulful — the irrepressible Les McCann.

Les was on stage and — as if by some universal telepathic cue — just as he came to the punch line of the third chorus of his game-changing hit, "Compared to What," the entire Hollywood Bowl audience shouted out with him: "*GODDAMN IT!*"

It was the moment we had been eagerly anticipating. That exclamation, never before heard on a record, in all its boldness and spontaneity summed up Les McCann. He belonged to us all.

Of course, I had heard him perform "Compared to What" many times before — his driving piano introduction, the expressive modulations, his co-conspirator Eddie Harris's blazingly outrageous sax riffs, then all of it settling into the straight fours of the relentless groove that set up Les's preach-and-teach vocals — *this* was it!

The atmosphere was electrifying — a sizzling convergence of soul, jazz, and *attitude*. The crowd was with Les on every lick, every passionate voicing. He was pounding the piano — and then making love to it.

MONTREUX

It recalled an earlier, similarly charged moment. In 1969, when Les and Eddie Harris's LP *Swiss Movement* ("Recorded Live at The Montreux Jazz Festival, Switzerland") had been released by Atlantic Records, no one expected a live "jazz" album to sell a million copies and top the *Billboard* charts — *Swiss Movement* became the touchstone of what some were calling "The Soul Jazz Movement."

The story of how Les, Eddie, bassist Leroy Vinnegar, drummer Donald Dean, and special guest trumpeter Benny Bailey ended up on that stage in Switzerland on that day in 1969 is the stuff of legend and varies according to who's doing the telling. They had never performed together in public before, and in some ways, for Les and Eddie at least, that day tied them inexorably together. It is considered one of the cornerstone moments in live jazz history.

Les's own account of the performance shows that he, too, was swept up in the moment, but he recalls an ironic twist: "Some of the time I wasn't sure if it was amazing or maybe not — but in the middle of our performance the audience started cheering, and I was spurred on. I found out later it was Ella Fitzgerald coming in to catch our set!"

Bob Dylan's "The Times They Are a-Changin'" had been released at the beginning of 1964. Sam Cooke's "A Change Is Gonna Come" had been released at the end of that year. As opposition to the Vietnam war grew and the battle for human and civil rights was being waged in the streets, Les McCann and Eddie Harris's "Compared to What" in 1969 was the perfect note for that moment — of its time, yes, but transcending it, too.

The one time I met Marvin [Gaye], he told me that he listened to "Compared to What" constantly and was inspired to create *his* milestone songs and the album that became *What's Going On* (1971) as he struggled to change himself as an artist.

The riveting lyrics of "Compared to What," written by Gene McDaniels, were played to Les over the phone by Gene on *acoustic guitar*, around the same time as the Dylan and Cooke classics referred to above. Roberta Flack, whom Les had discovered and signed to Atlantic, also released a version. But it was on Montreux's stage, June 21, 1969, when it all came together and they captured lightning in a bottle — a moment in music history unlike any other.

"DO YOU WANT TO MEET LES McCANN?"

In the early 1980s I was in the studio producing an R&B group for Capitol Records, and their manager was also Les's manager. He told me that he could arrange for me to meet Les whenever I wanted, and I asked simply, "How about right now!?"

I, like millions of others around the world, loved Les McCann's music — from his early Pacific Jazz albums (including *Plays the Truth*); to his classic collaboration with Lou Rawls, *Stormy Monday* (Blue Note); to the series of Atlantic recordings that includes *Swiss Movement* and this book's namesake, *Invitation to Openness*, and, of course, the experimental, innovative, oft-sampled *Layers*.

To know Les is to love Les. To know Les is to learn to know yourself. To know Les is to be mentored in music in a way that is unique to Les.

Les is about "no rules." To learn from Les is to be released from limitations that musicians, artists, and listeners may not even realize are holding them back.

I remember, in the earliest days of our friendship, going to his home (and yes, children, we smoked a little). He put earphones on me that he'd plugged directly into his suitcase model Fender Rhodes piano. I lay on the couch and was transported to another musical universe — not because I was high (although it didn't hurt) but because Les, "playing beyond himself," free form, on the Rhodes, with its vibrato, its sound (sometimes with the Boss chorus pedal effects added) — was an immersive experience that was mind-blowing.

As I spent more and more time in Les's world, more and more was revealed to me. His music was boundless. (I once thought that would have been a good album title: *Bound Les*.)

BEYOND THE MUSIC

The spectrum of his music turns out to be matched by the spectrum of his art. He is a prolific painter, constantly creative: watercolors, landscapes, flowers, abstracts. All sizes on canvas, paper, envelopes, even paper plates. We framed many, but we couldn't keep up with his extraordinary output.

"I let the colors tell me what to paint," he explains. He sometimes puts watercolors on the middle of a page and lets them flow together, holding the paper and letting it go in different directions, open to the mystery of creation, until suddenly he zeroes in on something and takes it from there. He becomes one with it all. He smiles, does that tongue-chewing thing that lets you know the magic is flowing in Lesland.

Les's senses are always at a heightened level, whether he has imbibed or not. He hears things in his head and especially through his heart. He sees things like no one I have ever met. He is able to translate it to every level of composition, performing music, painting, sketching, camera, pen, and pencil.

THE MUSIC

There are the albums I produced for him: records we made together that always included the greatest musicians, legends themselves, who just wanted to be in the same room with him.

There was Eddie Harris, of course, who contributed and played on his own composition, "Ignominy," on 1994's *On the Soul Side*. I didn't even know what that word meant, but when Les and Eddie let fly on it, I was damn glad the engineer had followed my instruction to "record everything from the minute they got anywhere near a mic."

Lou Rawls dropped in to sing a jazzy "God Bless America" in a swinging gospel 6/8. Les introduced it with a moving free-form piano rendition of "Lift Every Voice and Sing," a stroke of genius!

It reminded me of that first amazing day at the *Playboy* Jazz Festival when Les started another song with "Lift Every Voice and Sing." Thousands of people stood up, cheering and applauding. Les later informed me that "Lift Every Voice and Sing" is the Black National Anthem. "I thought *everyone* knew that, my brother." Another lesson from the Les McCann school of "You Got It in Your Soulness."

During the recording of *On the Soul Side*, the big Northridge earthquake struck. Les's apartment was damaged, so he moved in with me at my Agoura Hills home. As we approached the front door to my house that first night, he opened his hand to reveal what I thought was a joint. It turned out to be a tooth he had just pulled out!

While we were recording the vocal for the final track of the album, "Look to Your Heart," I heard a whistling sound on every lyric that had an "s" in it. What the beautiful vintage Neumann U47 microphone was picking up was the air whistling through the gap where there was no tooth! I ran to the 7-Eleven next door, got some Chiclets, and fashioned a "tooth" for Les to block the whistling. It did cut down the sibilance somewhat, but you can still hear it if you listen closely! What's more important, though, is that it is one of Les's most emotional vocals ever. Listen. You'll cry. I still do.

BACK IN THE STUDIO

In early 1995, Les had a stroke while onstage in Celle, Germany. But even that couldn't stop his humor. As he described it to me: "People thought I was going into some of my Thelonious Monk shit."

Once back in the U.S., and in recovery, his creative juices were undiminished as we went into the studio again, to record the *Listen Up!* album. We thought about calling it *A Stroke of Genius* but decided against it.

The *Listen Up!* sessions were a gathering of the tribe: George Duke and Greg Phillinganes on piano; Billy Preston on the Hammond B3 organ; David T. Walker, Steve Erquiaga, and Dori Caymmi on guitar; Abe Laboriel on bass; Ernie Watts and

Keith Anderson (another McCann discovery) on sax; and so many more. All were there to catch Les's vibe, play Les's compositions, and pay tribute to the man himself. All the while, Les was in the middle of the action, holding court, receiving his due, and enjoying every moment. He was playing his signature voicings on the Rhodes piano. If you tried to notate them, it would be a difficult task.

Every time I have ever asked any musician if he or she would like to sing or play on a Les McCann album — Marcus Miller, Bonnie Raitt, Dianne Reeves, Stanley Turrentine, John Robinson, Paul Jackson, Jr. — they were always eager to say "yes," to show their love and respect for the artist who had so profoundly influenced them.

PHOTOS AND RECORDINGS

From the early days, everywhere Les went, he carried two things: a 35mm camera and a professional Nagra tape recorder. As my co-editor Pat Thomas wrote, "he unwittingly documented a side of the vibrant cultural life of jazz and soul."

Not only of the great musicians, but everyday people, sports events (especially basketball — Les is a sports fanatic), actors, politicians, exotic women. On a trip to Africa to make the movie *Soul to Soul*, he recorded the sights and sounds of Ghana, even as he documented his fellow musicians Eddie Harris, Roberta Flack, the Staple Singers, the Ike and Tina Turner Review, Wilson Pickett, Santana, and the Voices of East Harlem.

Which brings us to today. When Les allowed me to start viewing his personal treasure trove of photographic images, I had no idea what a thrill it would turn out to be. He showed me only a few at first, hinting that there might be more. Hundreds, maybe. In fact, there were uncounted thousands of images: prints, slides, contact sheets, and negatives in boxes, closets, drawers — everywhere, seemingly.

He hadn't taken them for the purposes of creating a book. He was just following his heart — recording for posterity what he saw and experienced. But now, at the behest of Pat Thomas and Gary Groth (our publisher at Fantagraphics Books), it is my privilege to share with you this collection of Les McCann's amazing photos. As a fellow musician, Les had unique access to his subjects — backstage, at home, in the dressing room, and in the studio. And what he did with that access is another lesson from the school of cool that is Les McCann.

Turn the pages and see for yourself. You can actually *feel* the spirit behind the music in these photos. Take your time. Look into these artists' eyes — into their souls, revealed in these frozen moments of forever.

— ALAN ABRAHAMS
Baton Rouge, Louisiana
August 2014

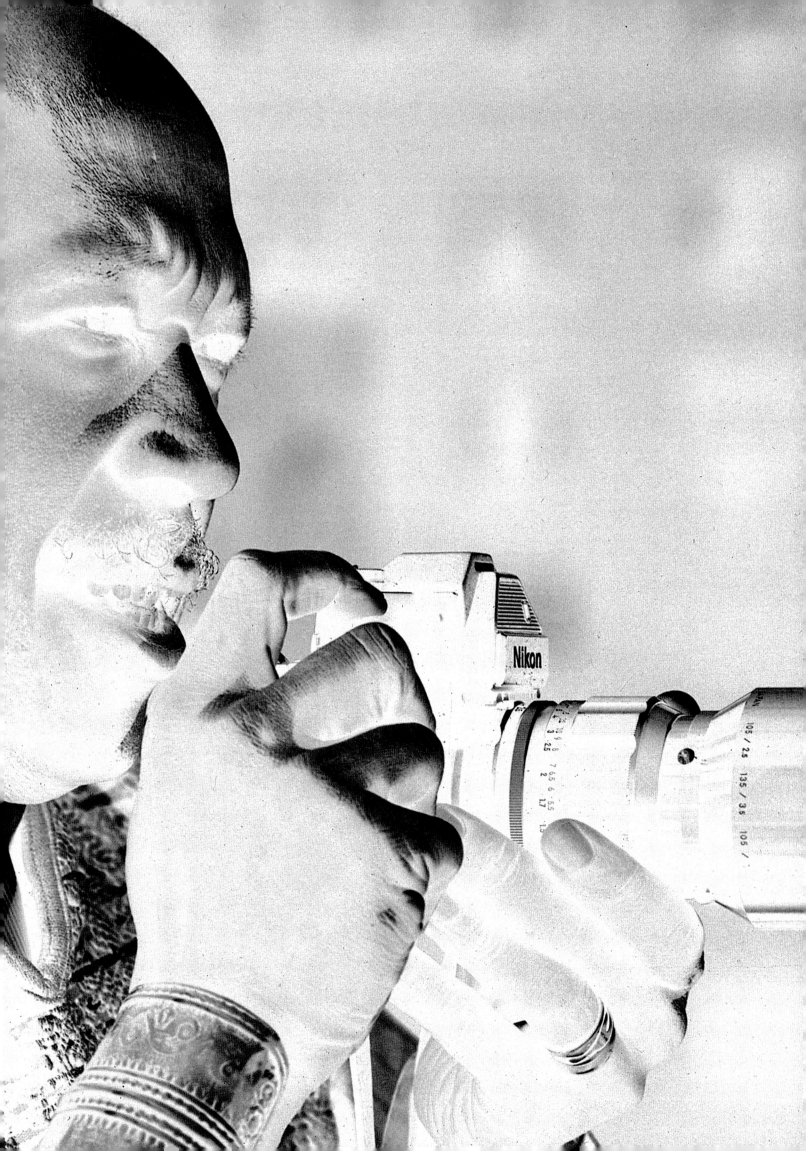

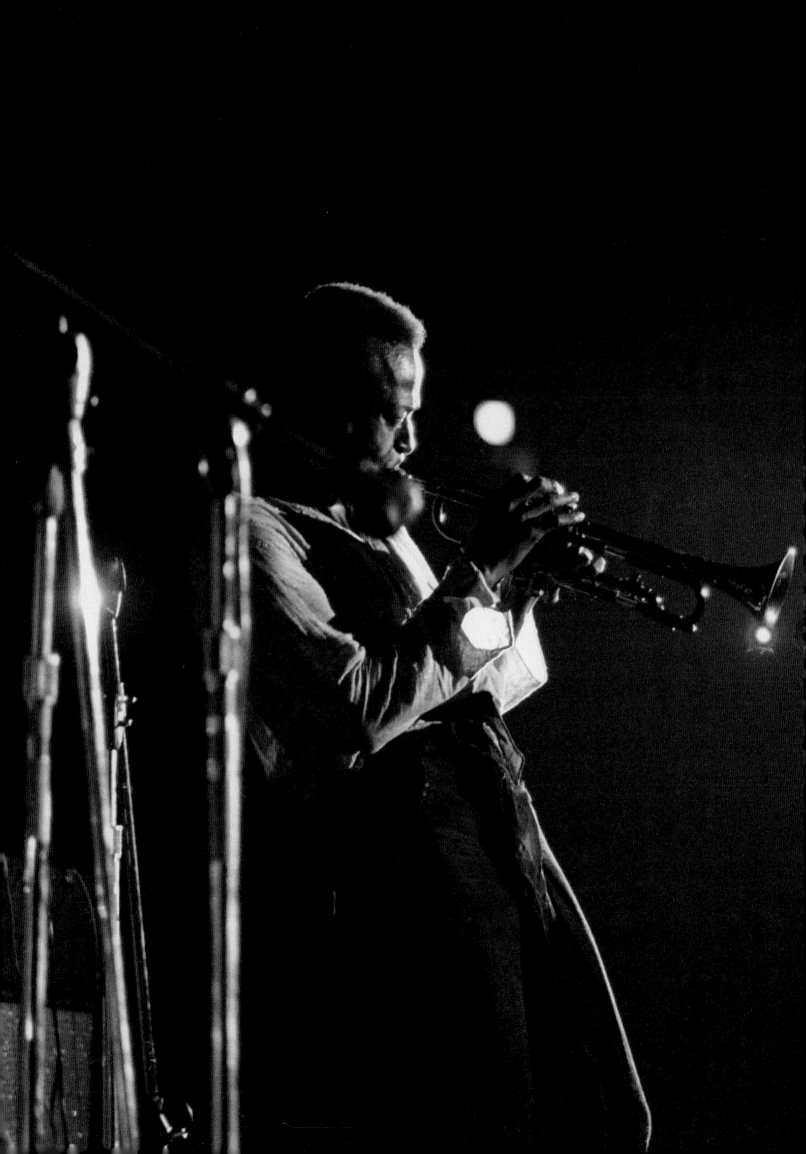

"I see my spiritual life as being me in this great school where everything is on the curriculum."

"You can't think of anything that's not on the curriculum."

"It's called Earth. Planet Earth."

Some one took this of my ax the club — I love You and "Happy" Mother's Day

C8
1970

POLAROID ® POLAROID ® POLAROID ® POLAROID ® POLAROID ® P

I dedicate this book to my beloved late daughter,
Cindy Waller McCann.

— **LES McCANN**

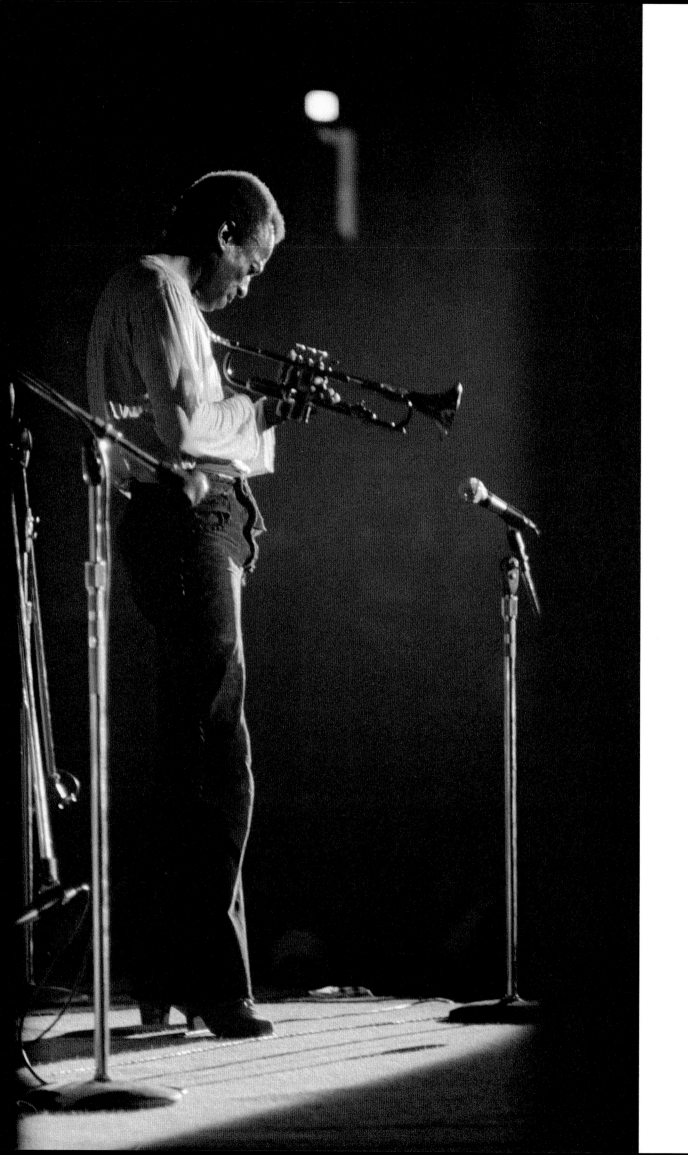

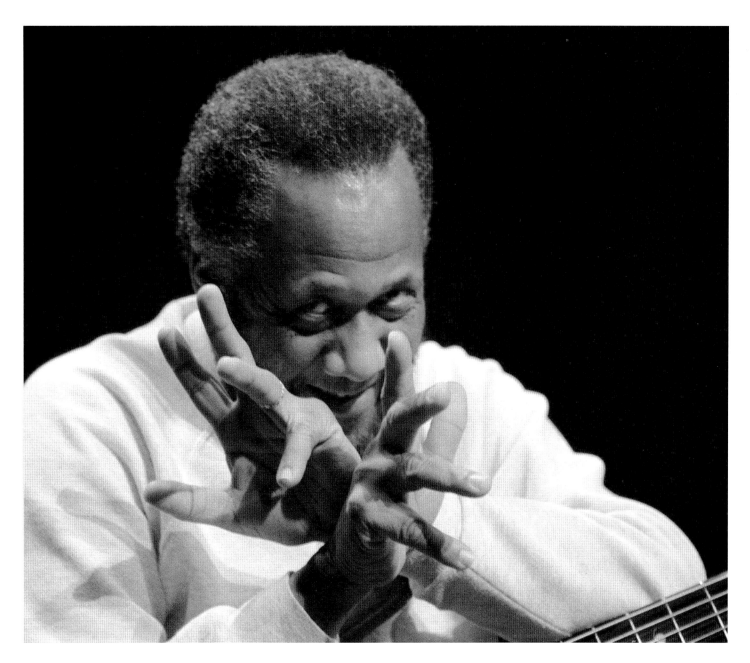

CHUCK r a i n e y

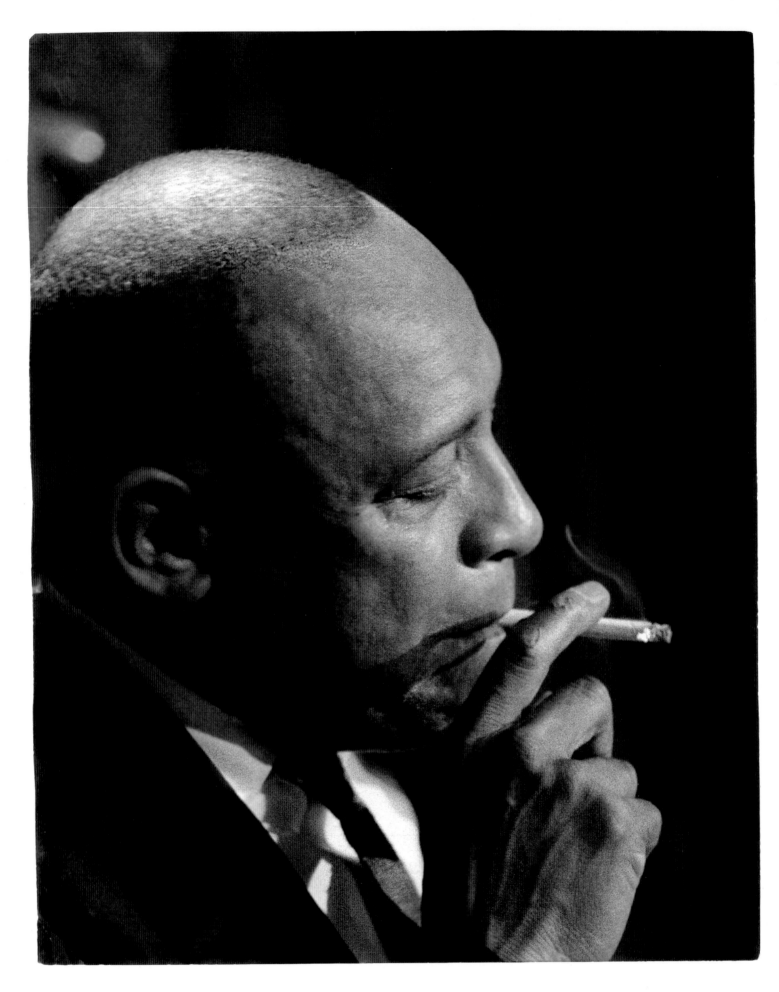

LIONEL hampton

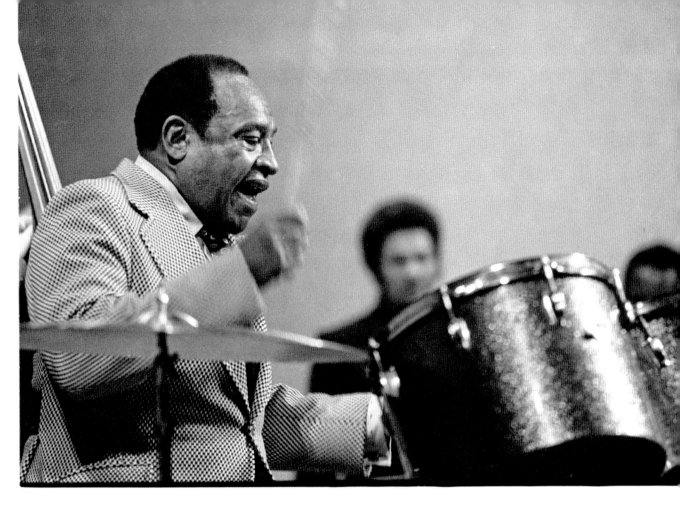

LIONEL hampton

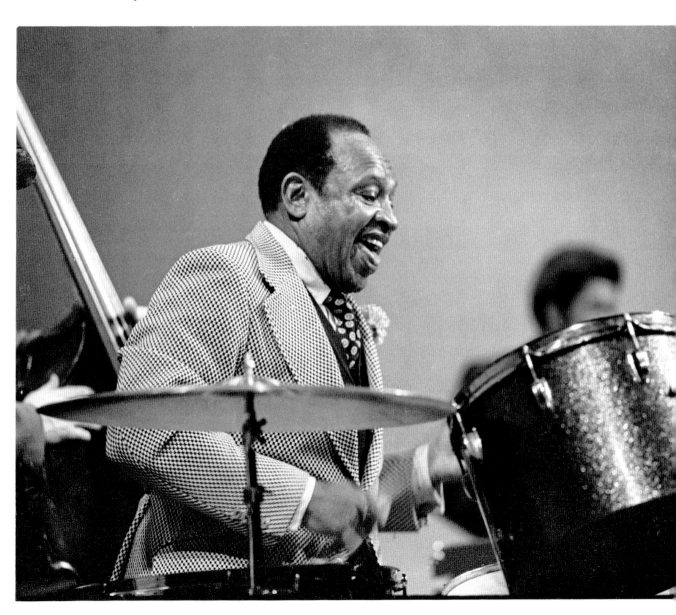

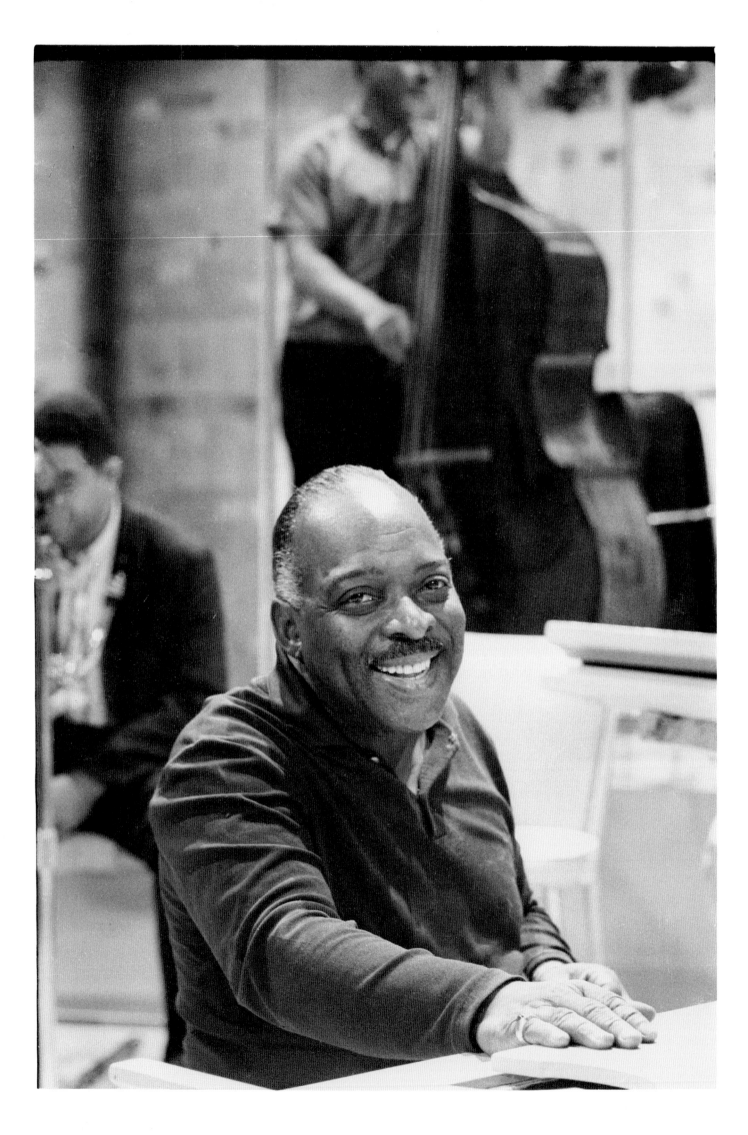

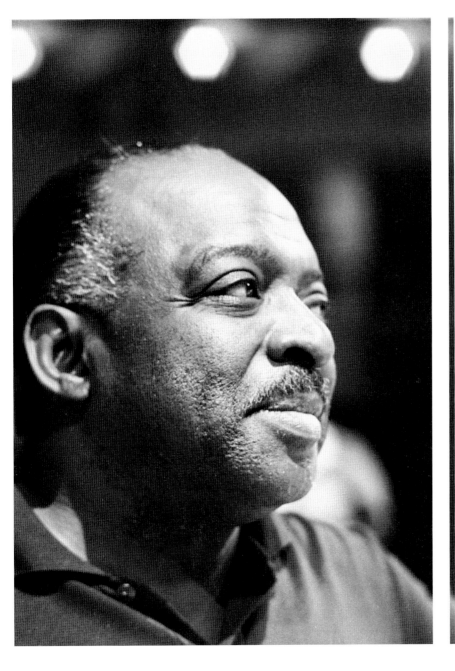

COUNT basie

"Count Basie? My brother. He gave me the greatest compliment I've ever had. My first ever concert in France was the Antibes Jazz Festival, and we were told to go on for fifteen minutes and get off. The crowd would not let us off and we remained onstage for the next hour and a half, and people would still not stop cheering. They were yelling 'revolutionary jazz!' When I got off the stage, Count Basie's standing there with Ray Charles and together they both said, **'You are the hardest act we ever had to follow.'"**

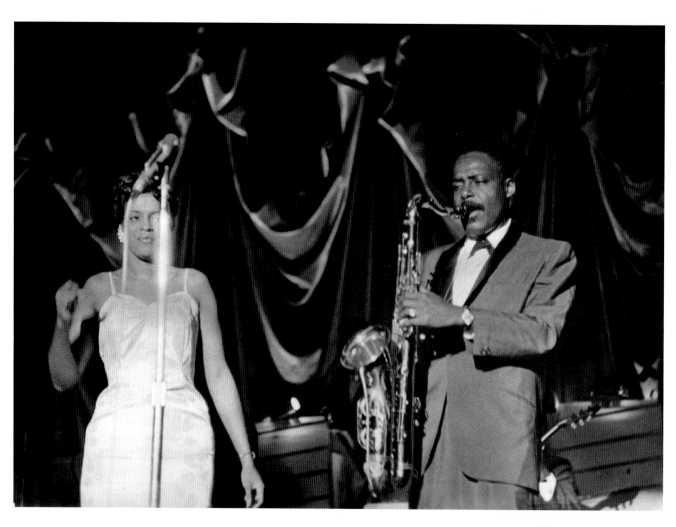

one of the raelettes + DAVID "FATHEAD" newman

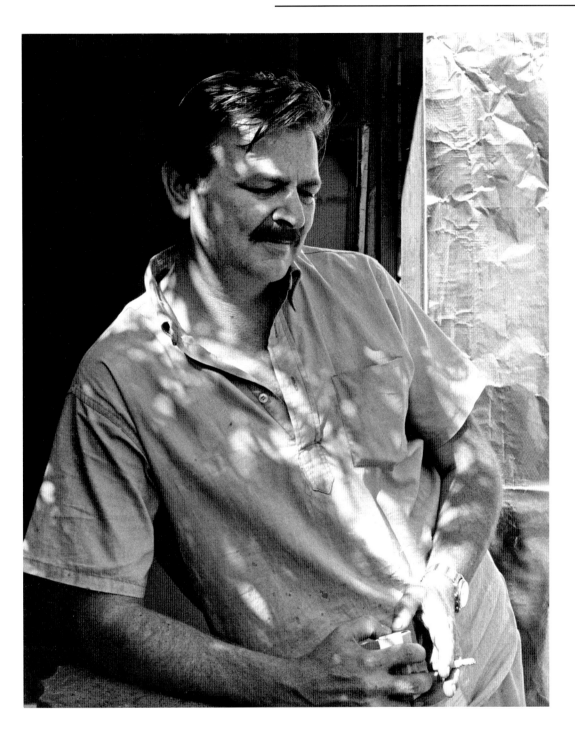

"I think of Chester as my early technique teacher for photography, because when I was working in Hollywood, I would go up to his house (each night, after I got out of work) and we'd meet in his darkroom after hours. Over a period of a year or two, I would watch him. It was fantastic. I did my own developing, my own printing, and I learned it all from him. He was a great photographer as well. He took all those cowboy pictures of me."

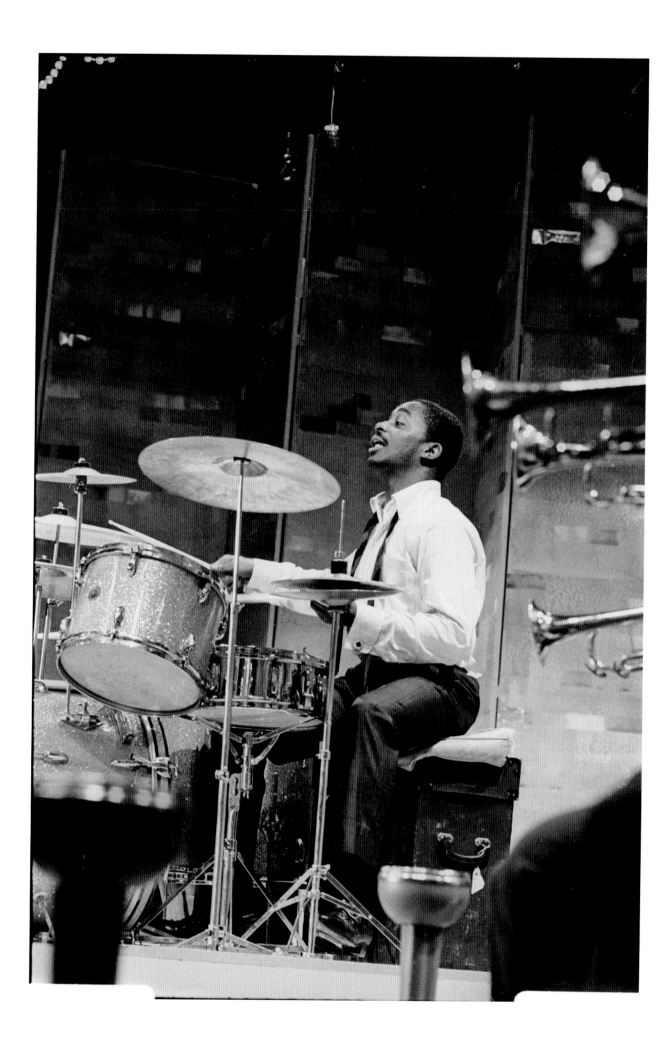

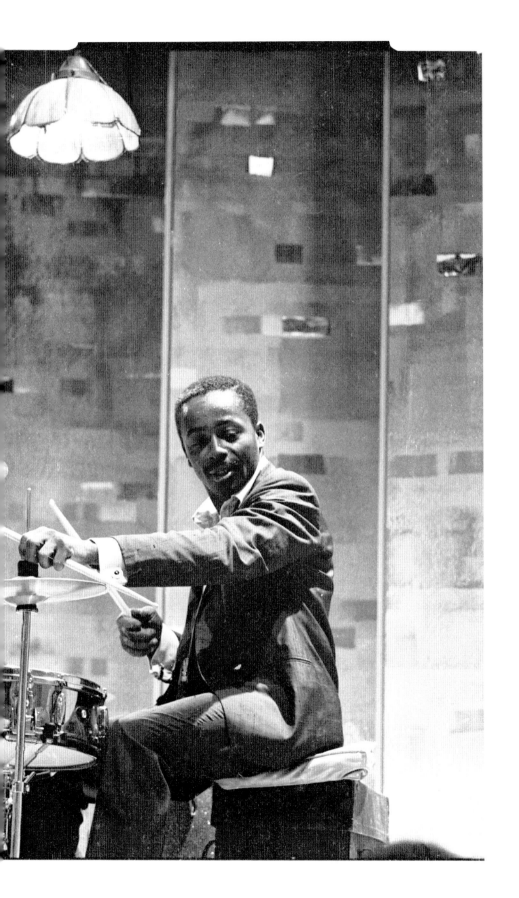

SONNY payne

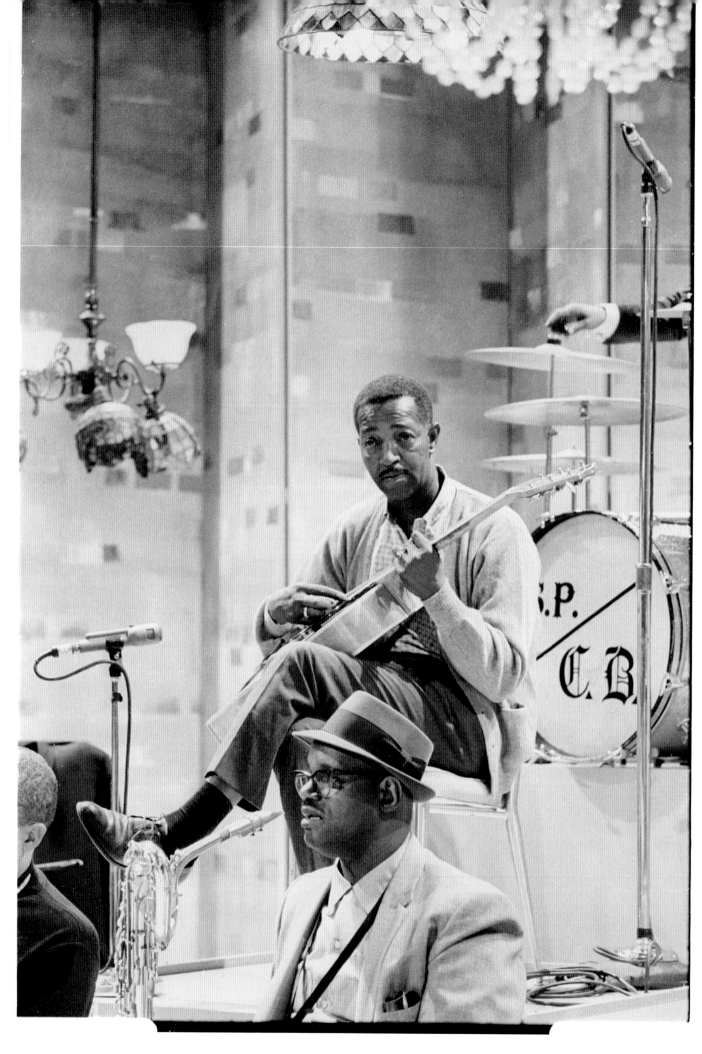

FREDDIE green

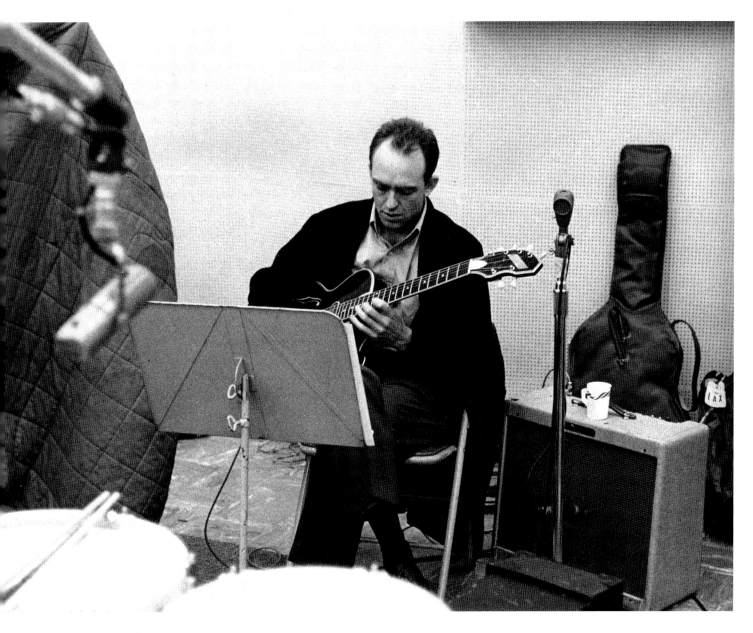

HOWARD roberts

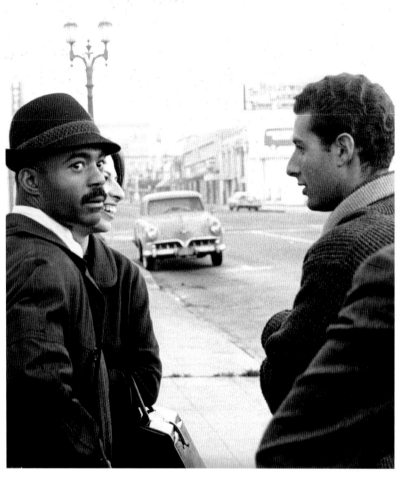

JOE gordon

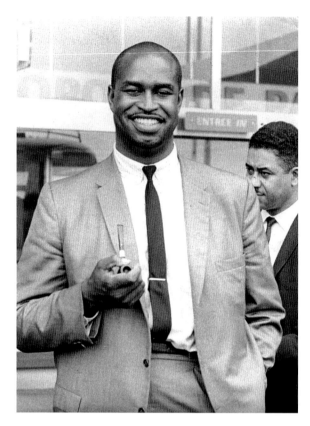

EDDIE jones + FRANK wess

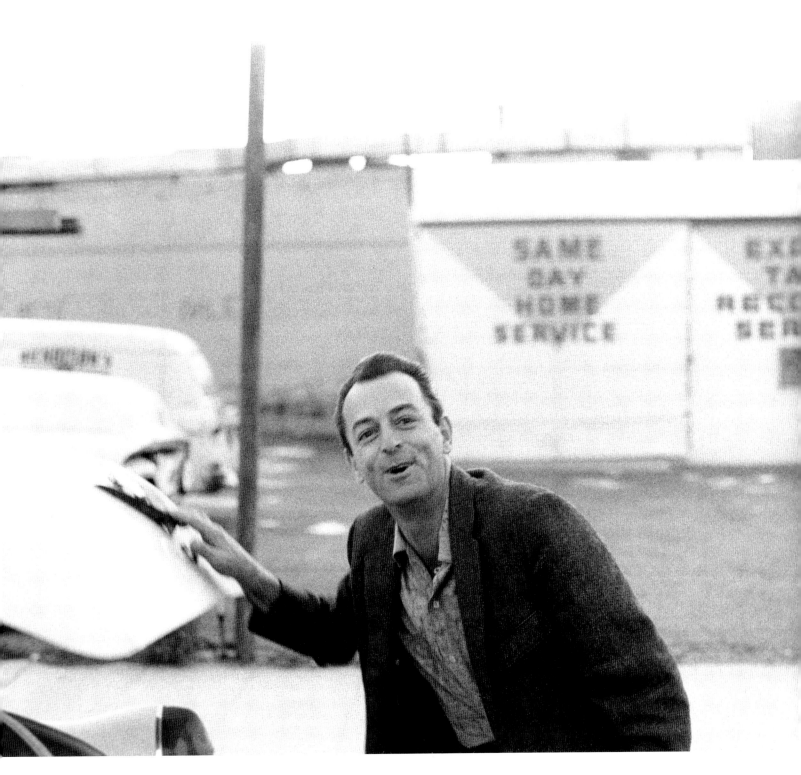

TOMMY b

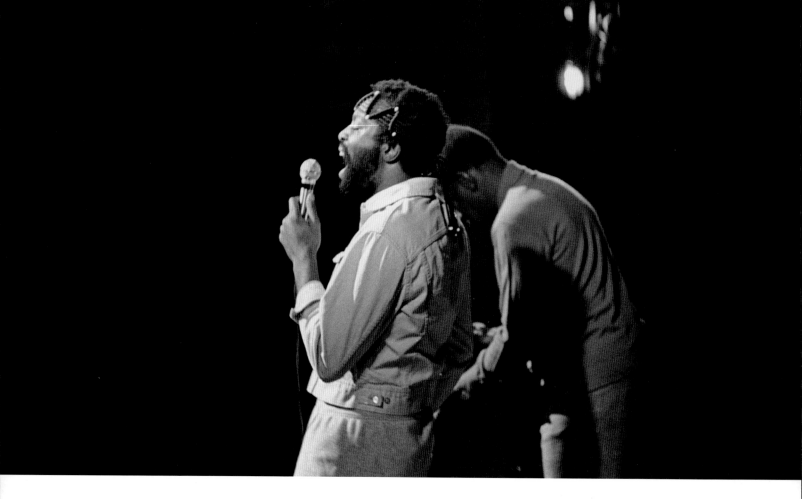

GENE mcdaniels

"*His father was a preacher. Gene was a free spirit but had not experienced freedom until he moved to Los Angeles. When I heard him sing I couldn't believe it. He was the greatest singer I ever heard.*"

"He was in my first band, in the coffee house years, and we killed everywhere we went. He was so good, so great that he was the first to be recognized. Liberty Records came to him and said, 'We'll offer you a contract.' They offered him a lot of money, the car he always wanted. We were kind of bugged that he bailed on us."

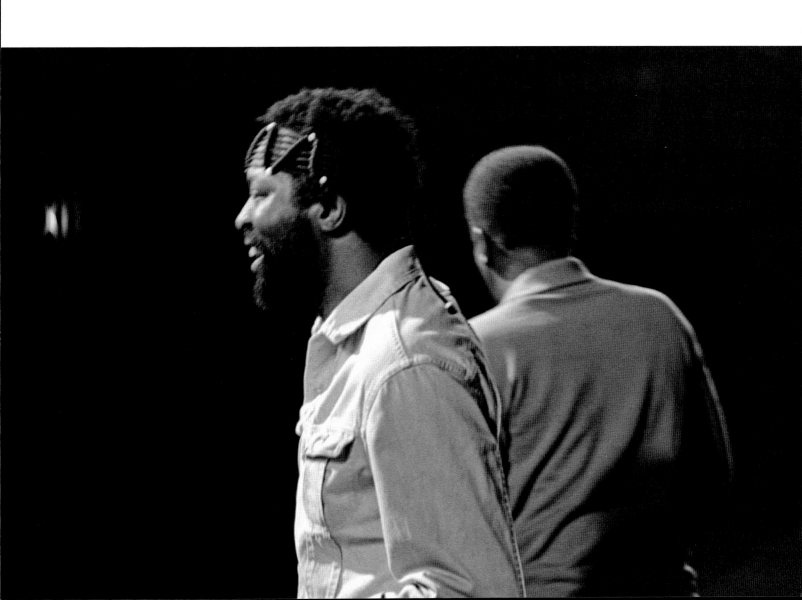

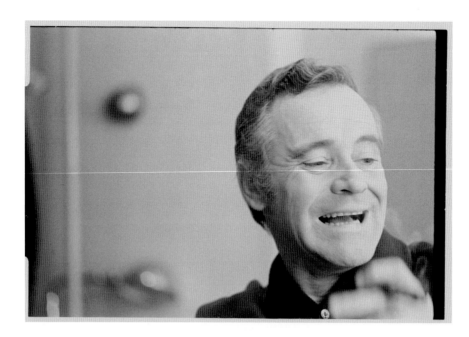

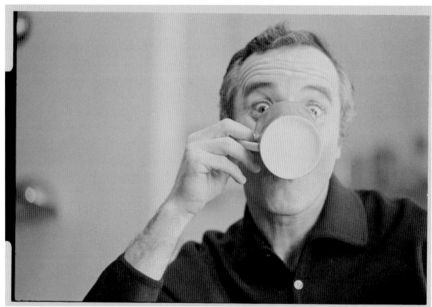

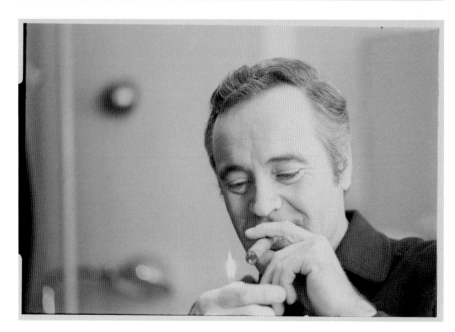

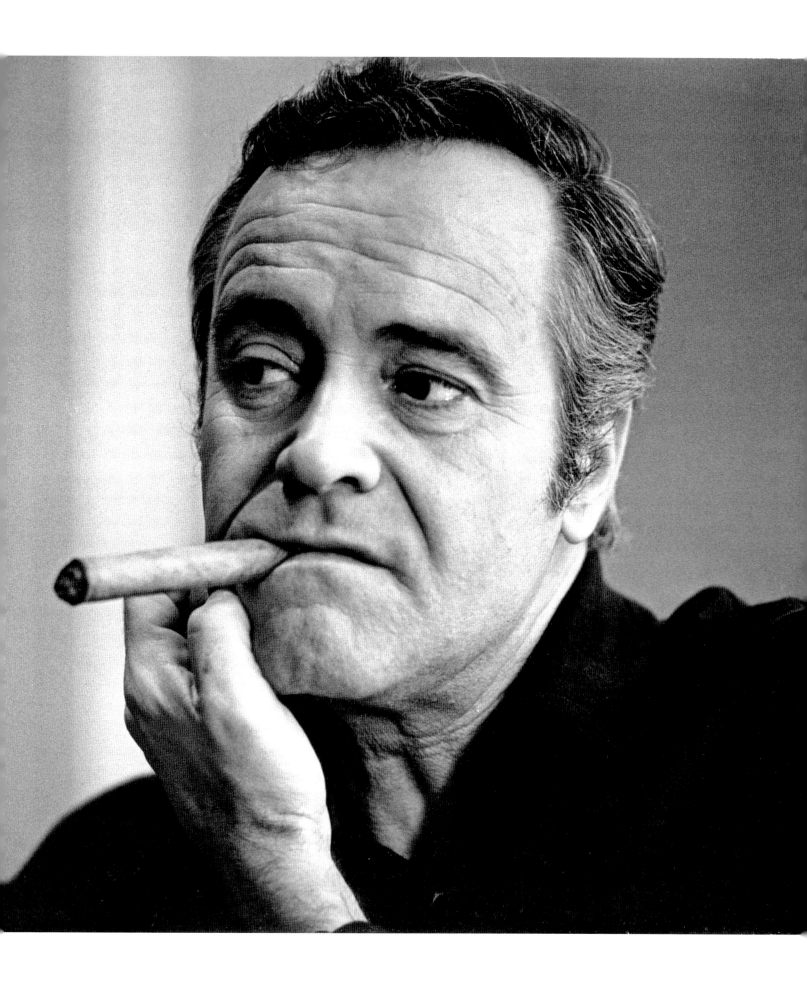

JACK lemmon

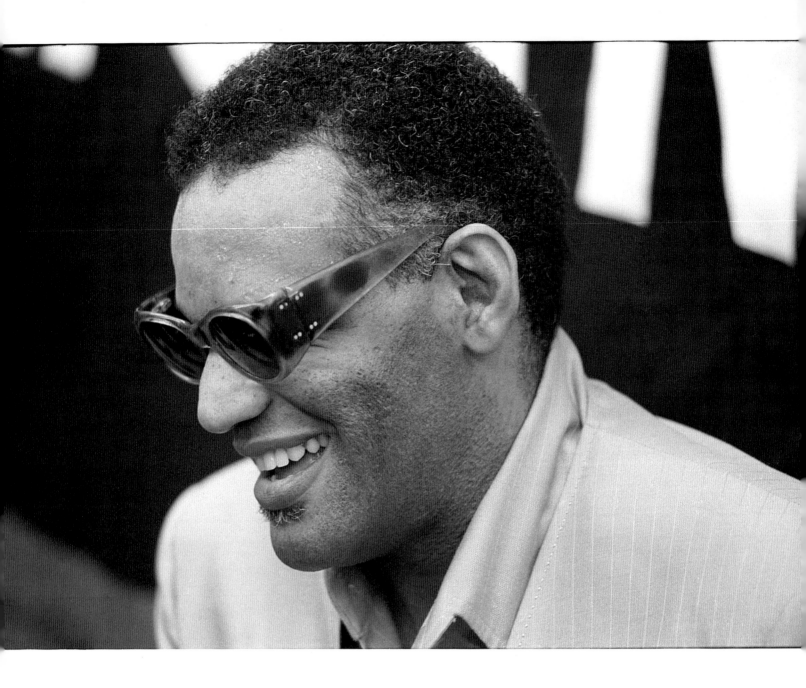

RAY charles

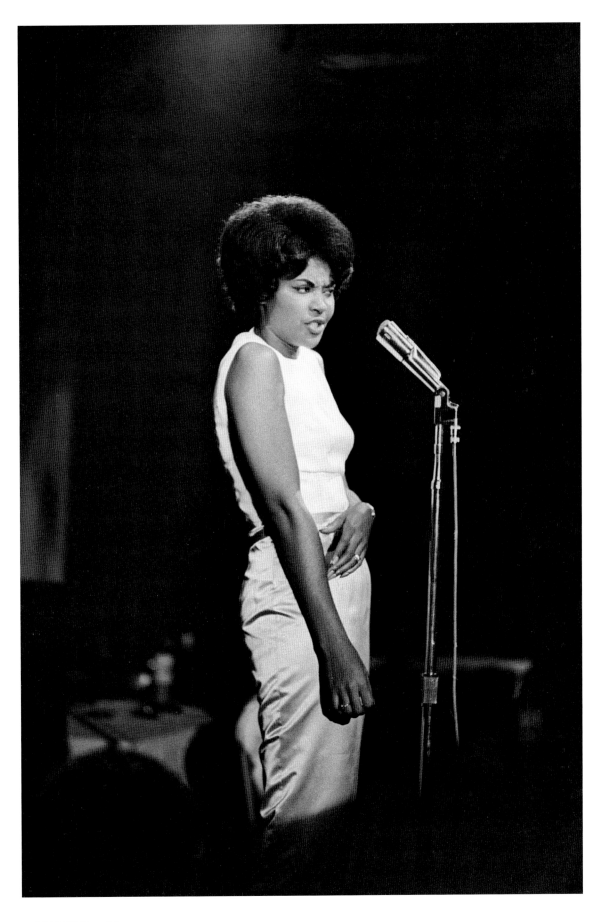

NANCY wilson

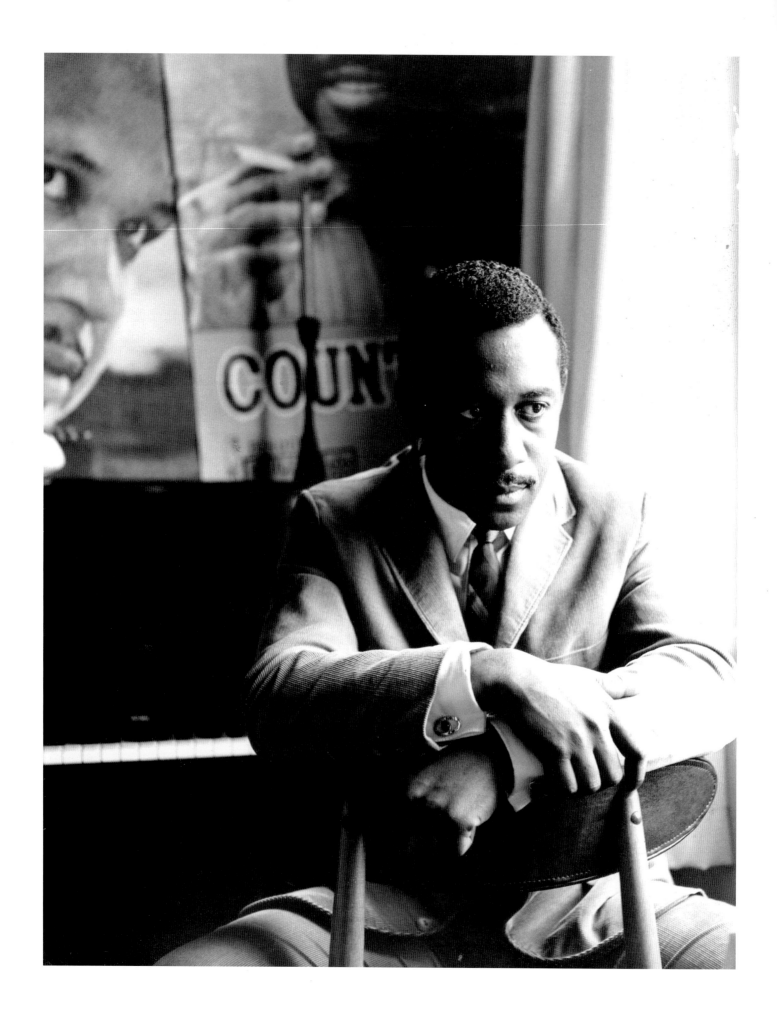

ROBERT doqui

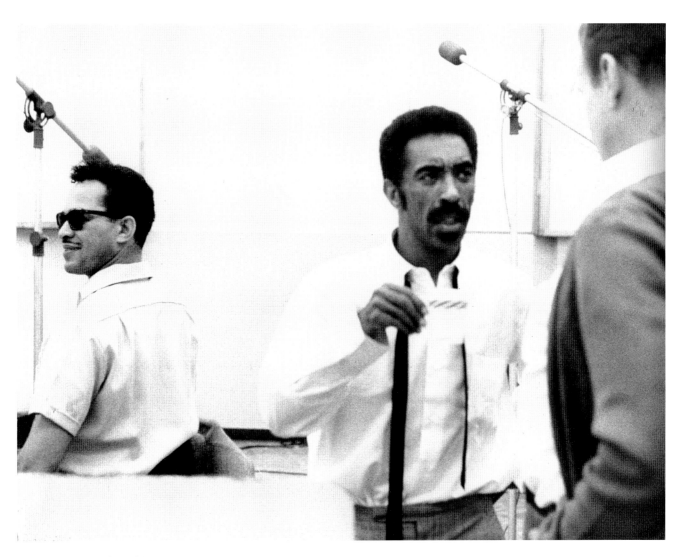

GERALD wilson

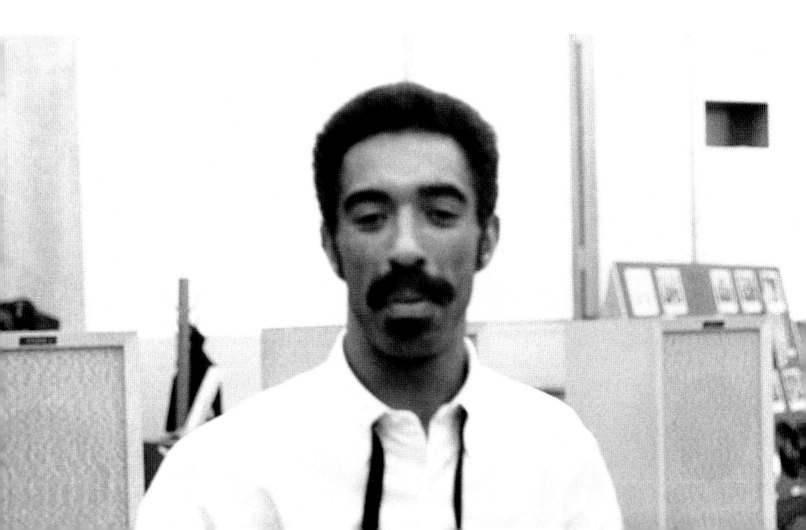

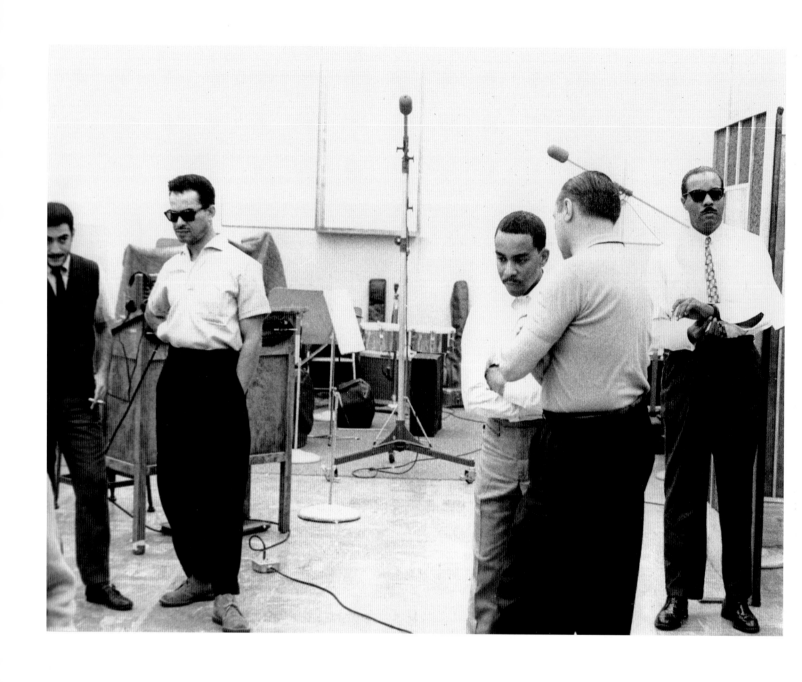

MARVIN j e n k i n s

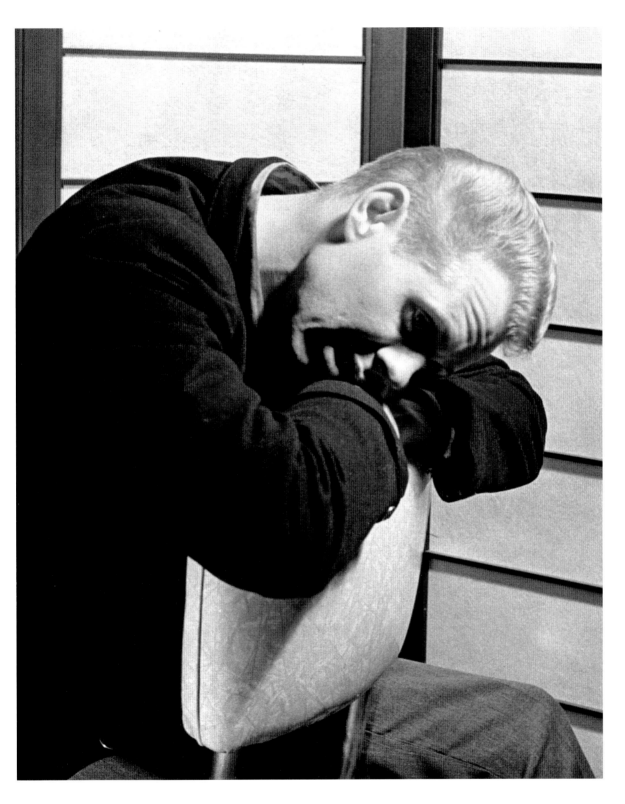

JACK bruce

les's first bassist
at l.a. city college

"One of my all-time favorites. Cannonball was great.
I think the picture I took of him is one of my favorites.
They printed the picture in a Japanese magazine, and they
wrote my name as 'Photographed by Les McCann Keyboards.'
That's my name, 'Keyboards.'"

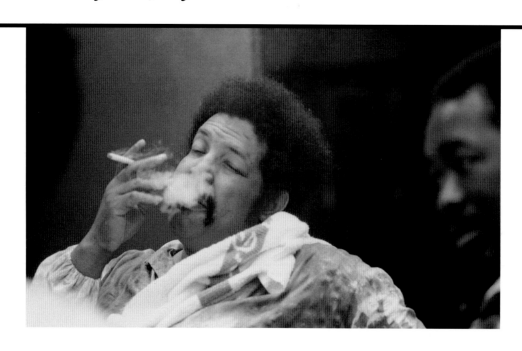

CANNONBALL adderley

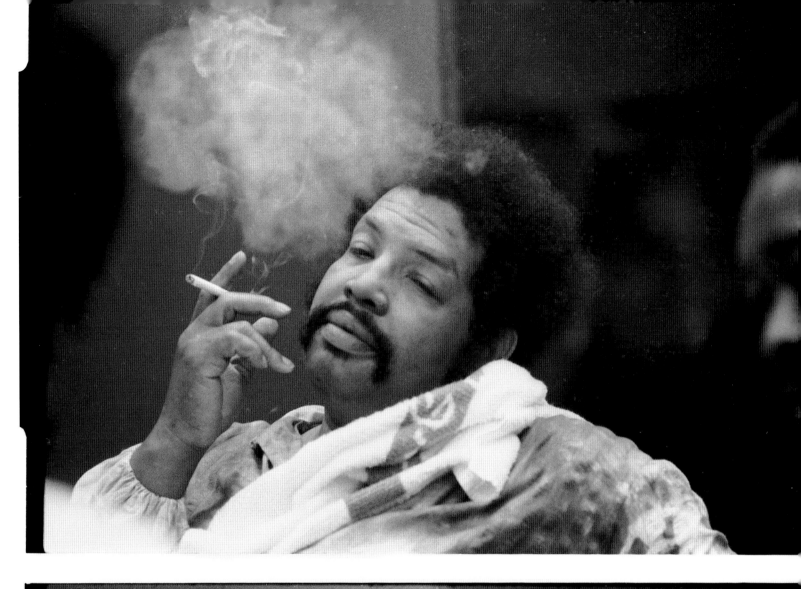
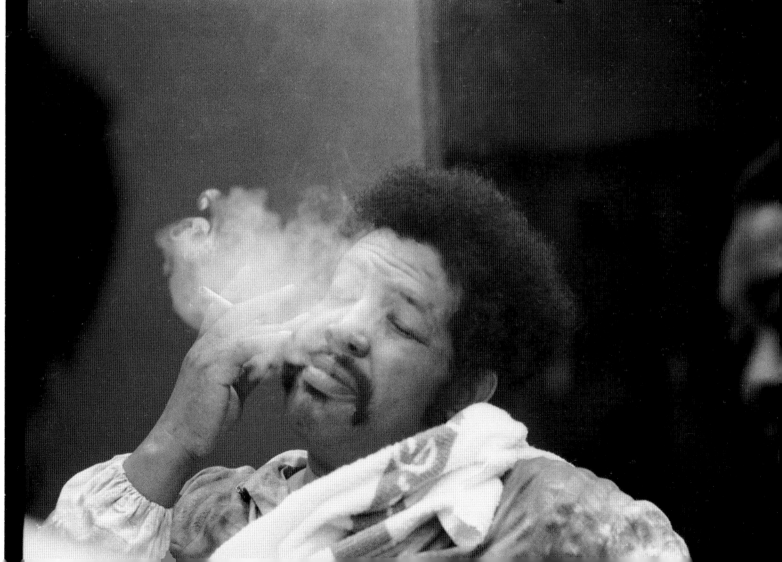

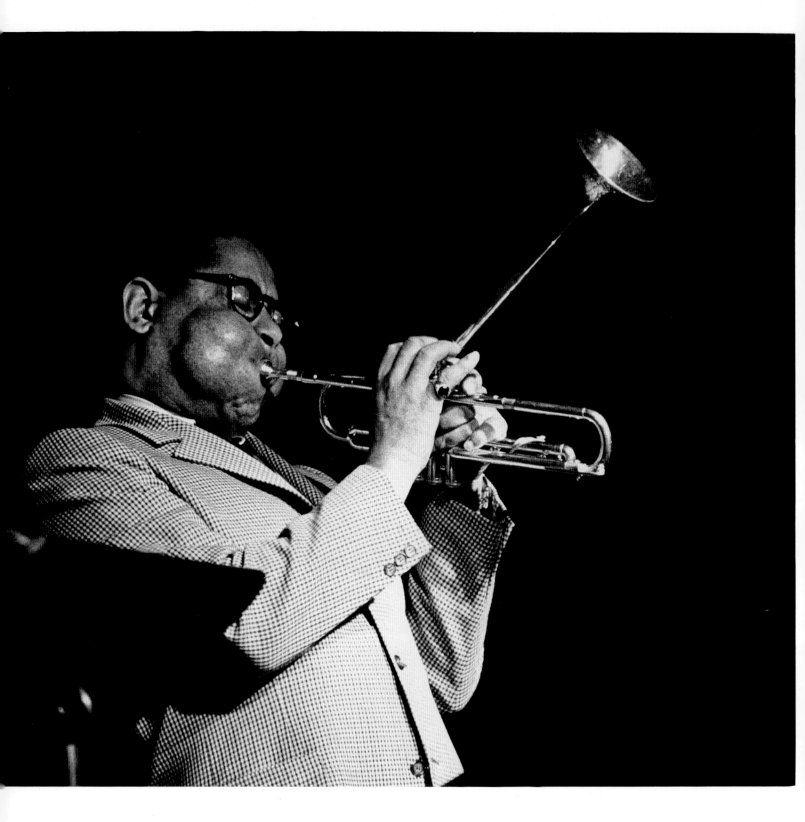

DIZZY gillespie

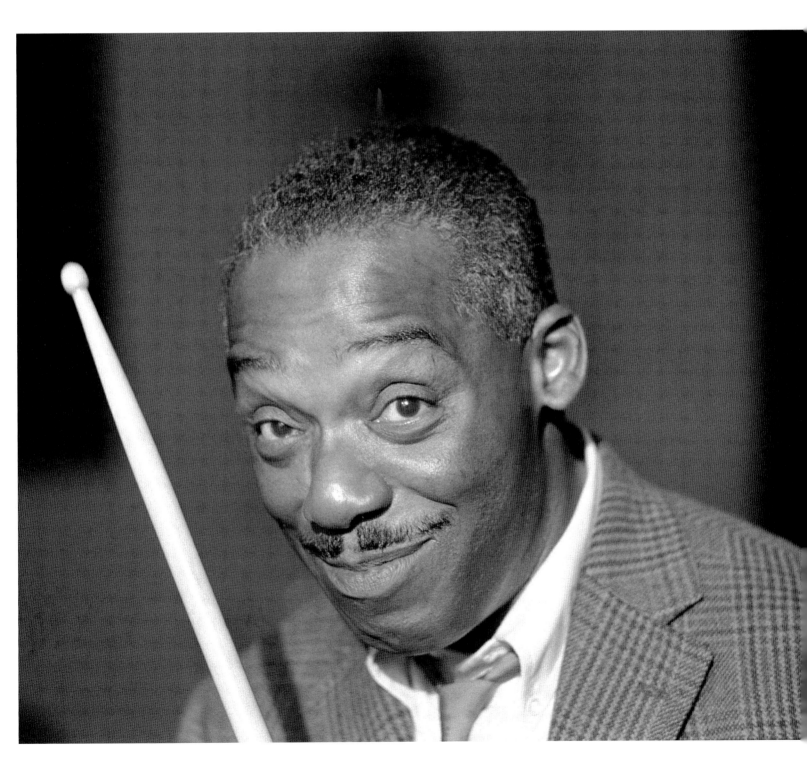

LOU rawls

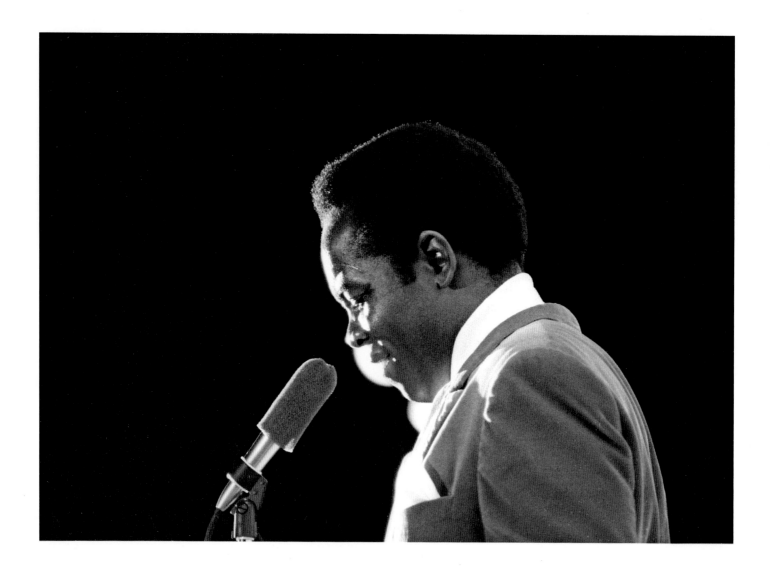

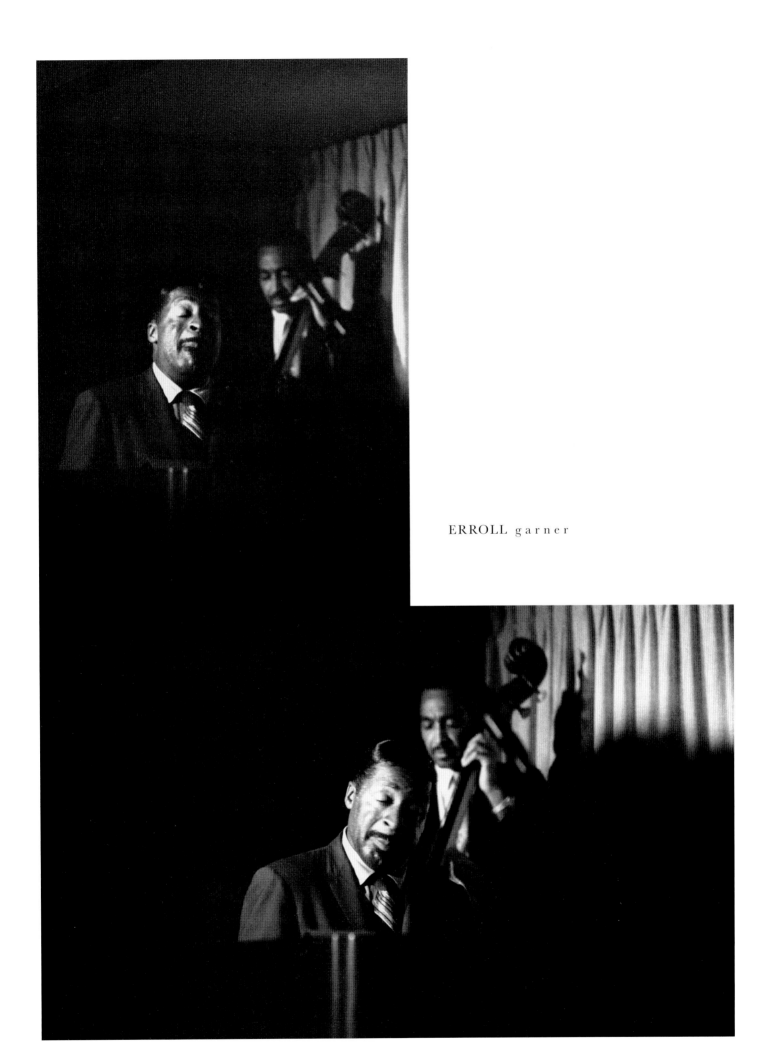

ERROLL garner

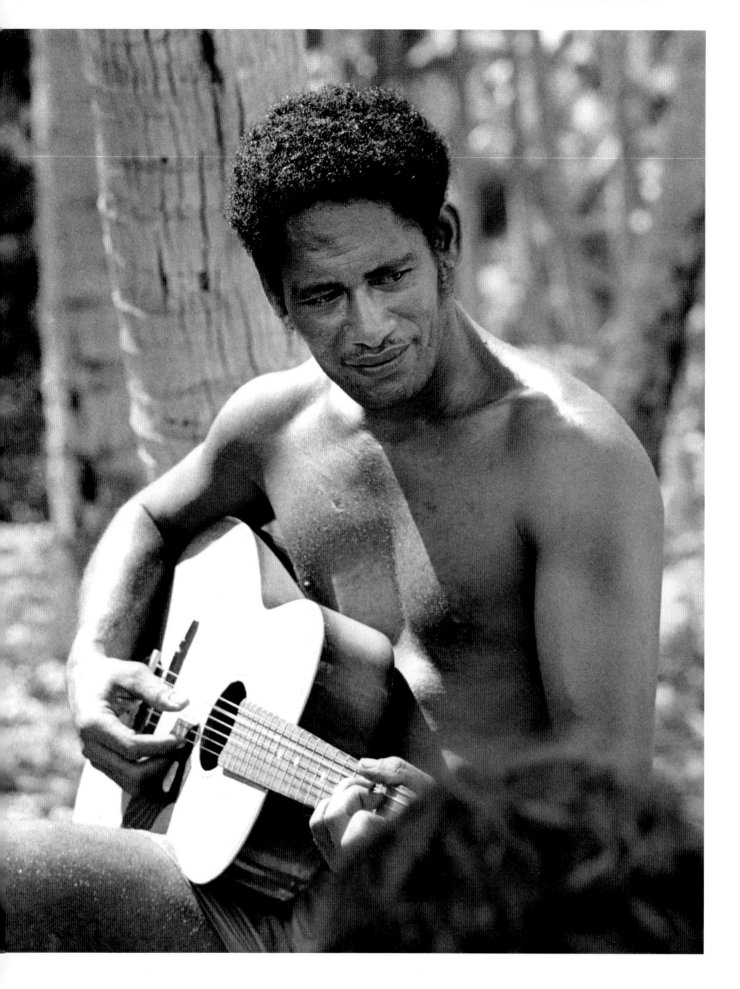

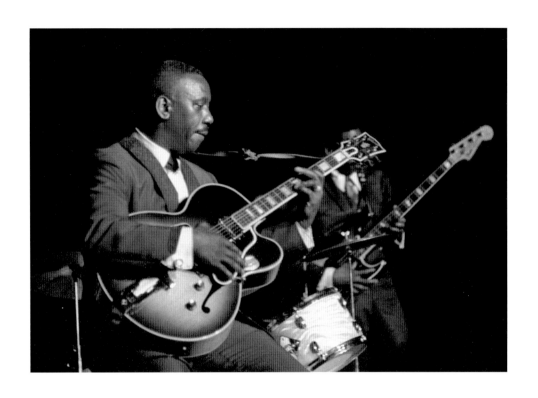

WES + MONK montgomery

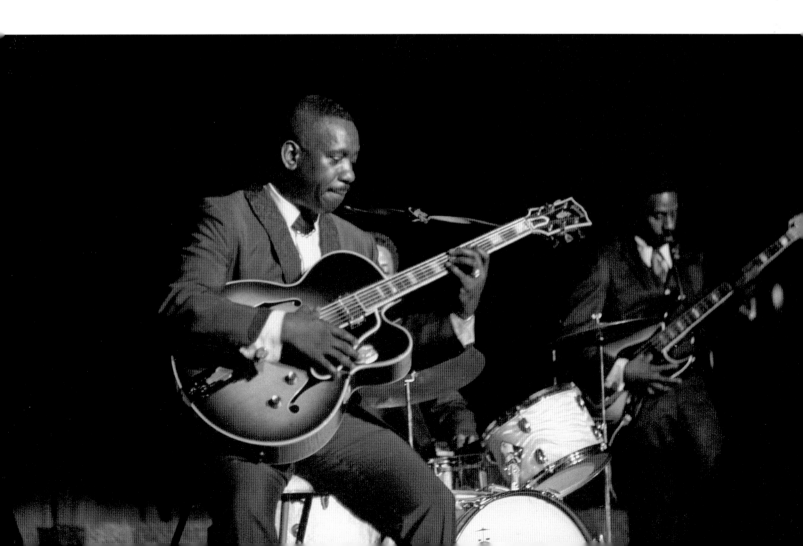

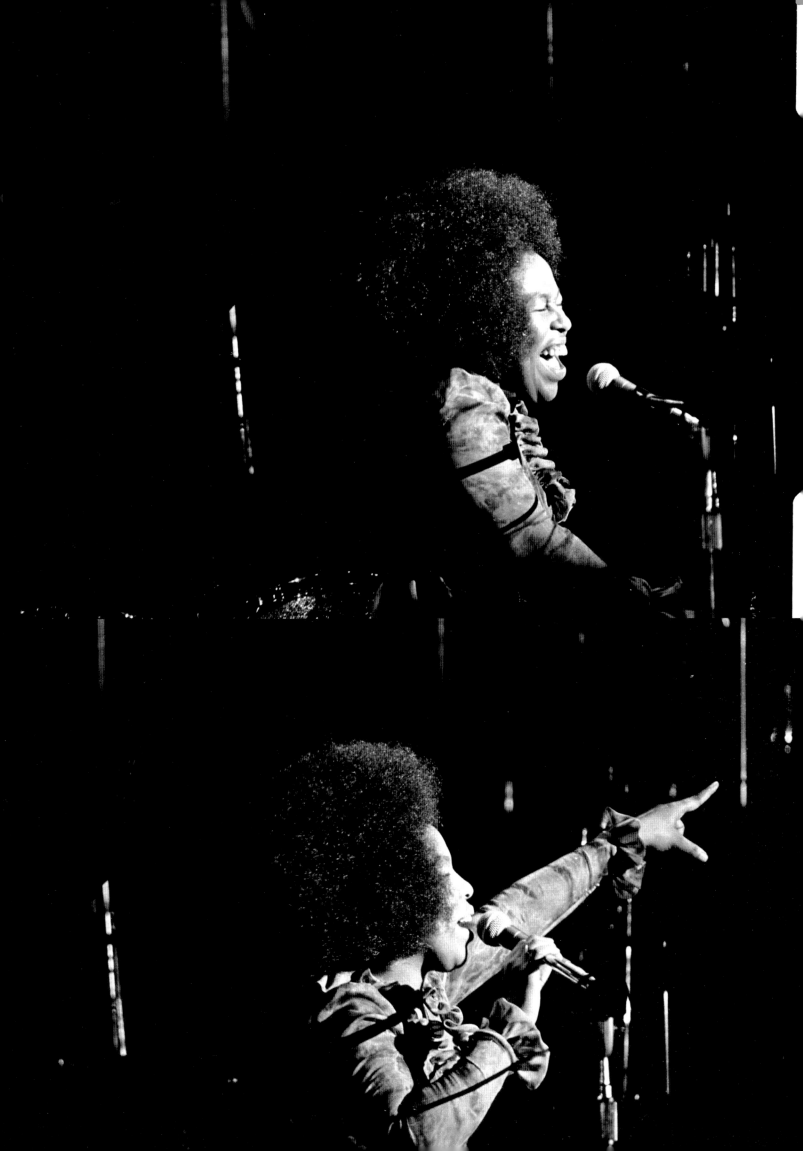

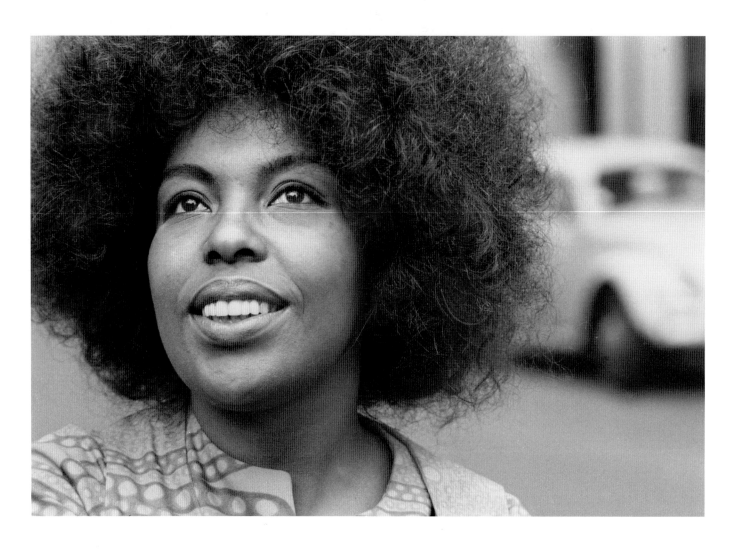

ROBERTA f l a c k

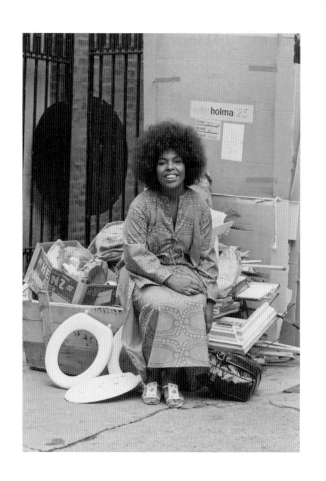

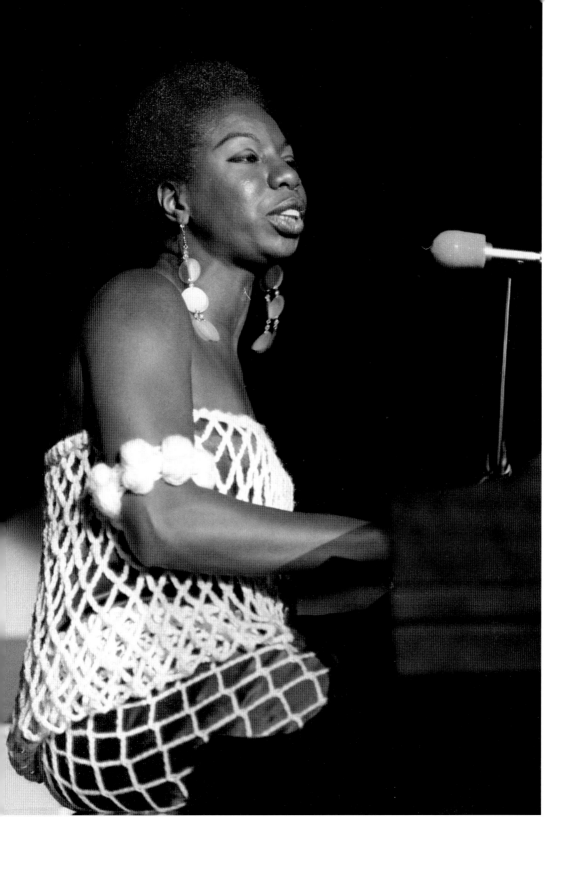

NINA simone

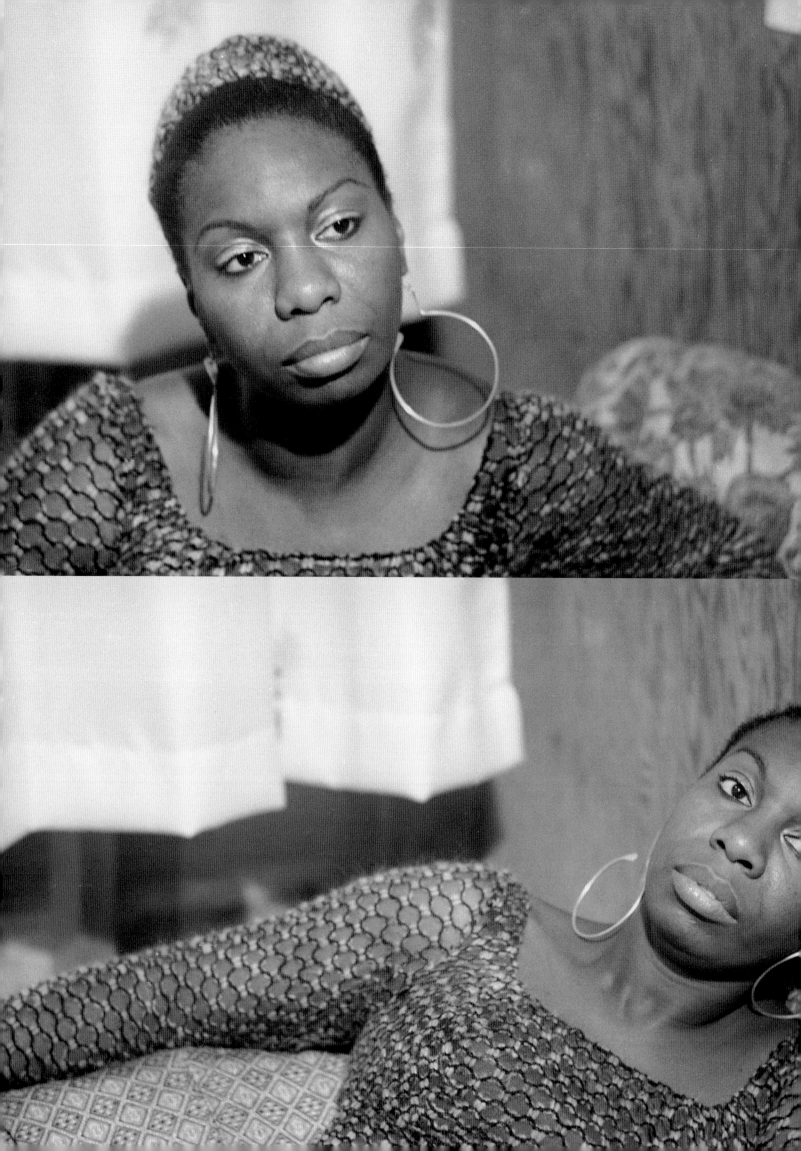

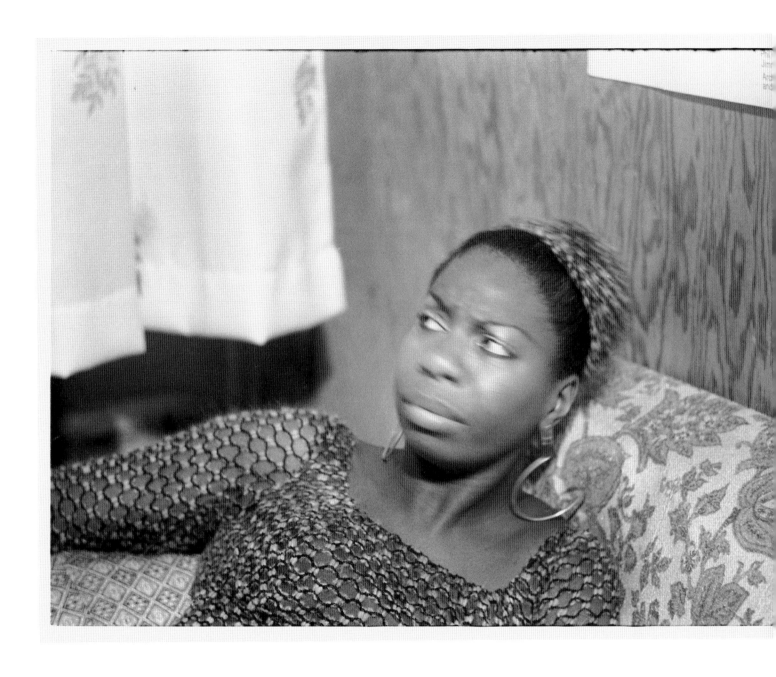

NINA s i m o n e

"Pitiful. Onstage, one of the greatest ever. Offstage, she didn't
know what the hell was going on, which probably is why she was
so unique. Her personal relationships were sometimes volatile. So,
I made friends with her kids 'cause I could tell they were looking for
a real daddy, you know? 'We like you, Mr. McCann, would you
consider being my stepfather?' I said, 'Hell no! Are you crazy?'"

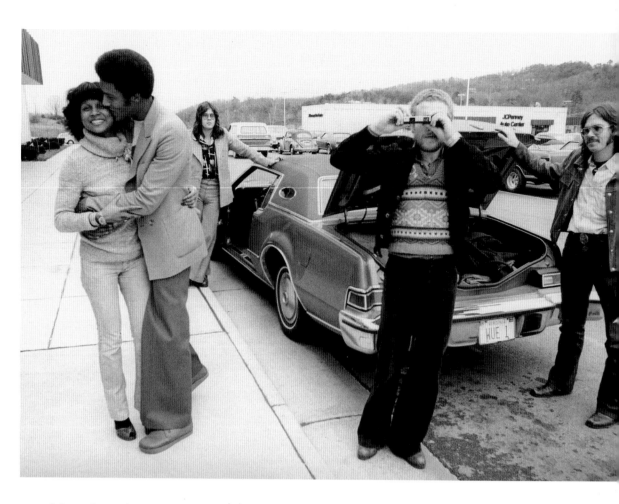

average white band

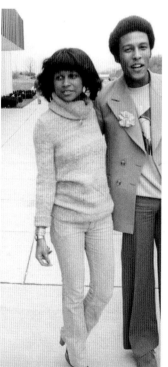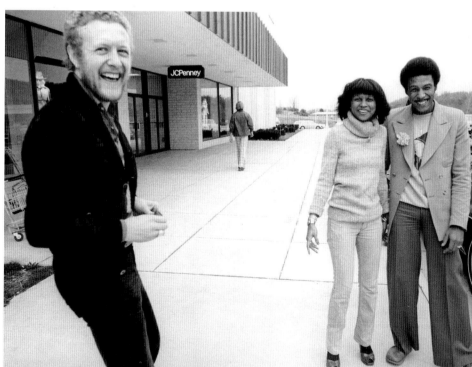

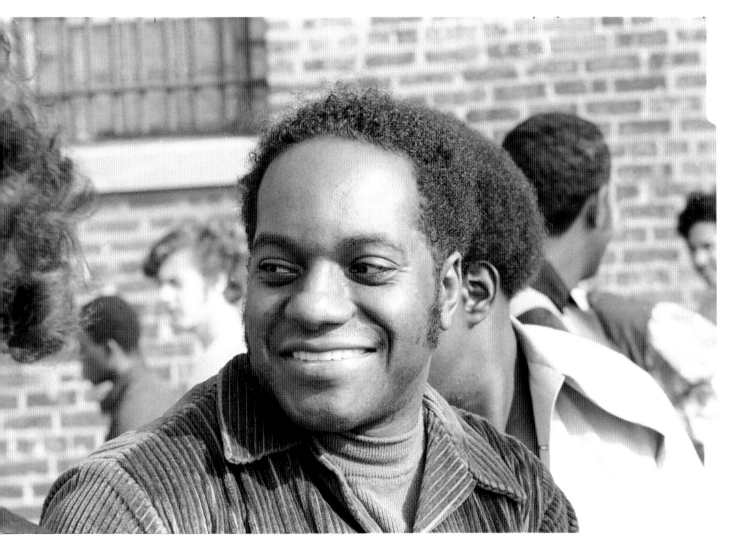

EDDIE harris

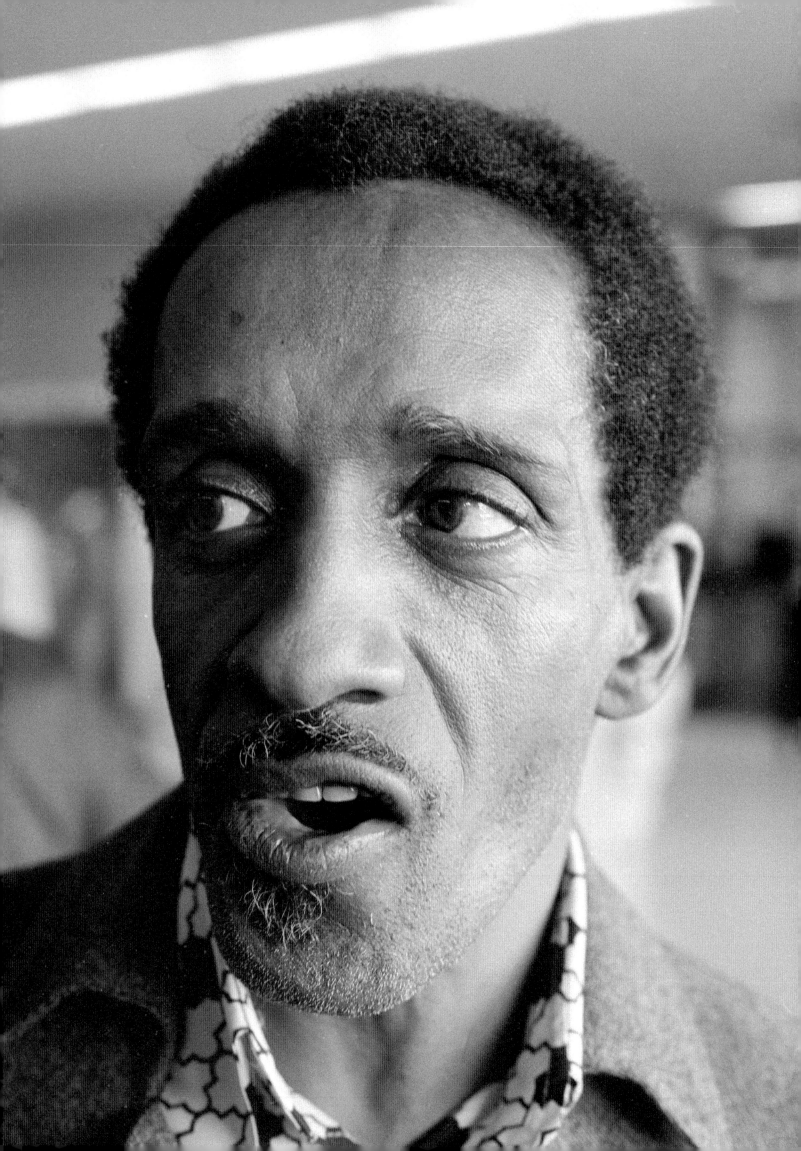

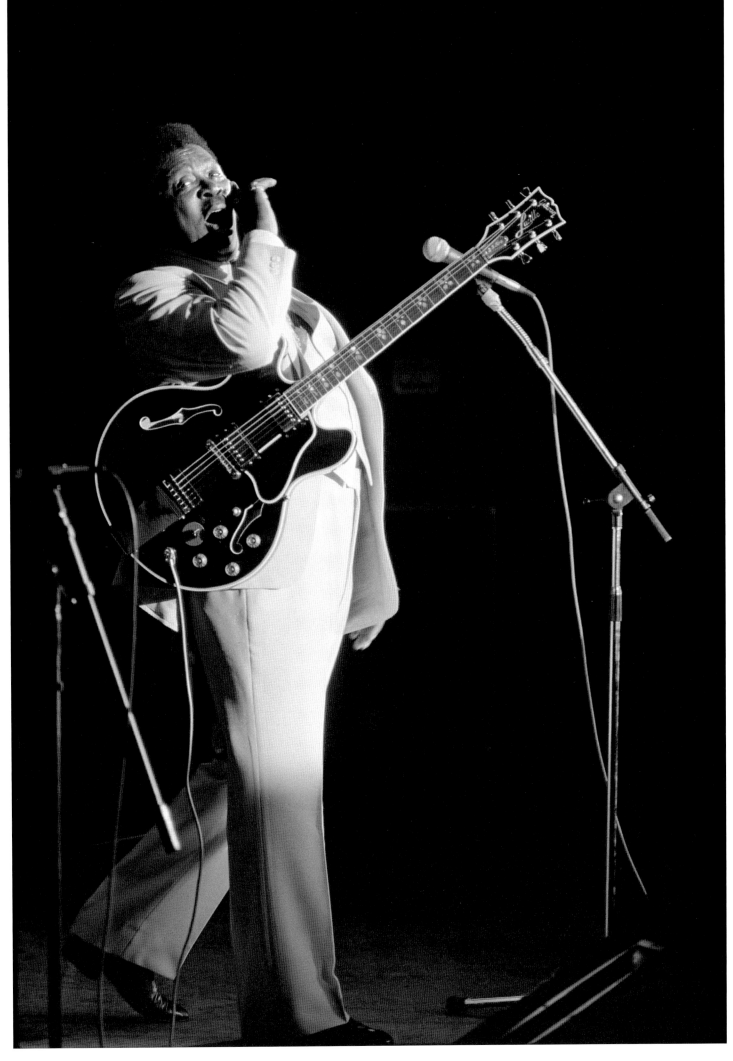

B.B. king

SONNY rollins

"When you think of Dizzy Gillespie,
you think of joy, laughter, total insaneness.
He was always a beautiful guy to me."

DIZZY gillespie

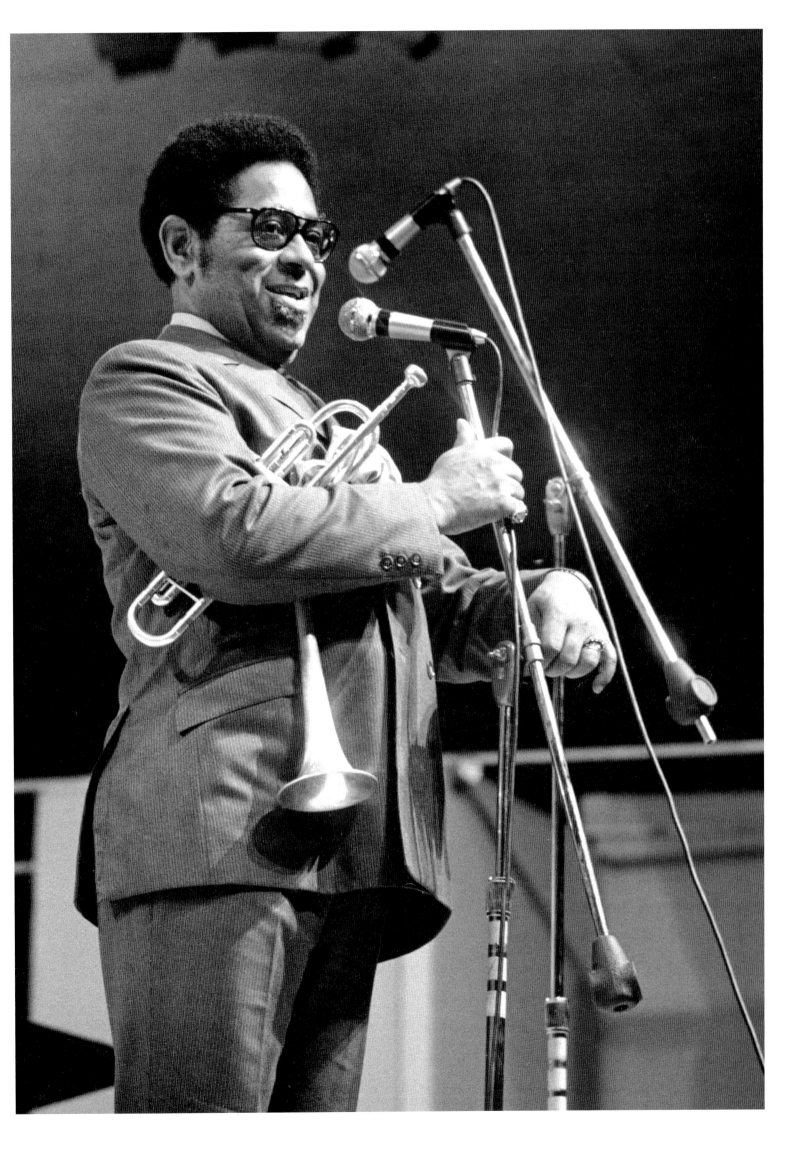

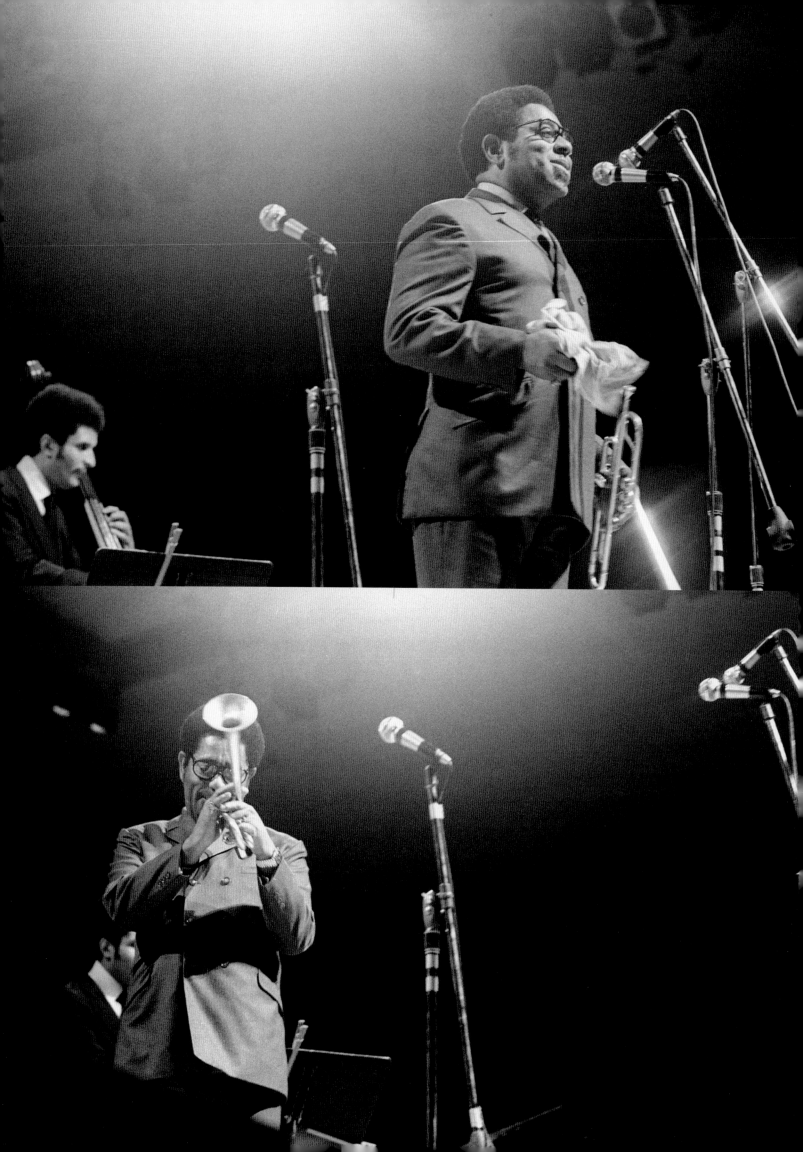

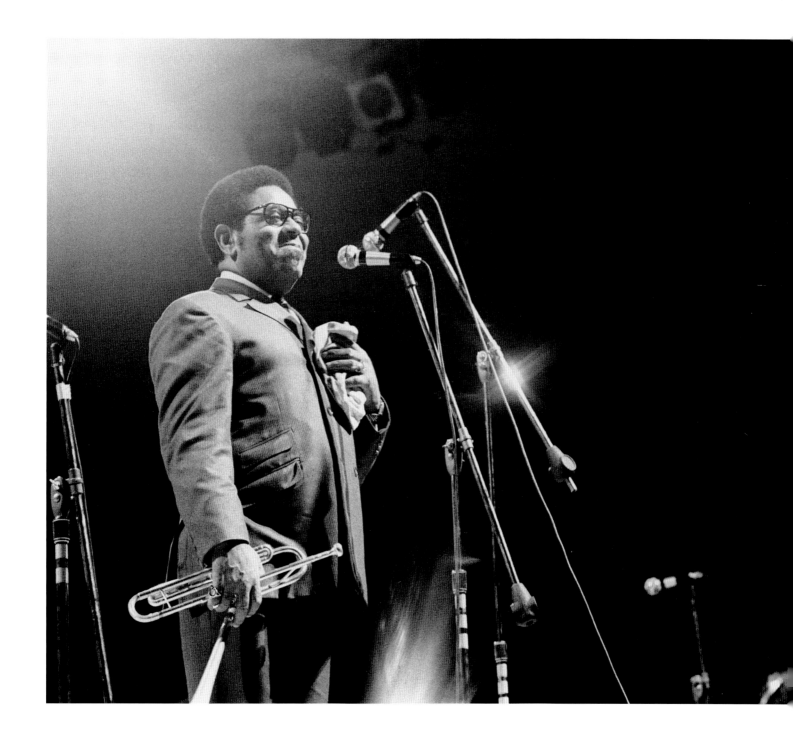

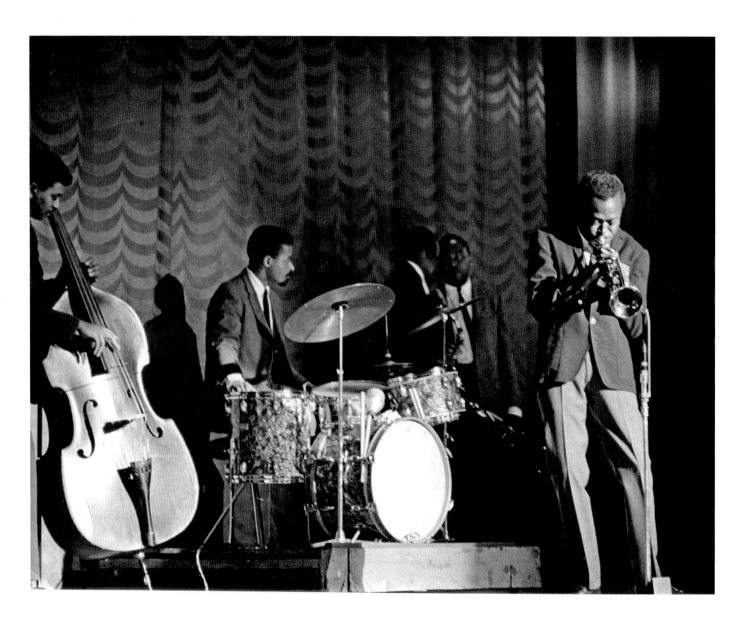

PAUL chambers + JIMMY cobb + MILES davis

JIMMY cobb

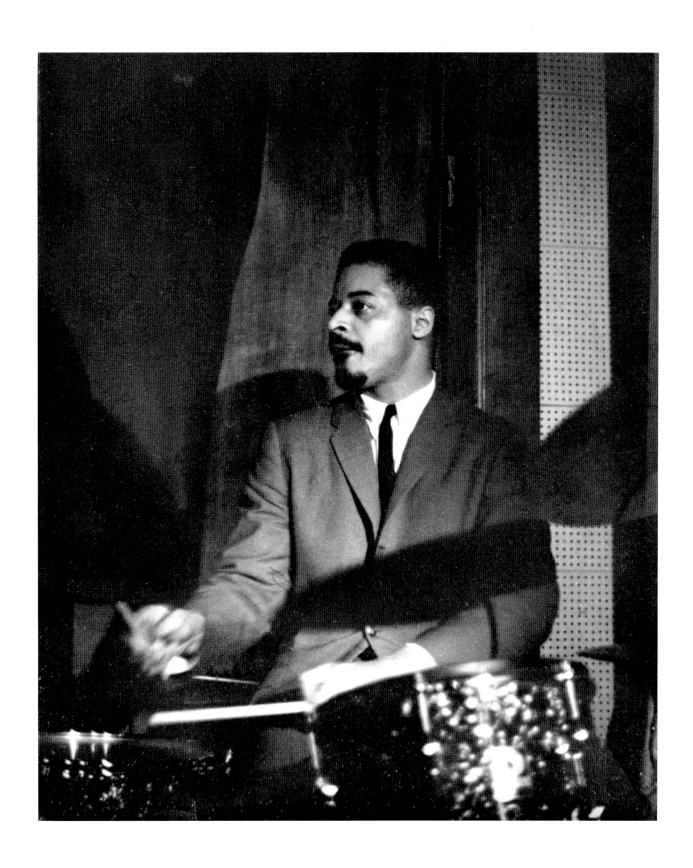

RICHIE kamuca

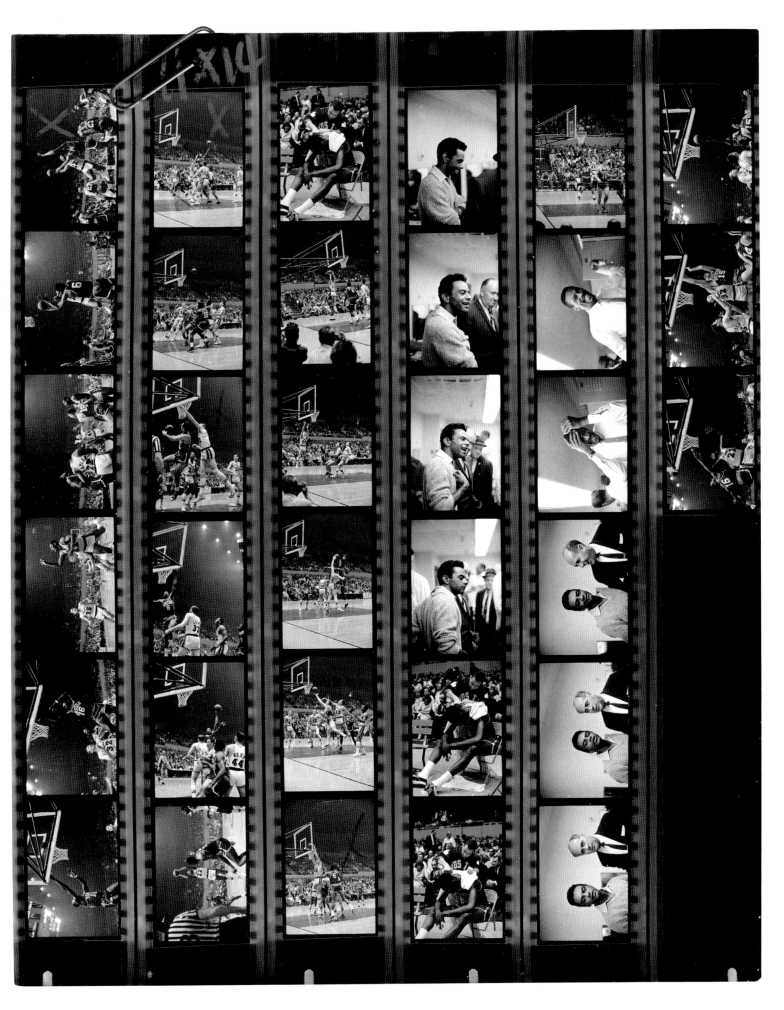

JOHNNY mathis + the BOSTON celtics (RED auerbach + BILL russell)

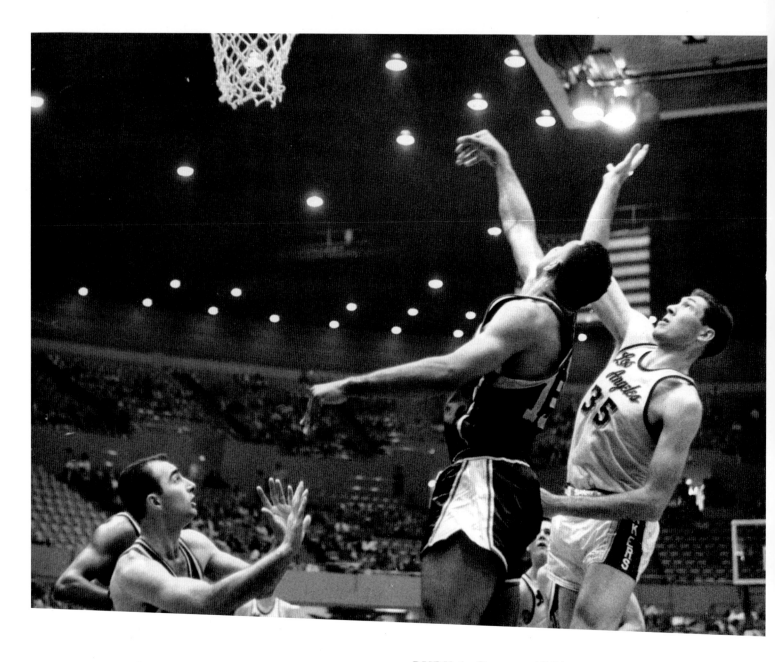

RUDY laRusso (35)

"I think of Elgin as my moving to different a level of understanding about sports. Of course, because I come from Kentucky I've seen all the great ballplayers, but when I saw Elgin play in Seattle, I'd never seen anybody do the things that he did on the basketball court. For some reason, that was a major epiphany for me because it made me go in a direction — and especially in sports — where I realized the levels never end: you keep going up as long as you're working at it. I got to know him a little bit. He's a beautiful man. I loved his playing."

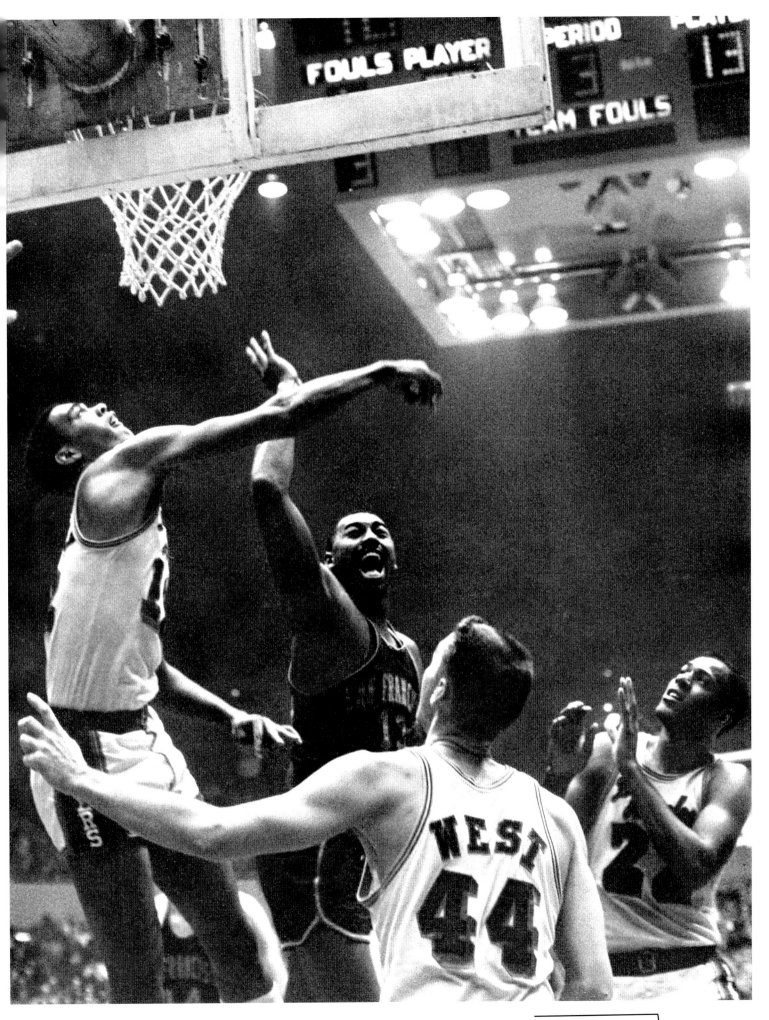

GENE wiley + WILT chamberlain + JERRY west + ELGIN baylor

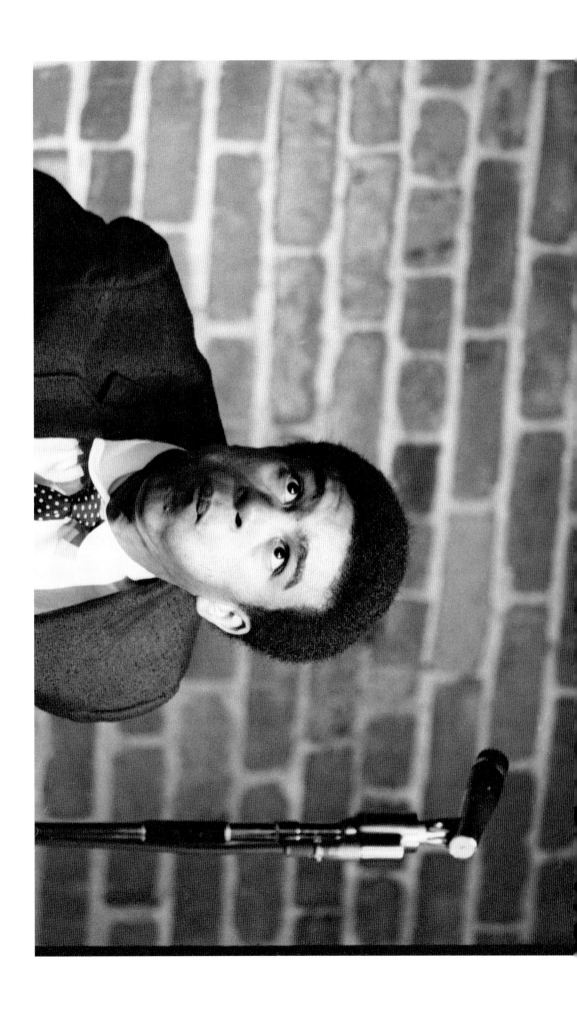

RICHARD pryor

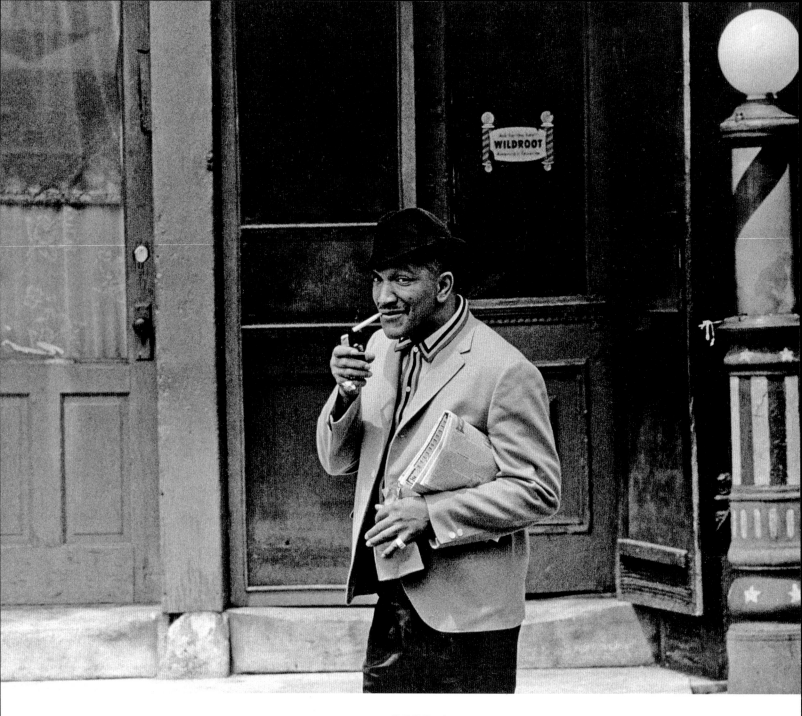

REDD foxx

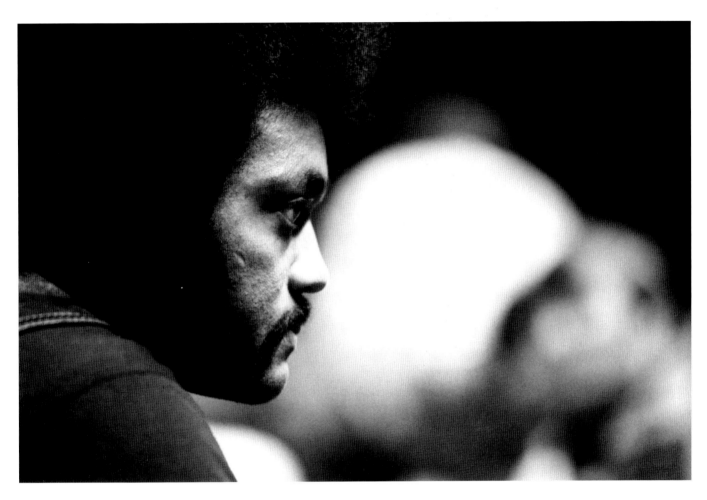

JESSE jackson

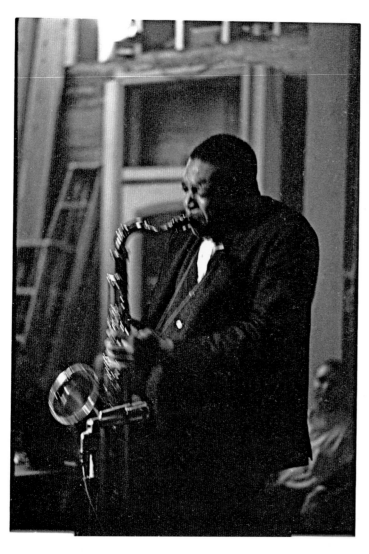

JOHN coltrane

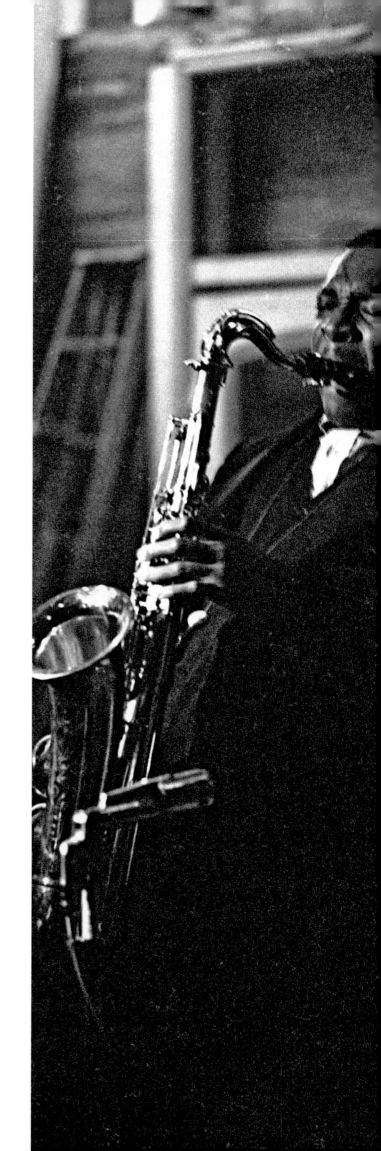

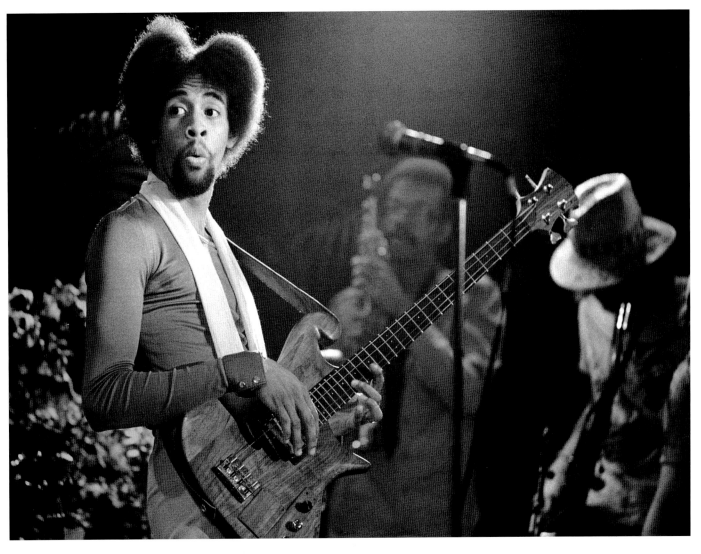

STANLEY clarke

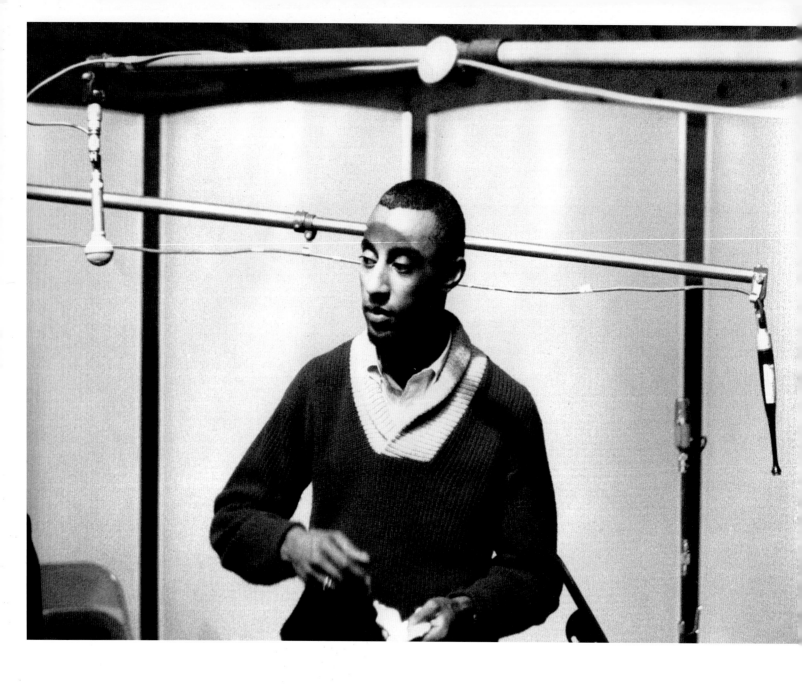

RON jefferson

"can't remember"

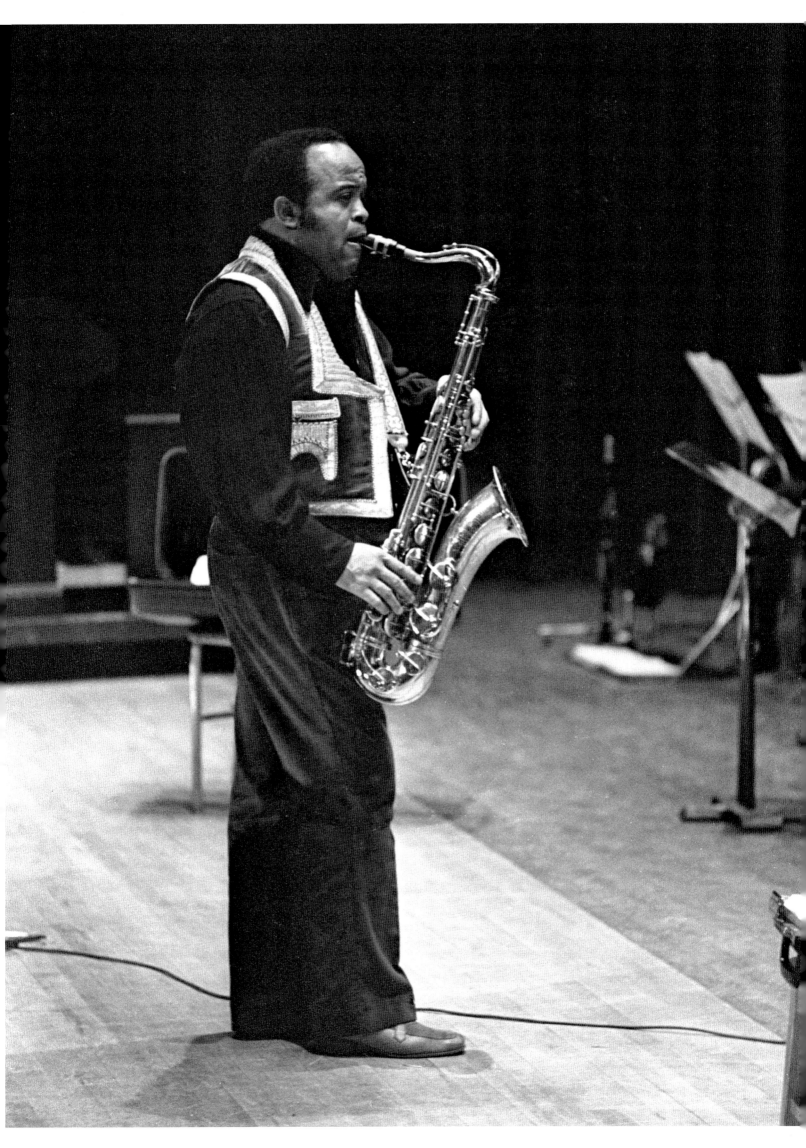

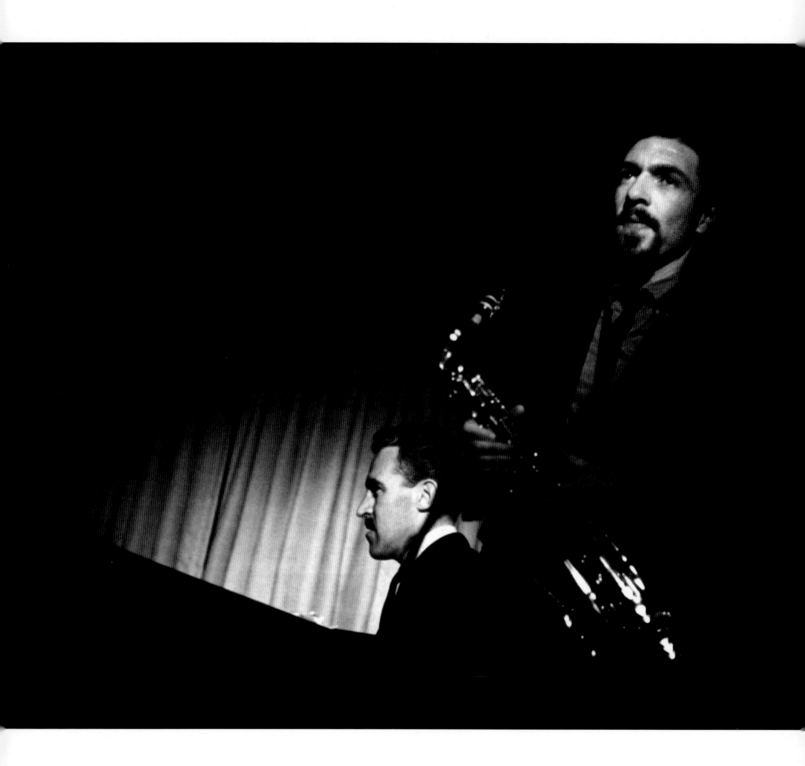

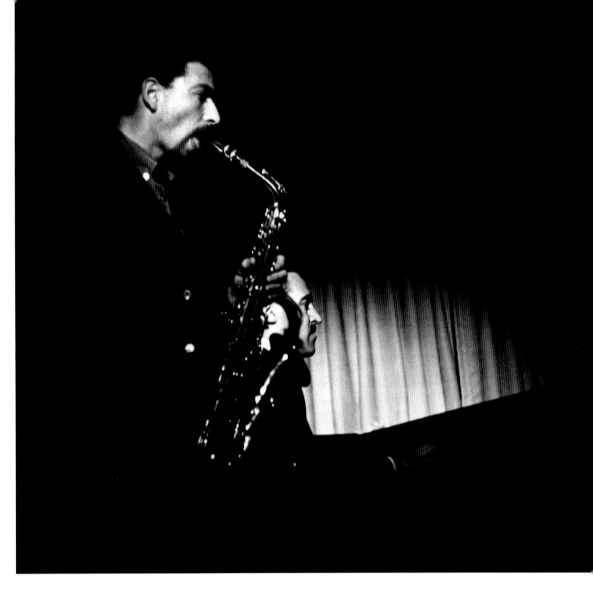

PAUL h o r n + PAUL s m i t h

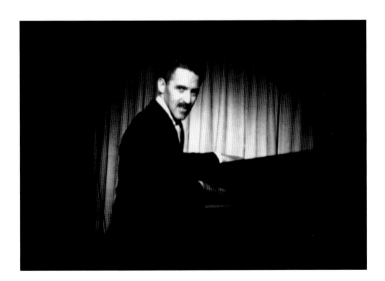

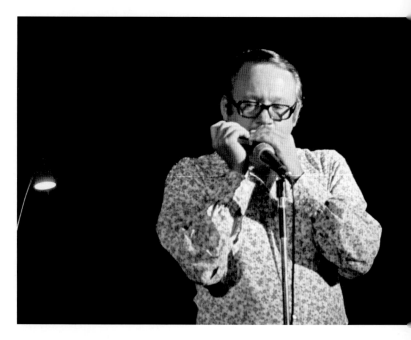

TOOTS thielemans

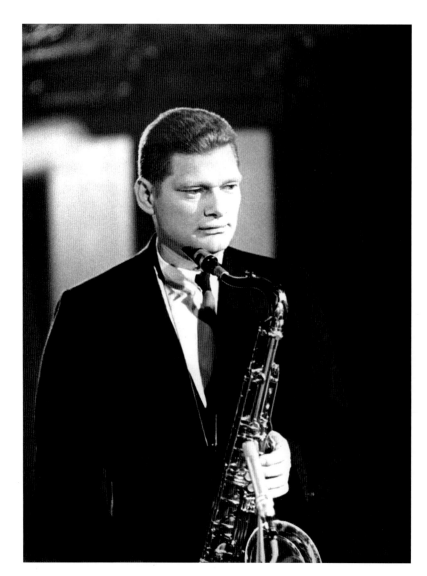

ZOOT sims

SHELLY manne + CONTE candoli + RICHIE kamuca

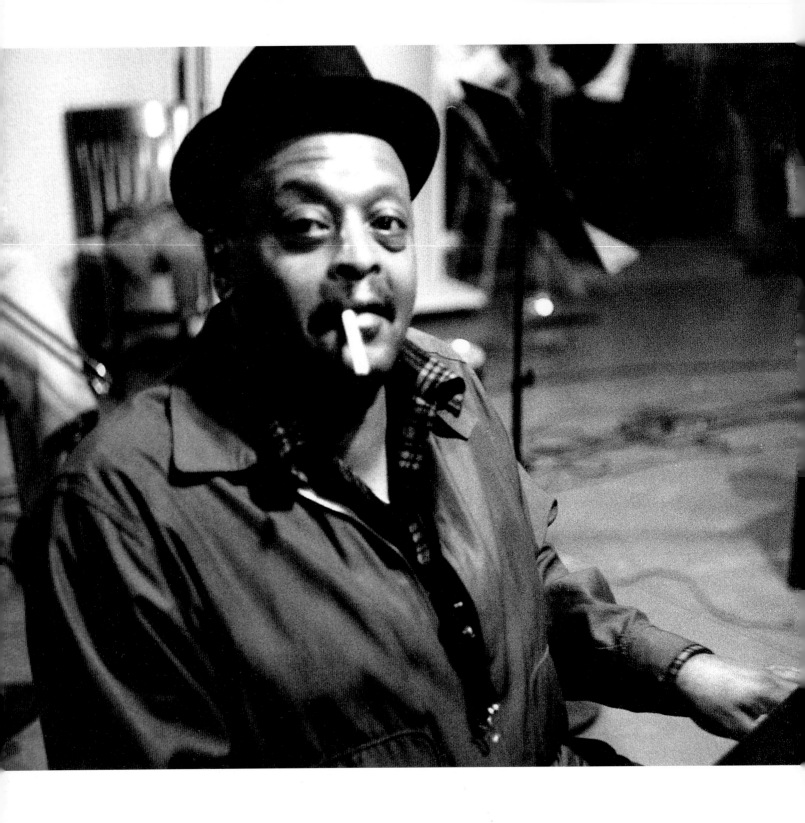

"When I think of Ben Webster I think of the people, especially in jazz, who ... One of the old expressions used to be 'I can feel him talking to me. I can feel what he's saying to me. It's not just the sound of the horn, he's actually communicating with me.' Even my wife said the same thing. So, that's the way I think of him. I didn't really know him that well — I just recorded with him. I was asked to. 'You wanna make a record?'"

"Hell yeah, I'll make a record with Ben Webster! Are you kidding?"

BEN webster +
RICHARD "GROOVE" holmes

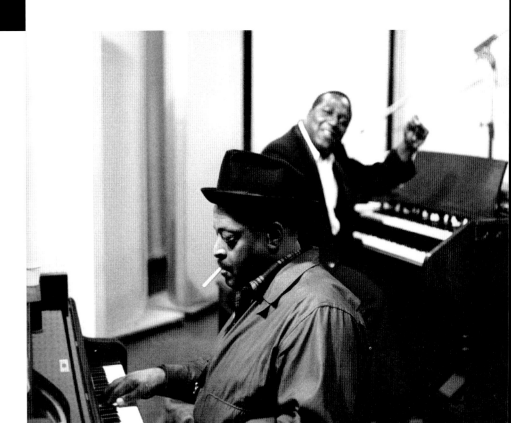

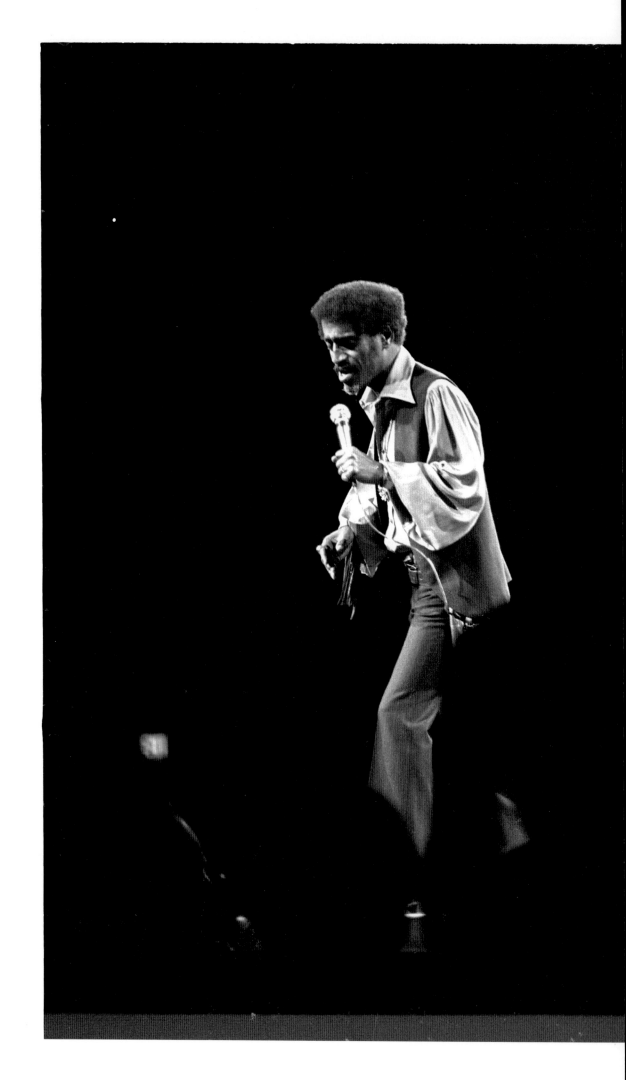

SAMMY davis, jr.

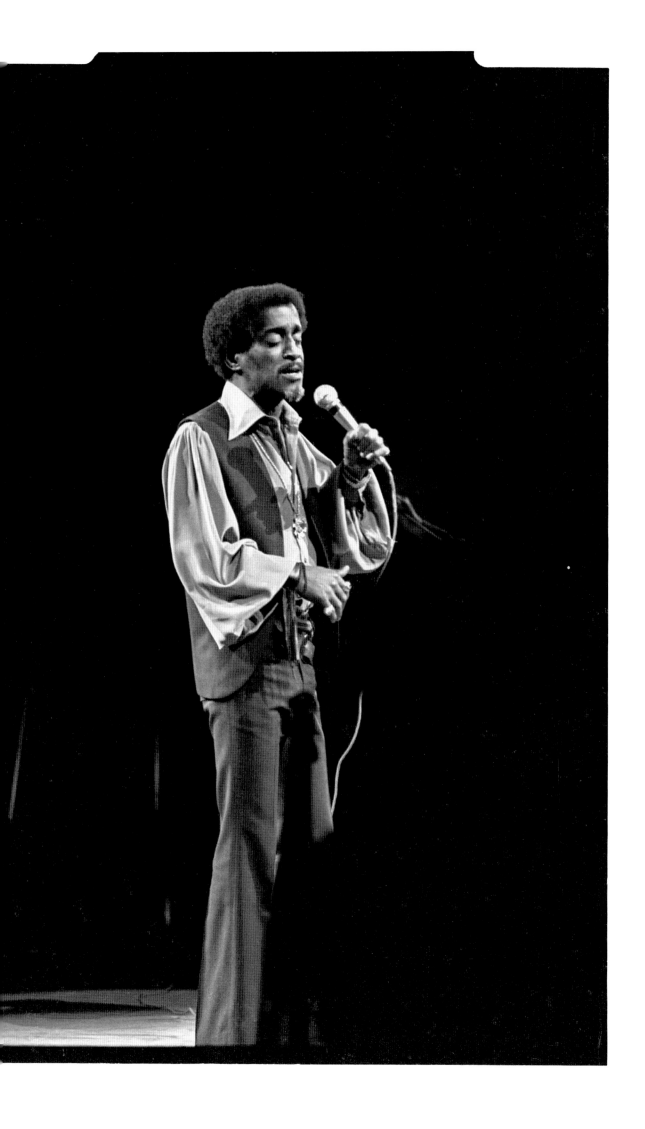

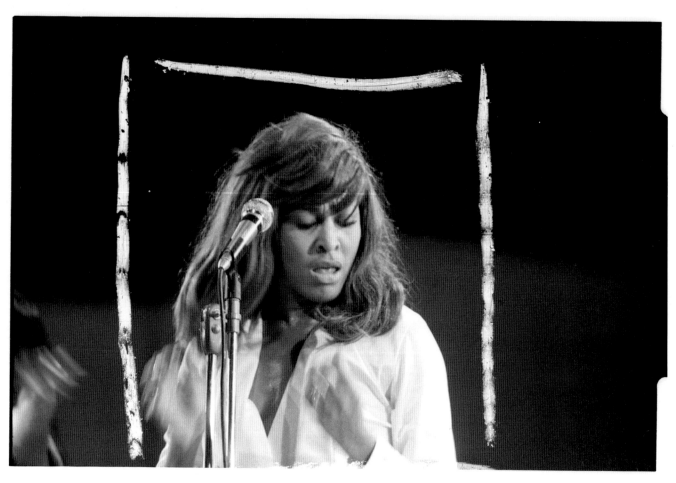

TINA turner

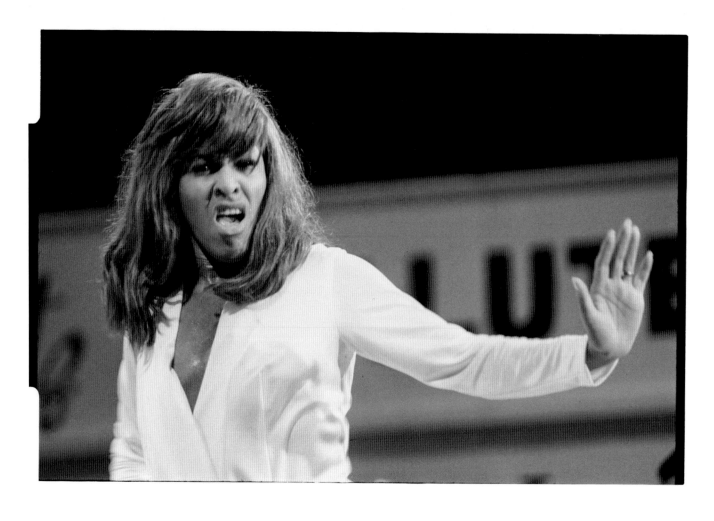

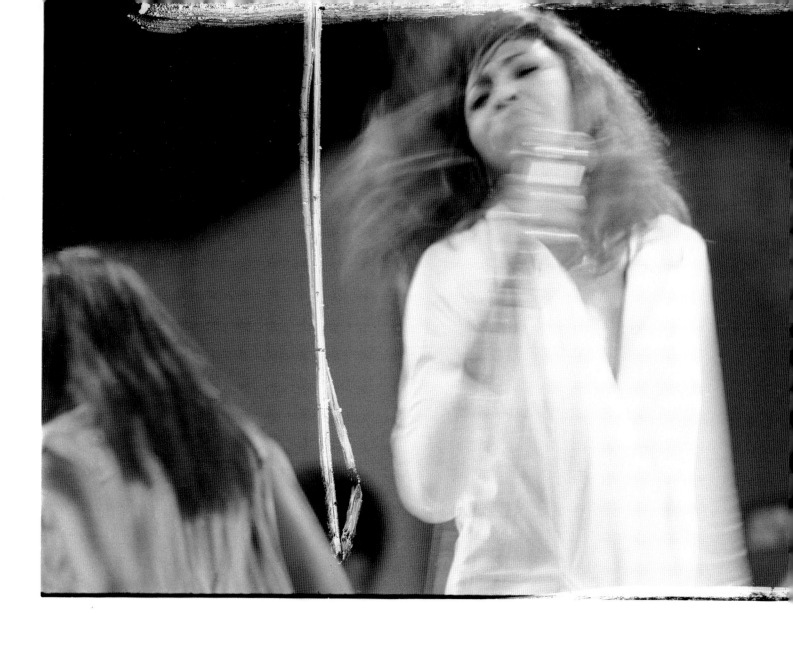
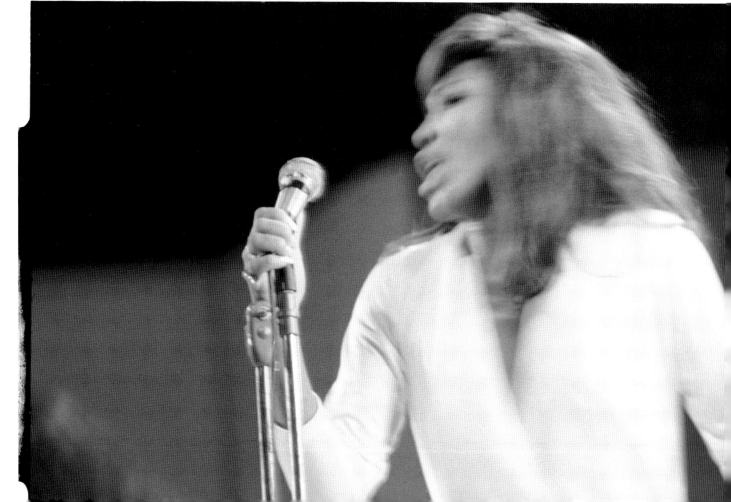

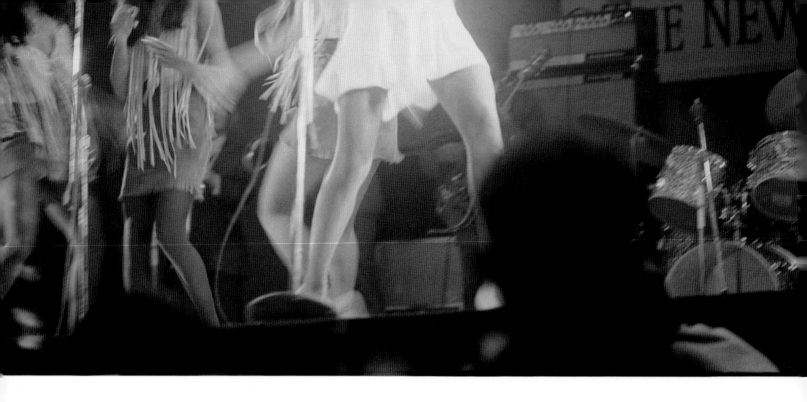

"I love lookin' up her dress. When I was a youngster and she'd be working on the soul side of town in L.A., my friend and me would run up on the stage, all star-crazed. We'd stand on the bottom of the stage. We was like … crazy, 'Oh Tina! We love you! We love you!' 'Oh, Les, get the hell away from me!'"

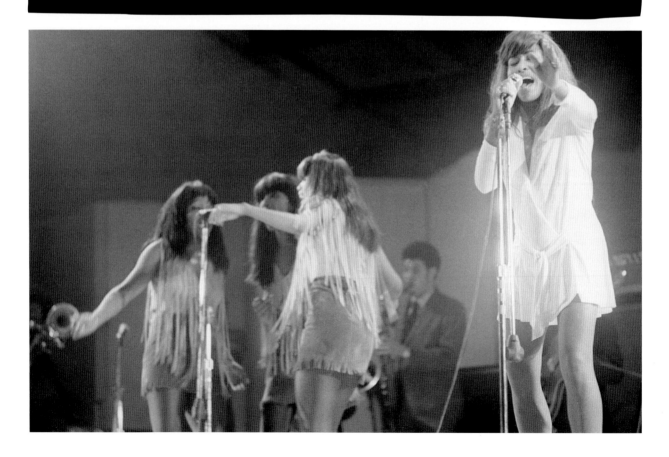

TINA turner

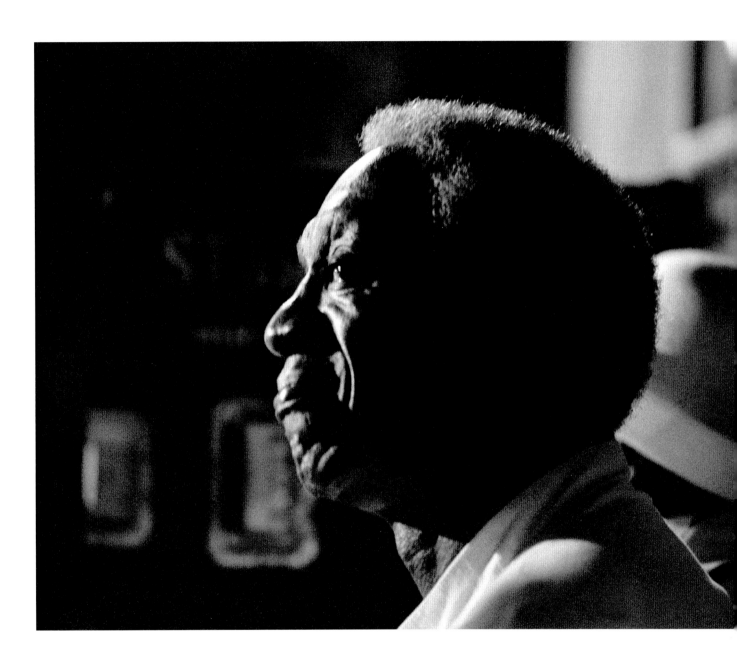

ART blakey

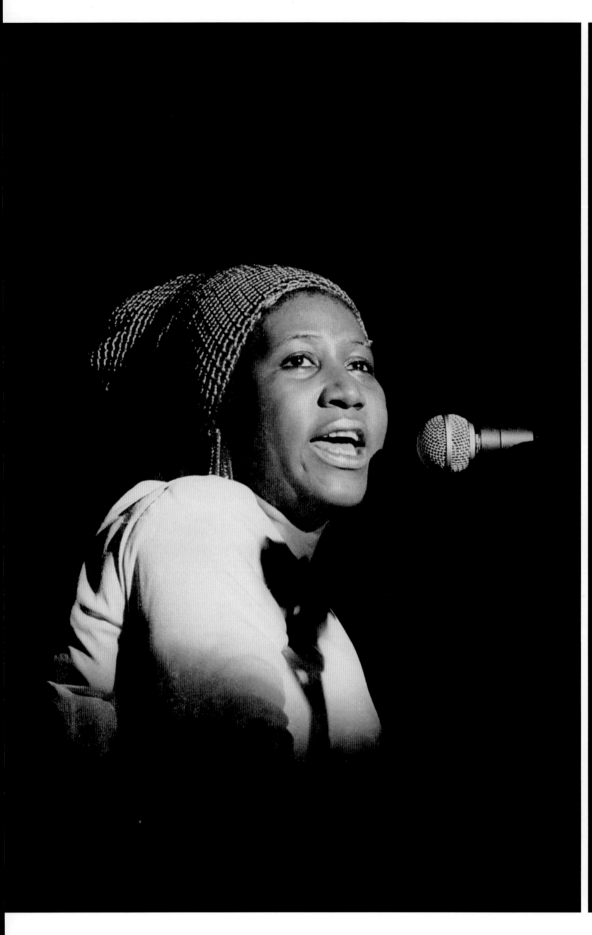

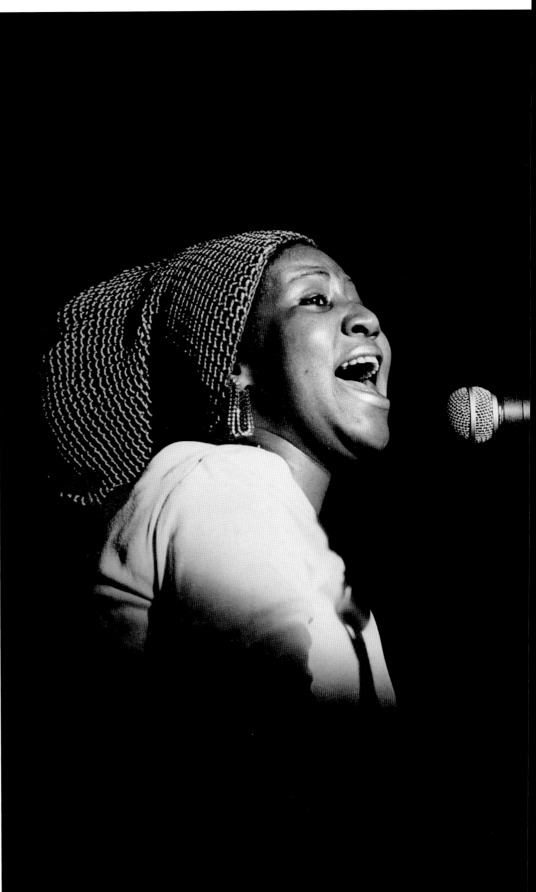

ARETHA franklin

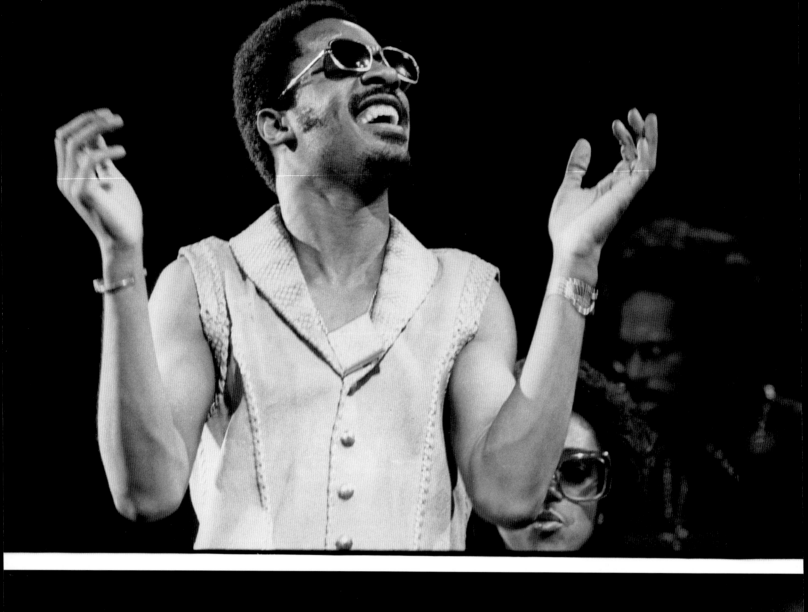
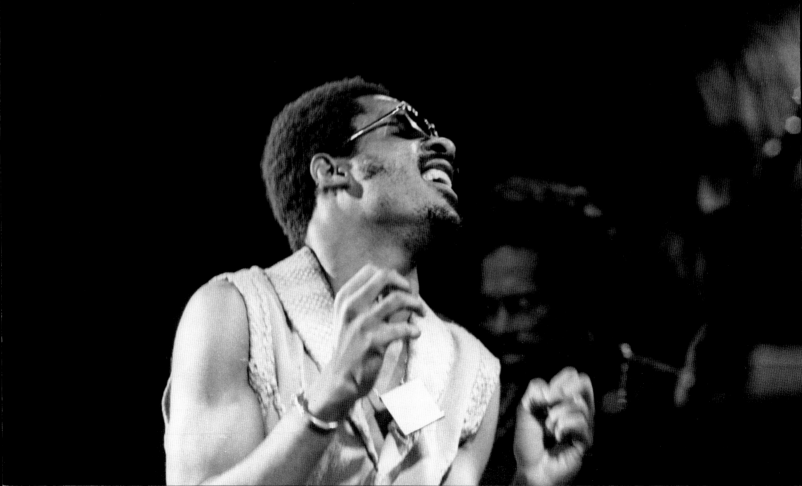

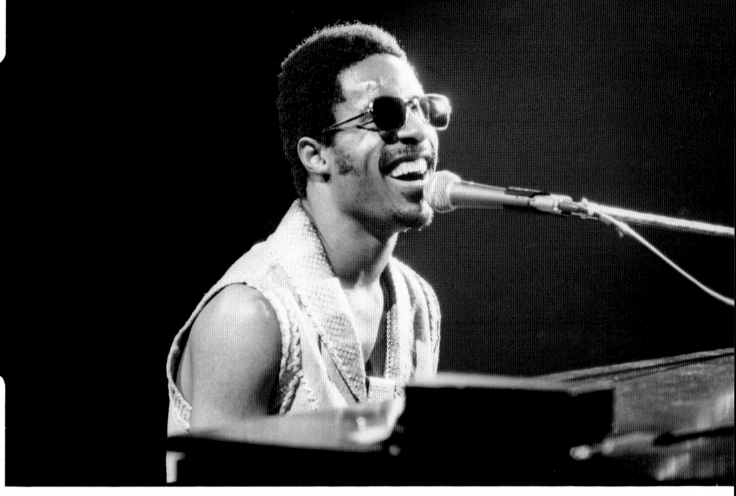

STEVIE wonder

"I did one of his songs once and he loved it. A couple years later I see
him and he said, 'How come you don't do my songs anymore?'
I said, 'I'm waitin' on you to do one of mine, motherfucker!'"

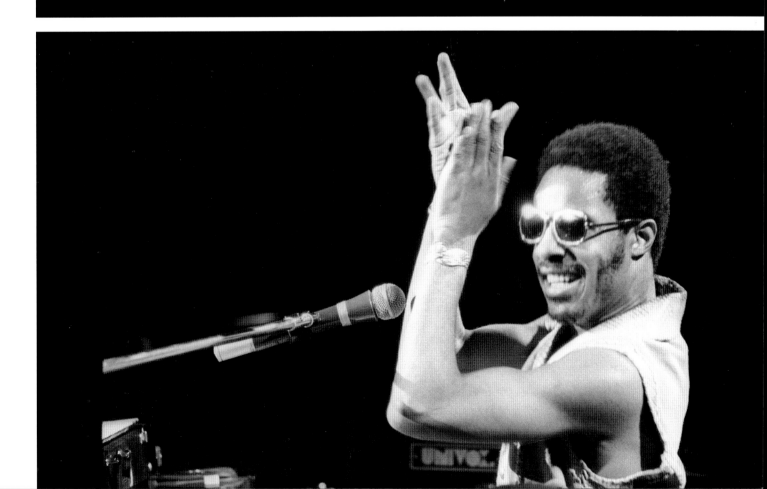

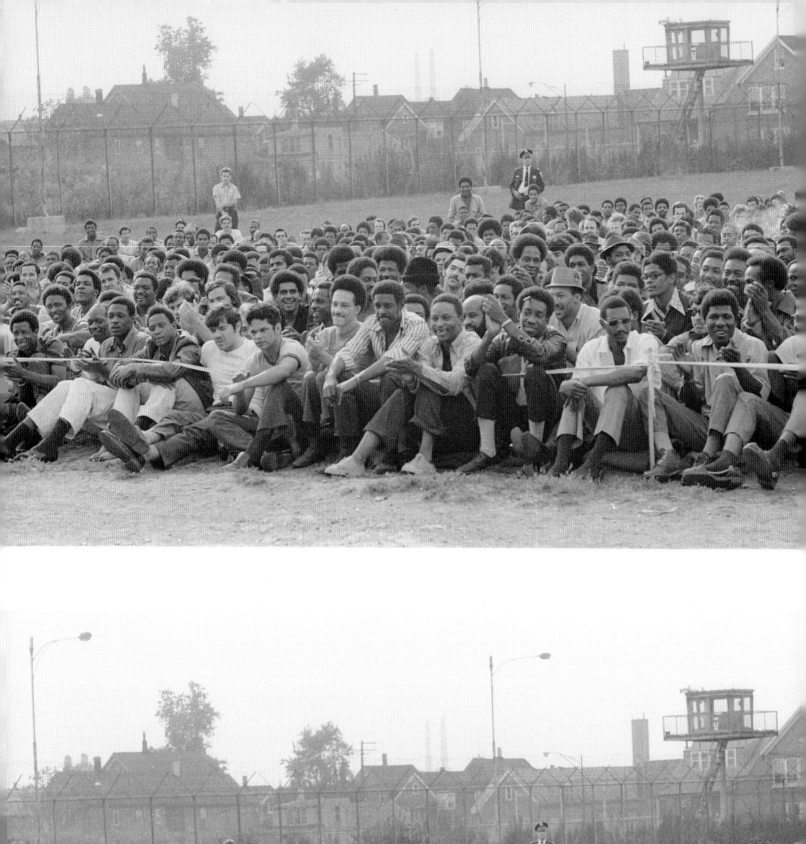
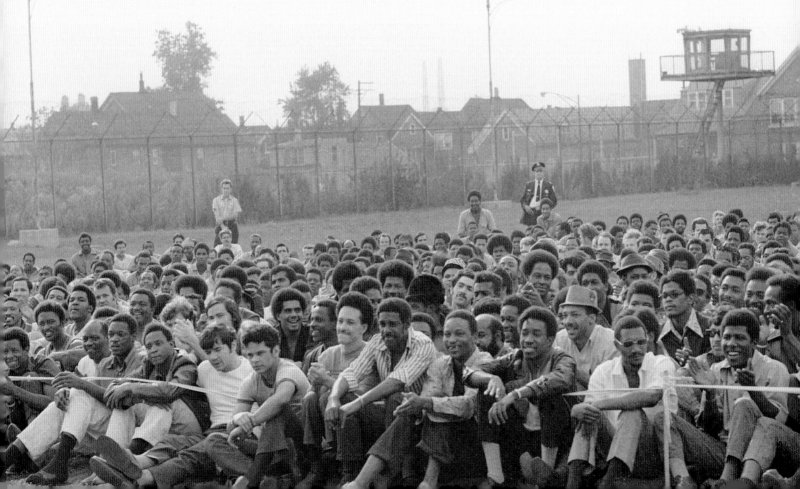

COOK COUNTY JAIL circa 1970

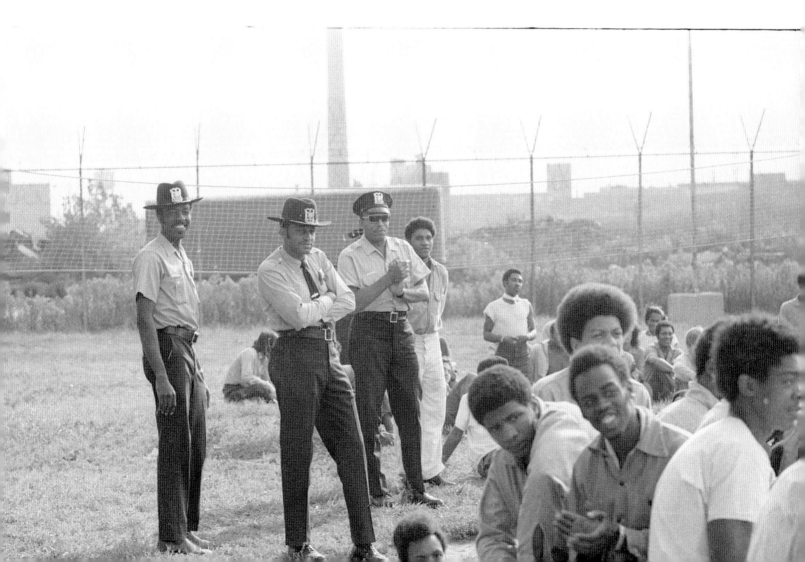

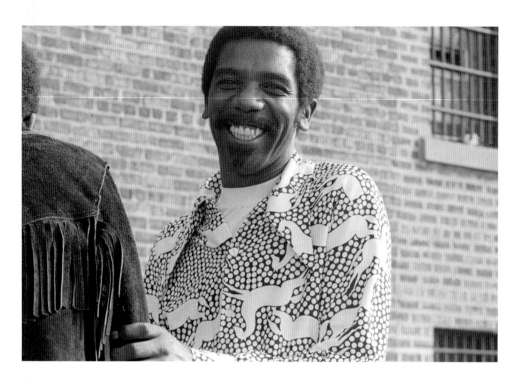

JIMMY smith

TURK murphy

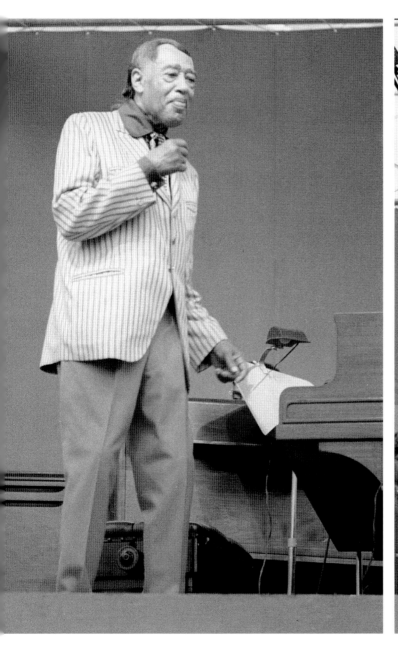
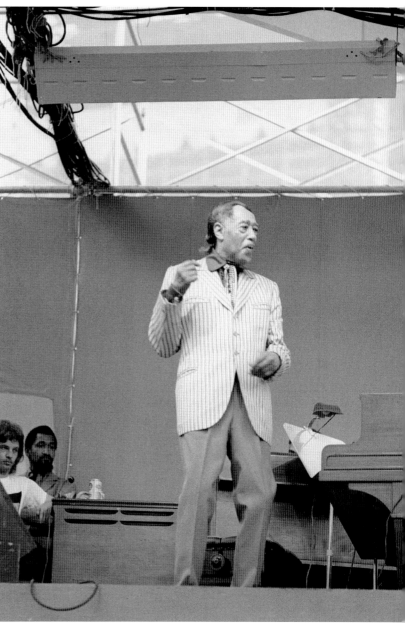

DUKE ellington

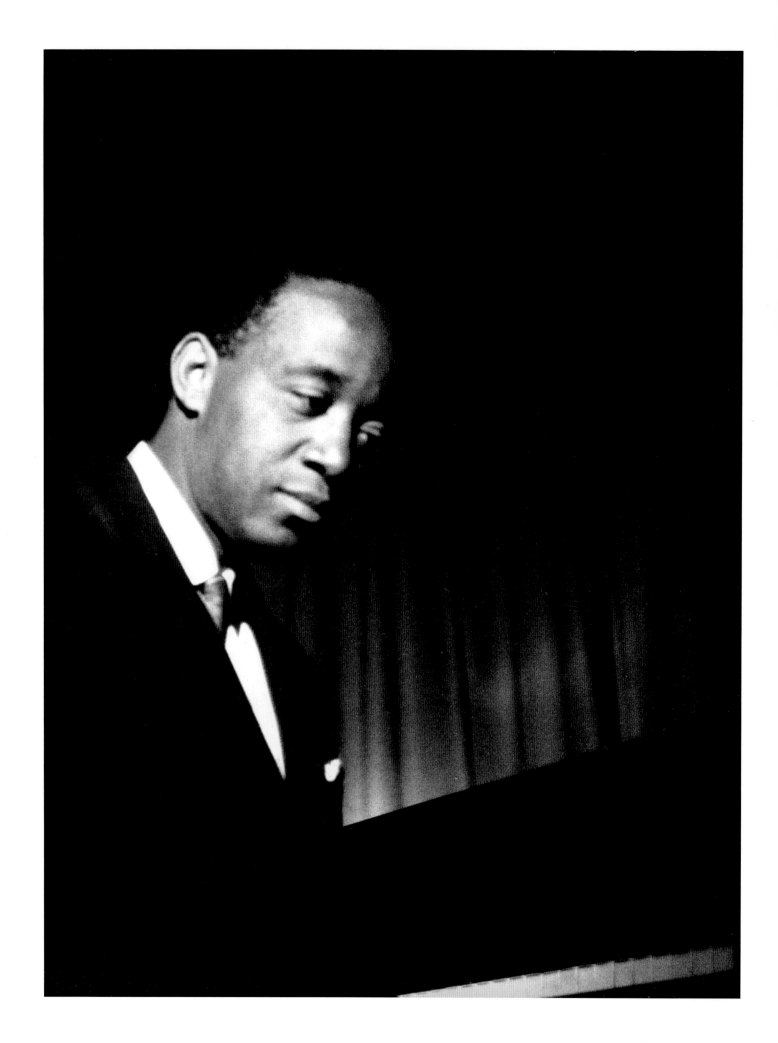

JOHNNY jackson

SMILEY davis +
ALAN osmond

EMIL richards

TONY scott

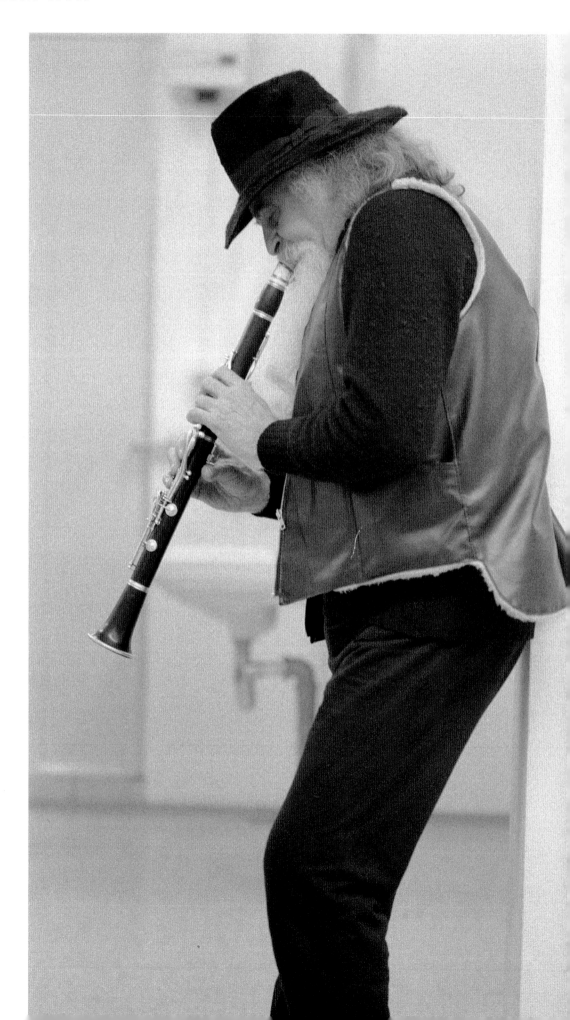

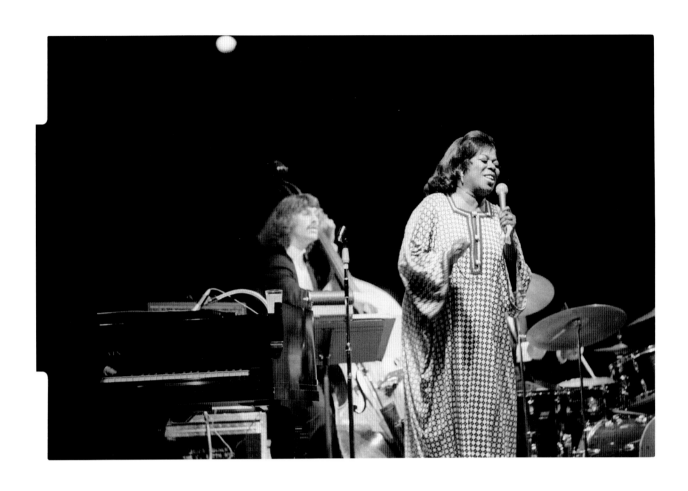

EBERHARD weber + SARAH vaughan

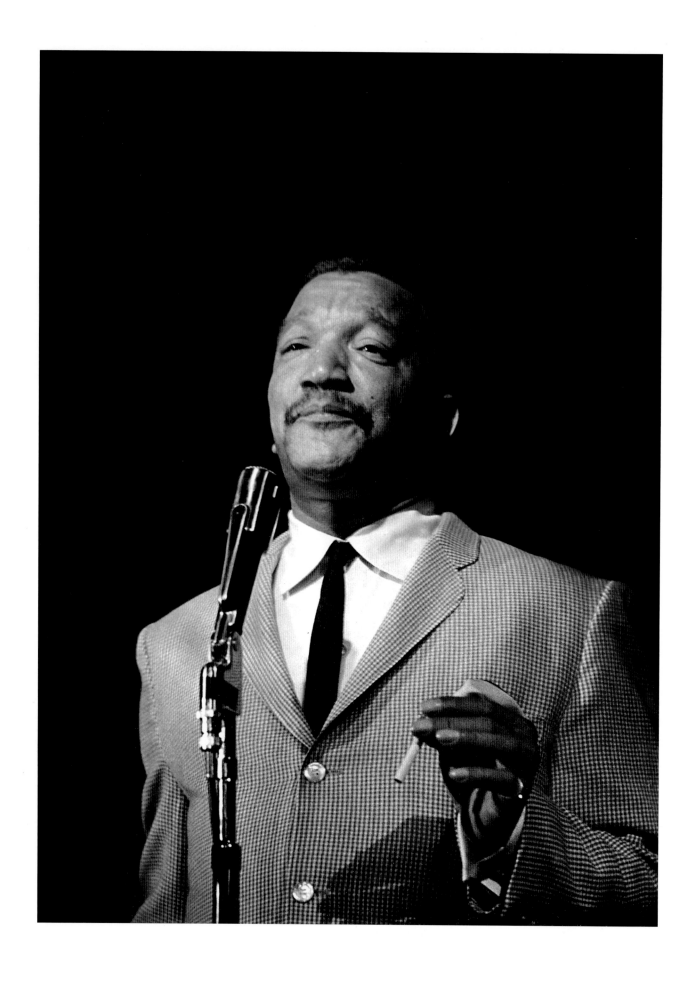

REDD foxx

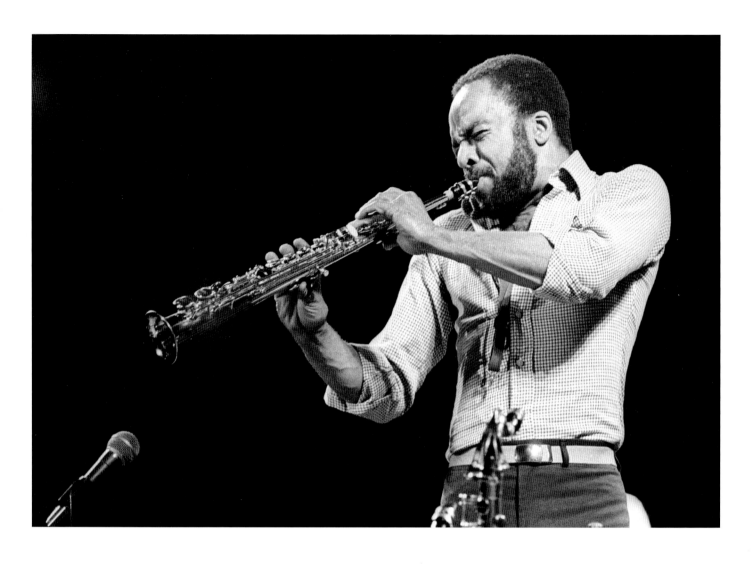

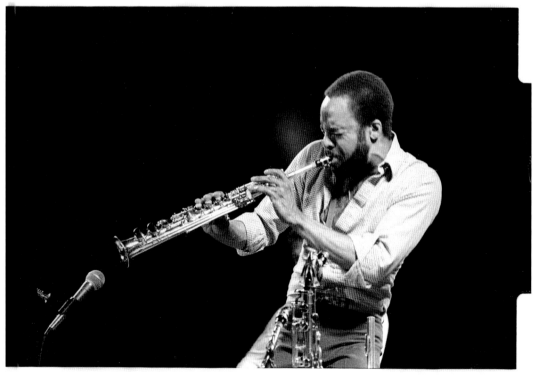

GROVER washington, jr.

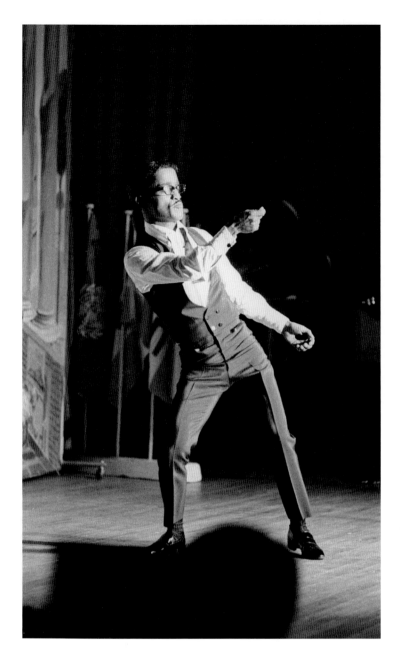

"When I went to New York to go see him in Golden Boy, which was a big show on Broadway – I mentioned to him that I went to school with his sister, so he and I became friends and he gave me the golden treatment. 'Come backstage,' that type of thing. And when I met him I was in my Navy uniform, so that was beautiful. Over the years we always kept in touch. He made a movie about a jazz musician, and he used the name 'Les' as his character."

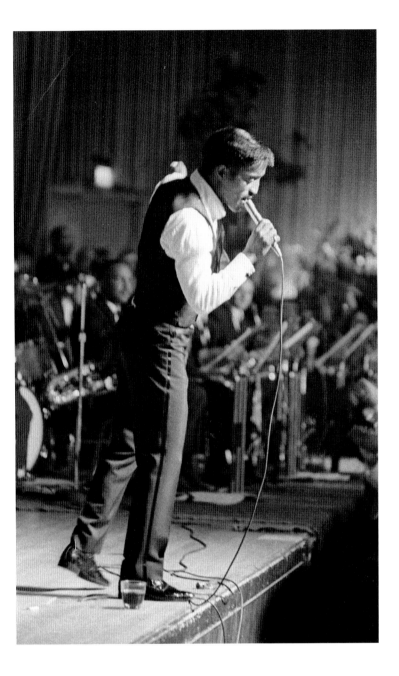

SAMMY davis, jr.

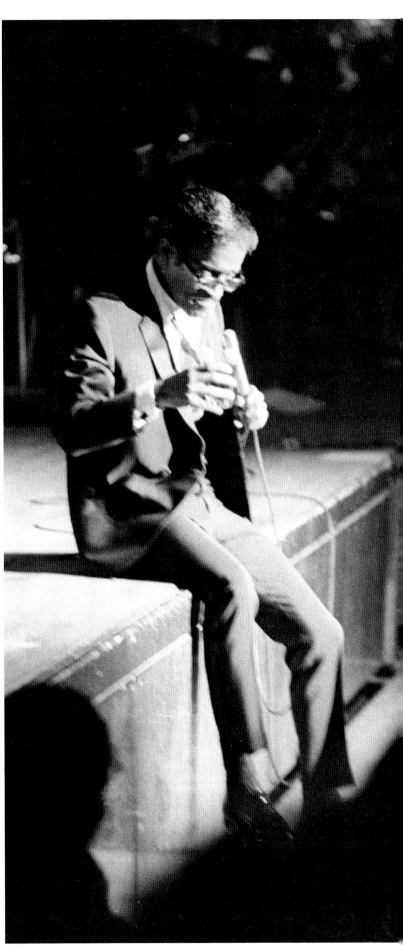

"When I think of Coleman Hawkins, I'm honored I had the opportunity to play with him. It only happened once – in Toronto – and he said to me, 'When you come to the gig tonight, if anybody asks you to play my hit' – I guess he had a 'hit' record at one time, I can't remember the name of the song – 'if anybody asks you to play this song, you tell them you don't know it,' and I realized it's like when people say, 'Are you going to play "Compared to What" tonight?' Unfortunately, I have to play it every night, but Hawkins was sick of his song. Some guy walked up to the stage and insisted. Now he's getting violent. My man Hawkins picked up a pitcher and hit him over the head with it. Knocked him out cold."

COLEMAN hawkins

BUSTER williams + RAY brown

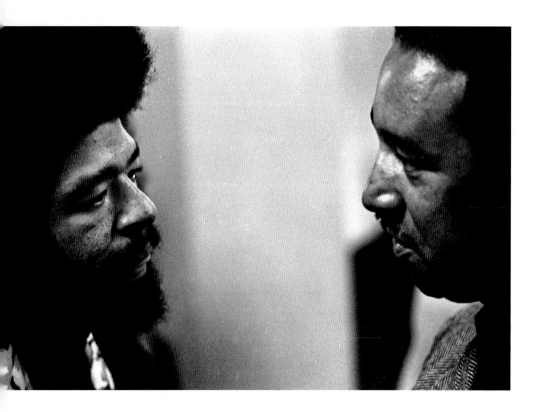

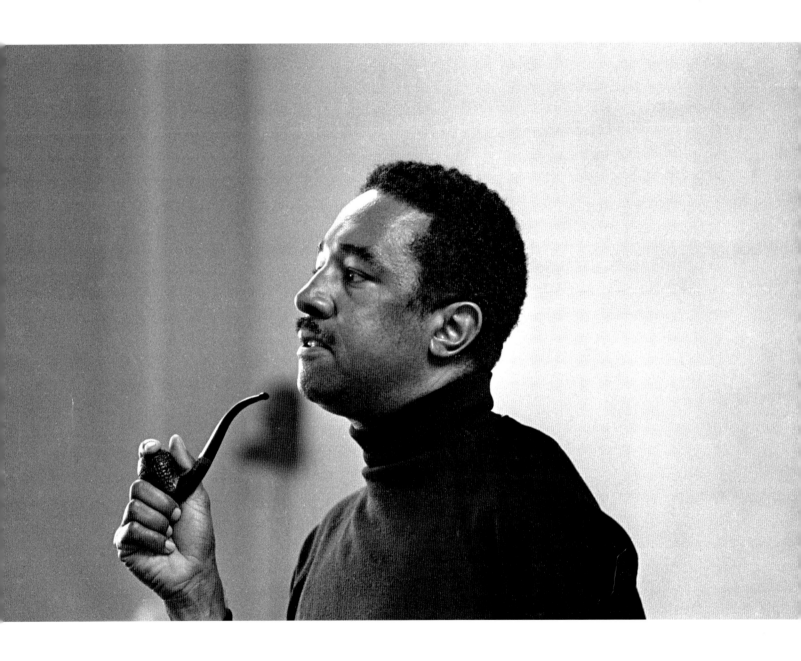

RAY b r o w n

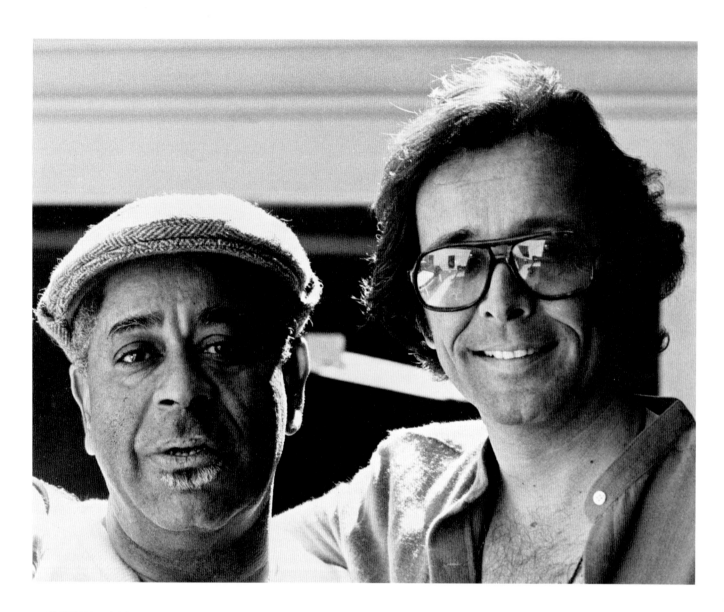

DIZZY gillespie + HERB alpert

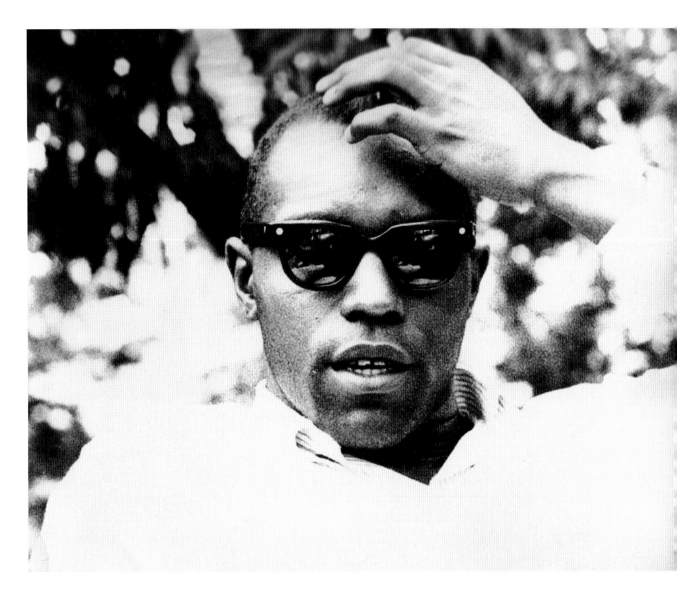

RON neal

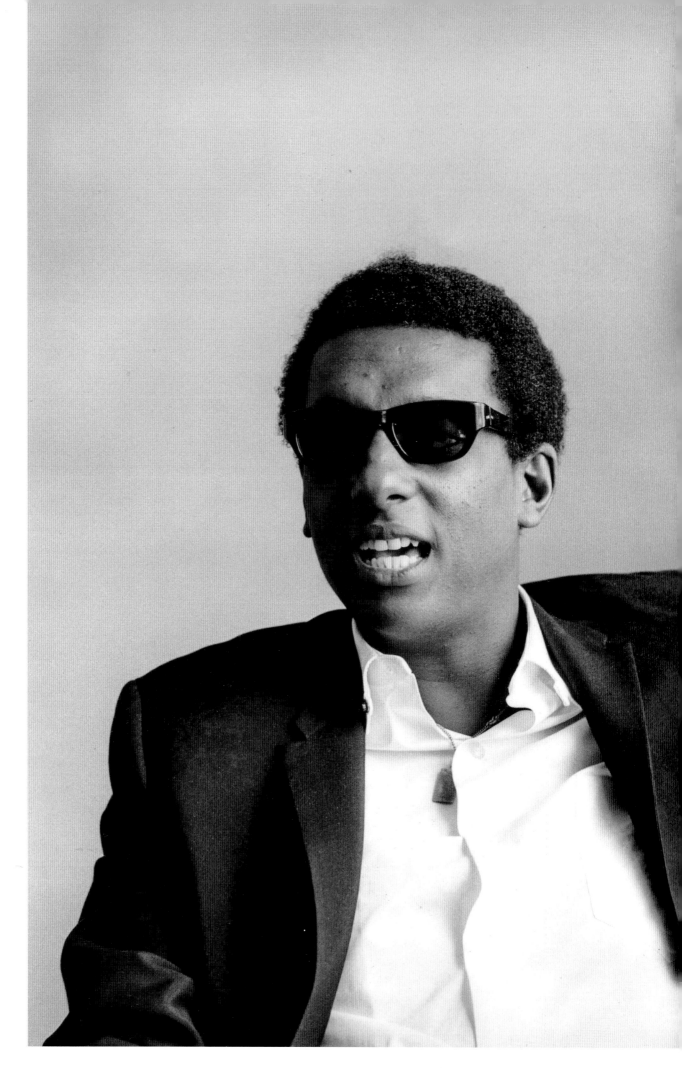

STOKELY carmichael

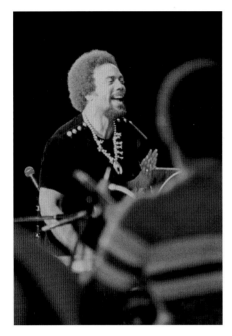

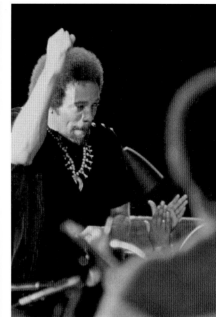

QUINCY j o n e s *"I love Quincy. I love his music."*

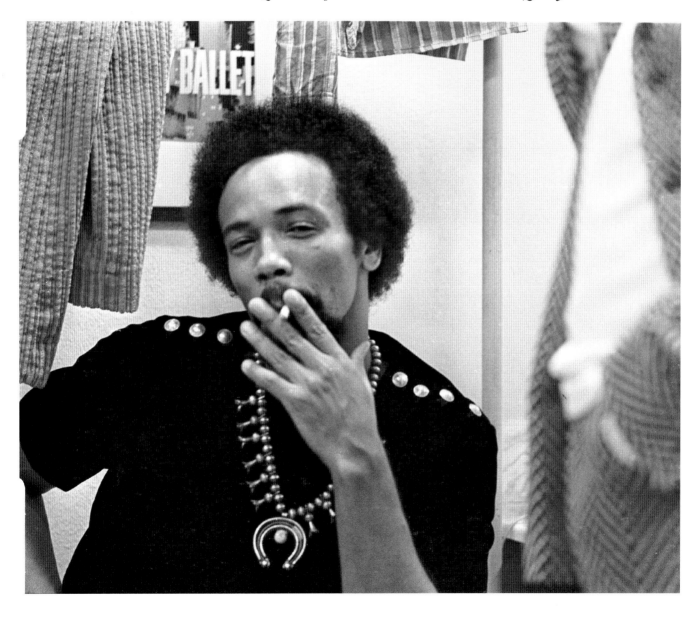

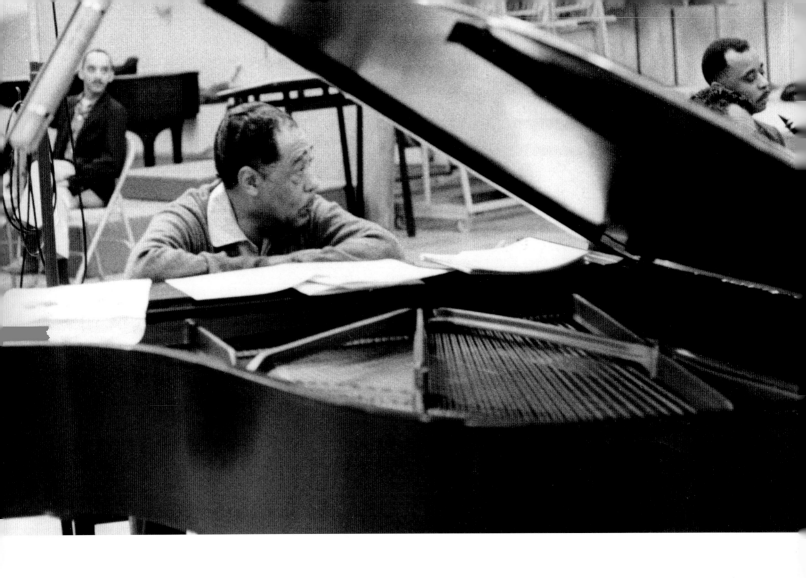

"*Duke Ellington ... I never really liked his music. I think I was quite disturbed with the fact that in watching his band play Carnegie Hall, they were all talking to each other, reading books, looking at the newspaper. I thought it was the most disgraceful thing I'd ever seen. I was young and I was quite disappointed at the professionalism, but years later I went to go see him at several recording sessions. At one ... I remember Frank Sinatra being there. Once I really got into Duke's music, I began to see that he was different from everybody else, but he had no control with the band. Of the ten albums I would take on a desert island, his album* Live at Newport *would be one of them.*"

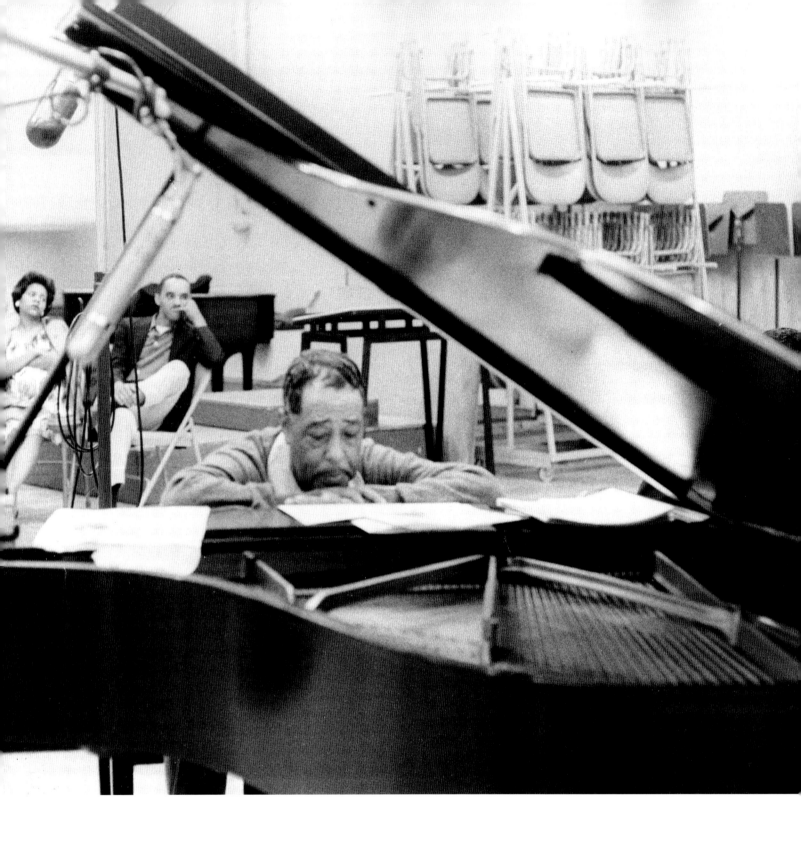

DUKE ellington

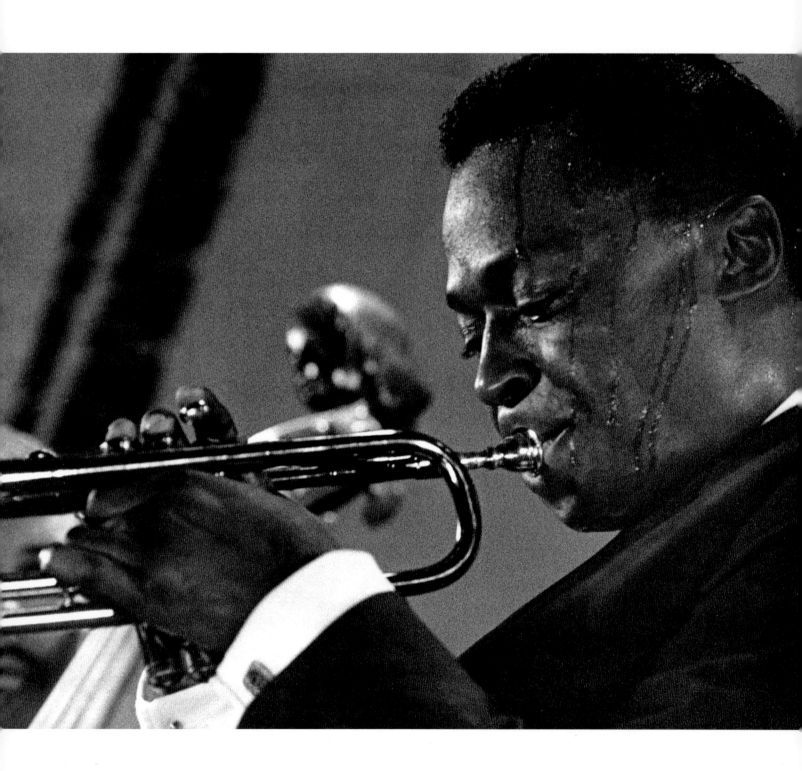

MILES davis

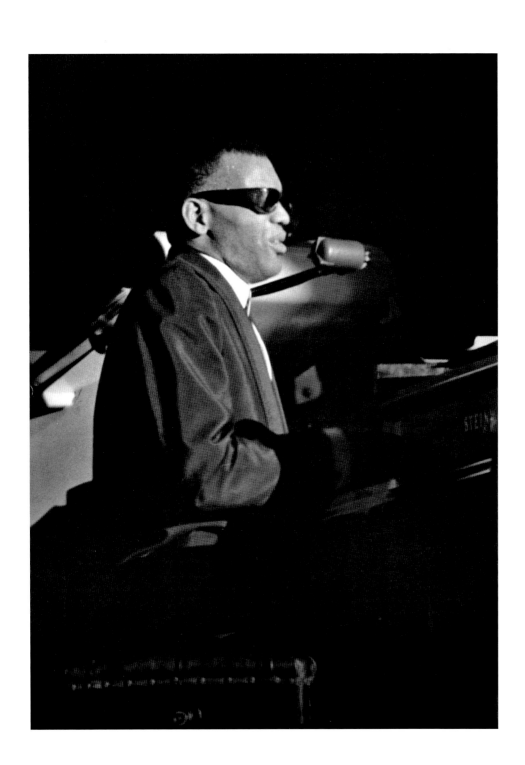

RAY charles

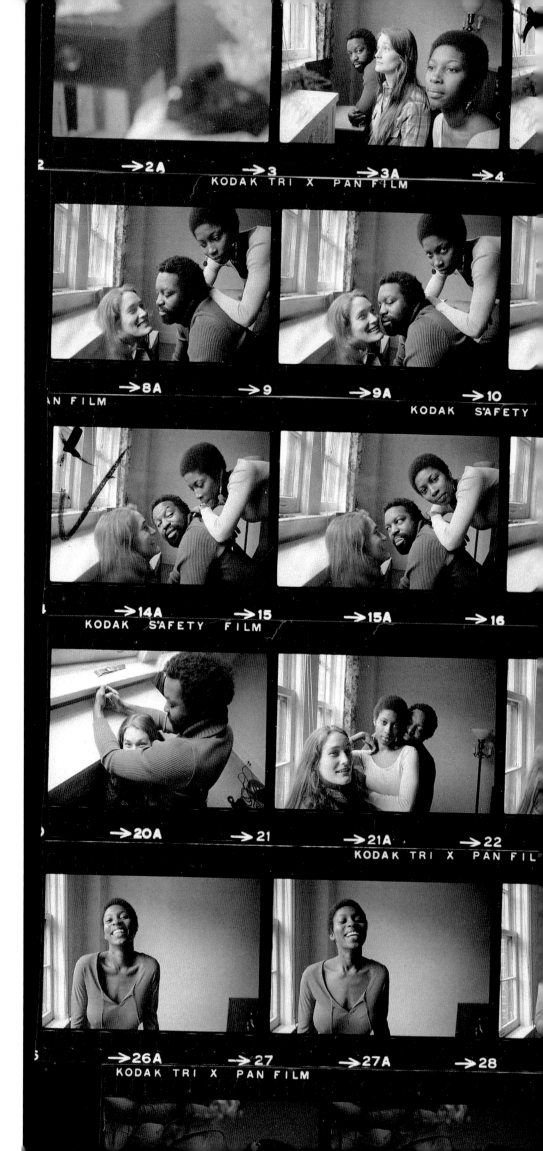

SUSAN jane +
GENE mcdaniels +
SISTER charlotte

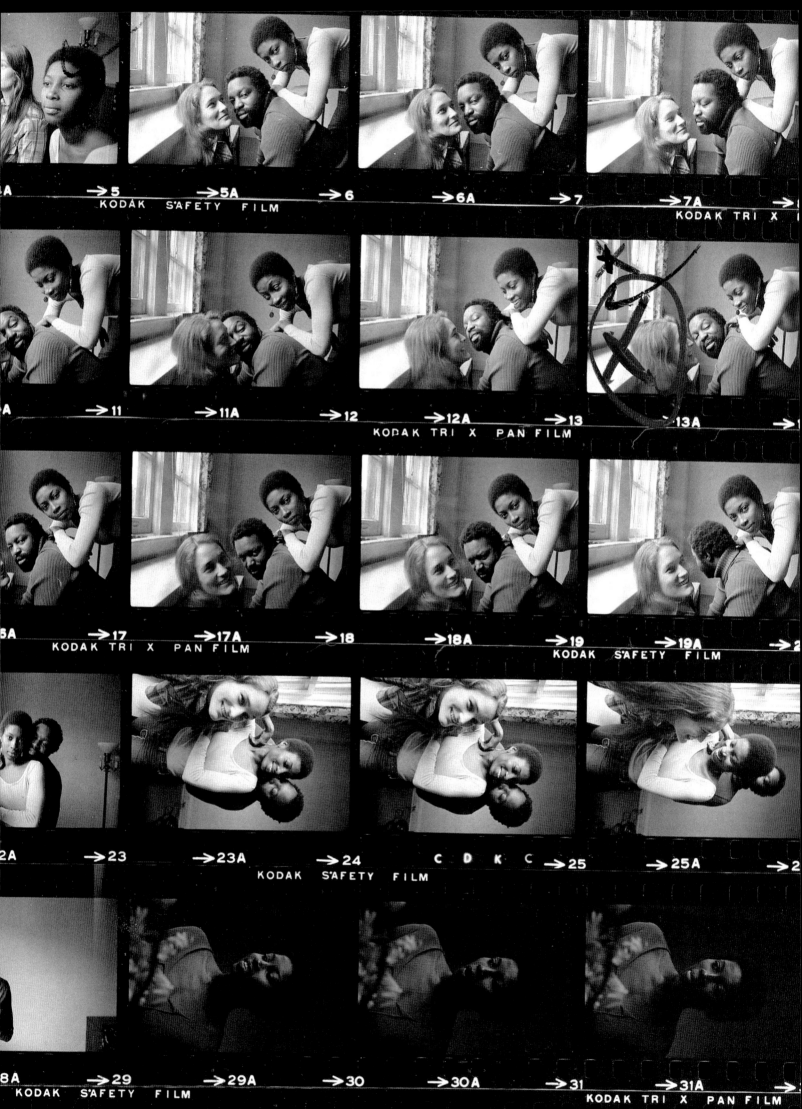

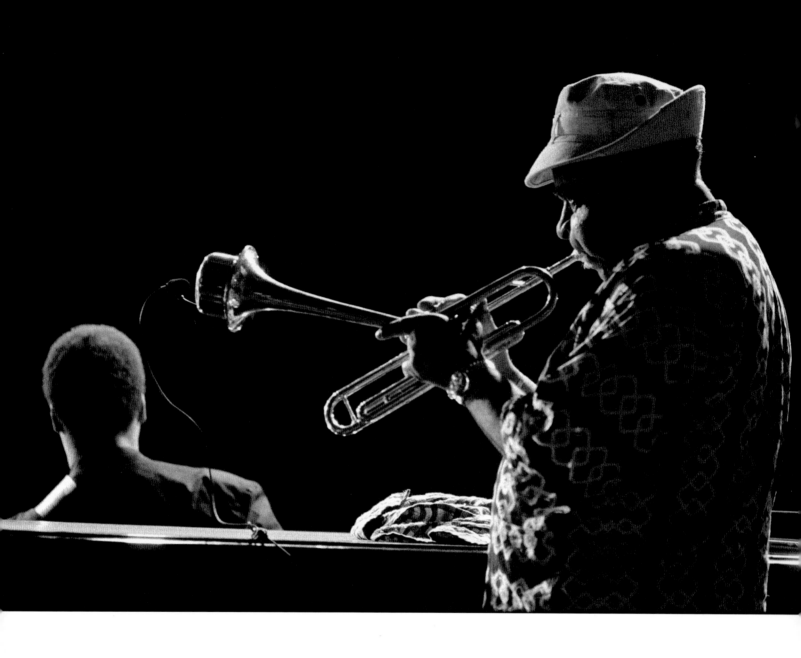

DIZZY gillespie

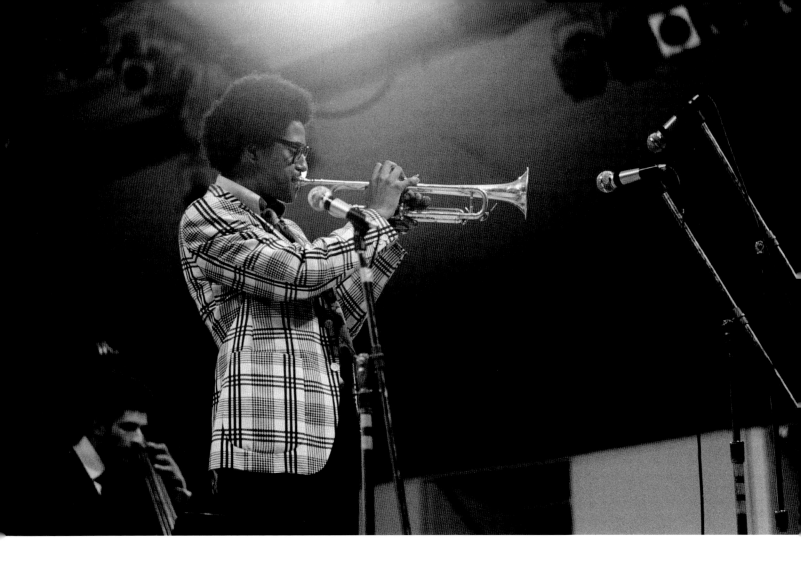

JIMMY o w e n s

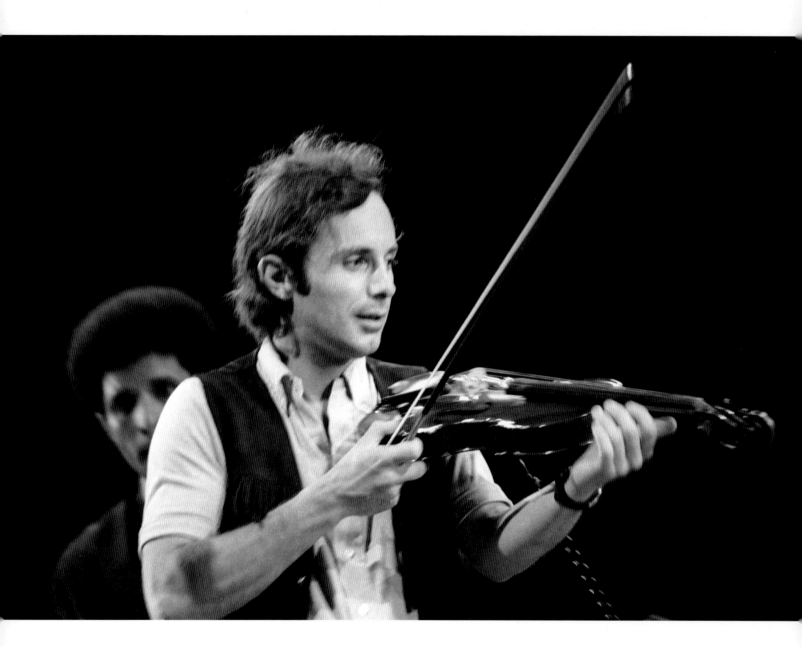

JEAN–LUC ponty

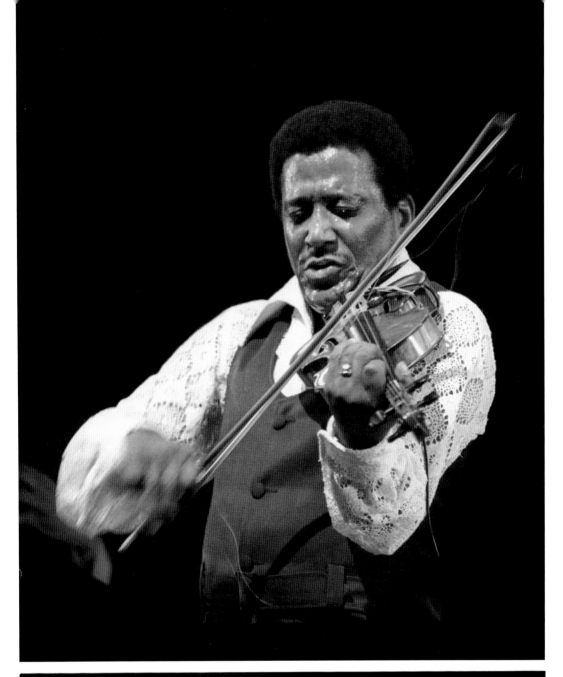

RAY nance

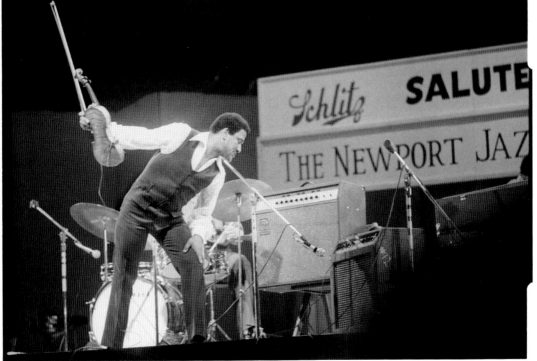

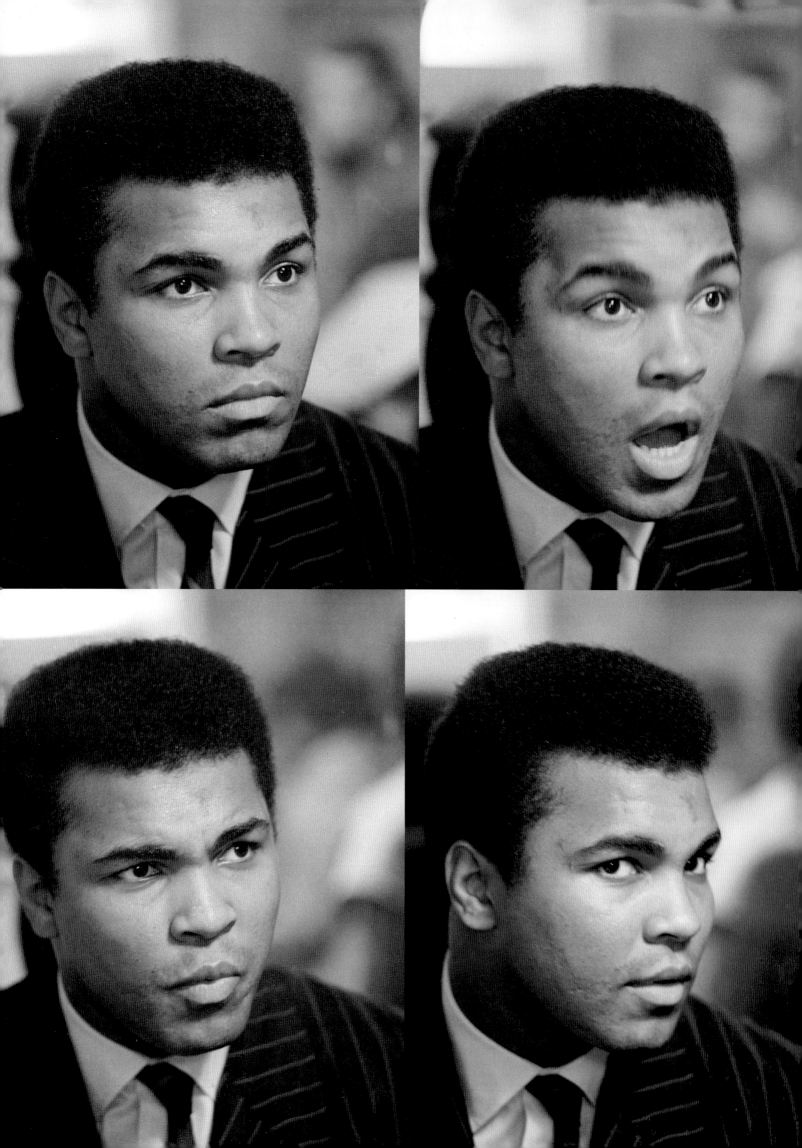

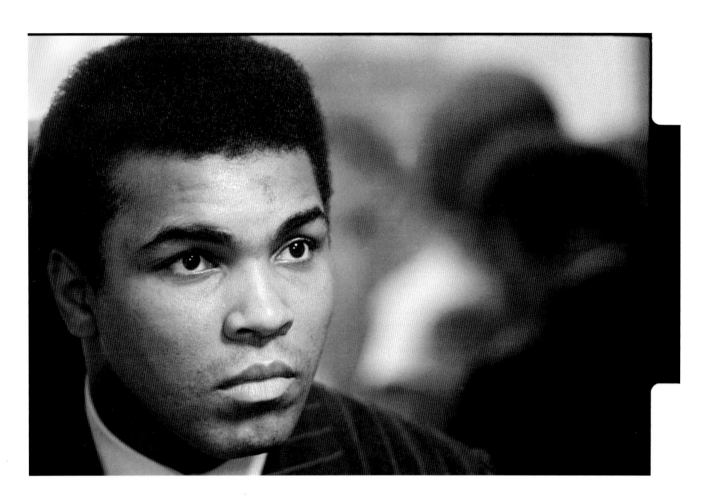

MUHAMMAD ali

"Best handshake I ever had in my life. So much soul."

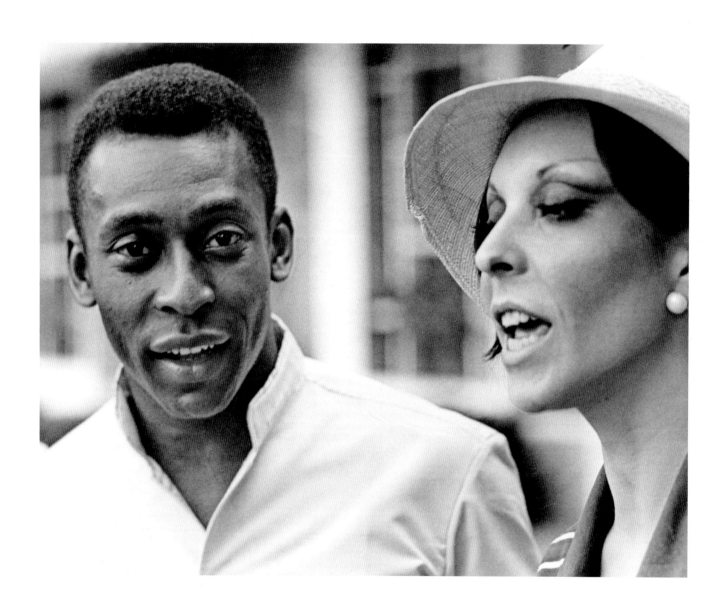

PELÉ

JAMES coburn

HERBIE hancock + DONALD byrd

DONALD b y r d

MAN in ghana

WILSON pickett and fan in ghana

MILES davis + SALVADOR dalí

MARTIN LUTHER king, jr.

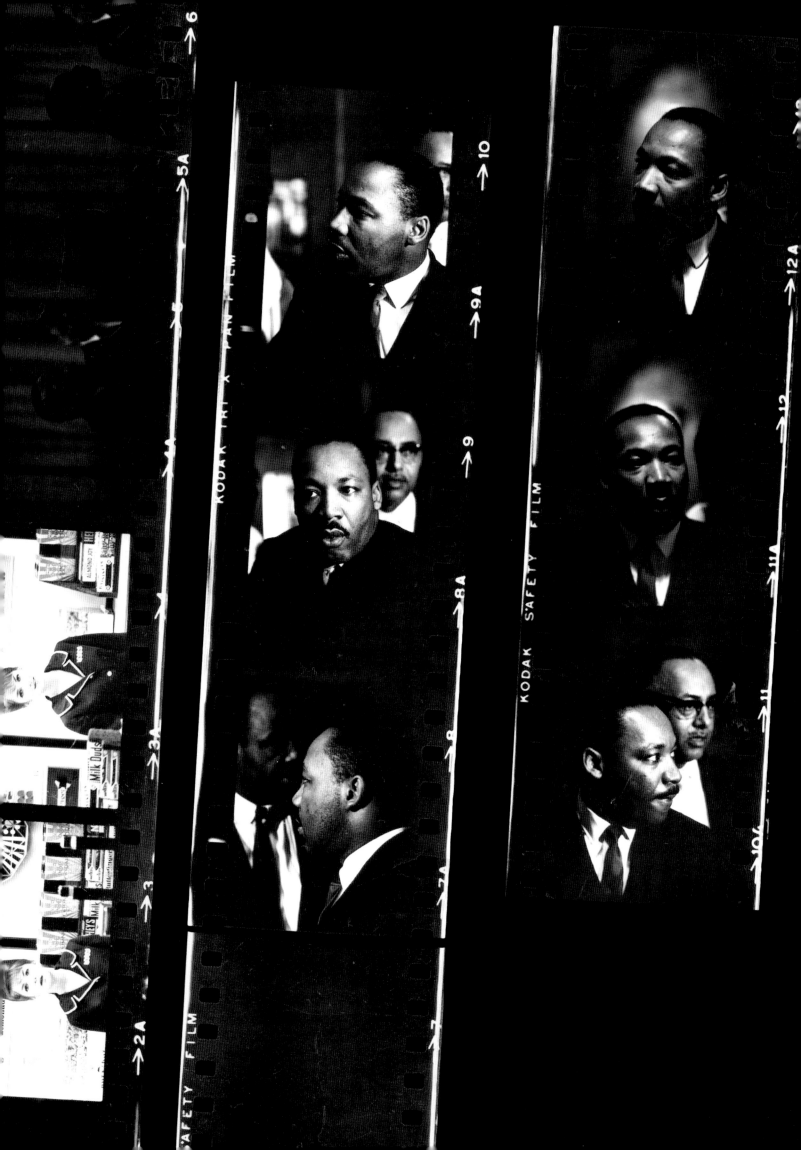

"I knew that Count Basie was going to be on his show at that little theater on Vine Street right across from Capitol Records — I lived right up the hill there. I had met Jerry on the telethon and I was friends with his bandleader, so I made a book of the photographs I took of Jerry conducting the Count Basie orchestra. So I went to see him and he's working. Busy. You know, Jerry Lewis is involved in everything — he's a cameraman, the lighting, everything. So I gave the book to this guy and said, 'Give this to Mr. Lewis. Here's my card and tell him I love him.' I go home.

Two or three hours later the phone rings. 'This is Jerry Lewis. Hey, man, this book is unbelievable, thank you!' He said, 'Come back down here!' I said, 'Oh, I'm working. I'm a musician, too.' He said, 'I'm making a movie. Why don't you come be my photographer on the set?' I said, 'OK, when does it start?' He said, 'Tomorrow.'

So I go down to the studio, everybody's there, I'm walking around doing my little shit. This guy walks over to me and he says, 'Hey man, what are you doing taking pictures in here?' I said, 'I work for Mr. Lewis.' He said, 'Well, you're not in the union.' I said, 'How would you know?' He said, ''Cause there ain't no niggers in the union.'

I said, 'Jerry!' He said, 'Yes?' I turned to the union rep. 'Tell him what you just said.' The guy repeats it. Still couldn't believe it. So Jerry closed the whole set down.

That was it. I went home. I was pissed. I wasn't as enlightened as I am now but my wife always was cool, and she said, 'Come on, you told him you'd take pictures, go back!' I said, 'I ain't going back.' Jerry kept sending me telegrams saying, 'Come back, man. You must come back. I want to use you as my photographer.'

I refused to go back, which I kind of regret years later, you know."

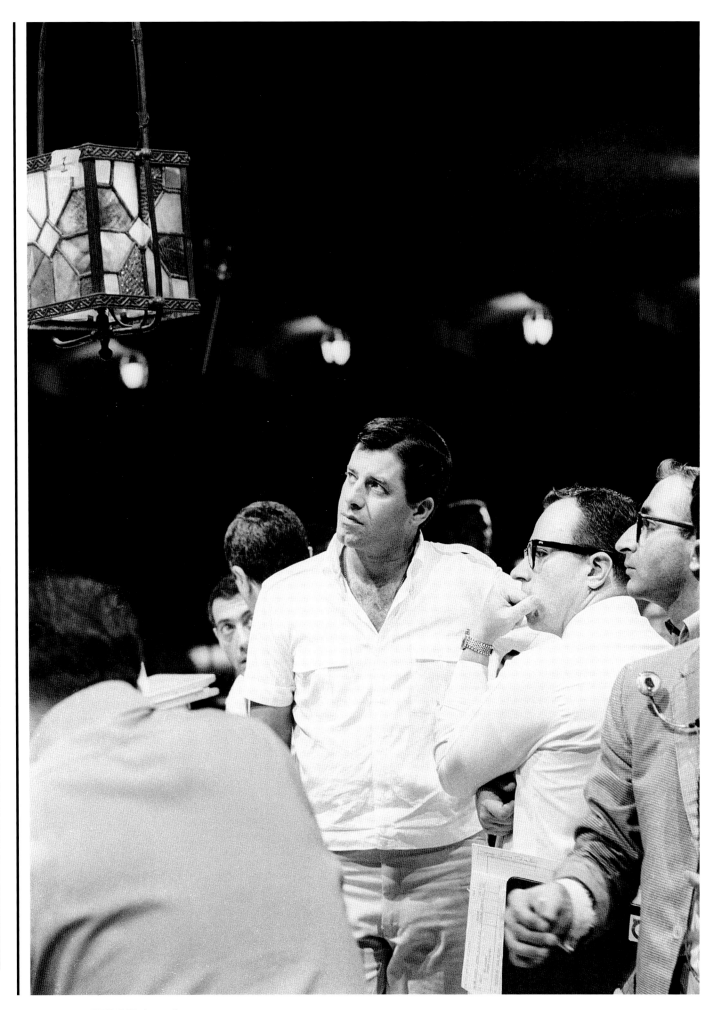

JERRY lewis

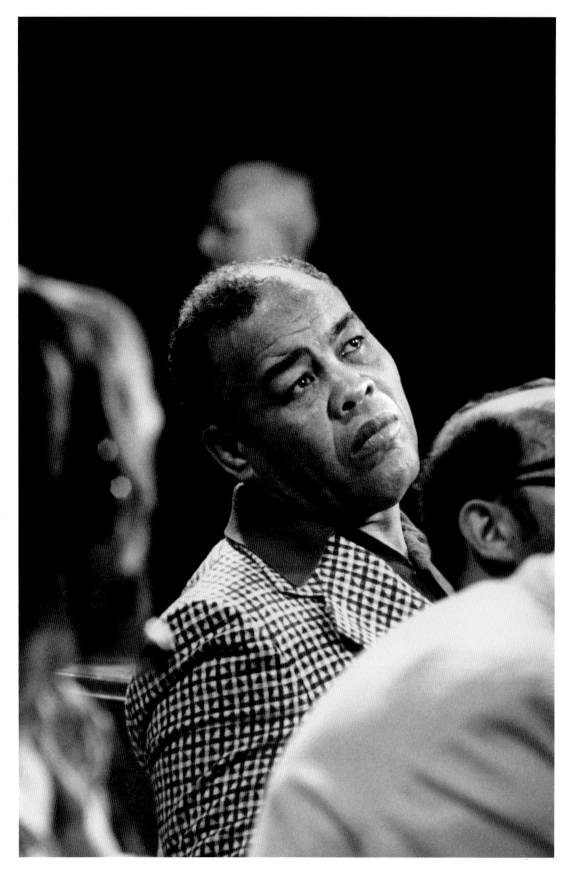

JOE lewis

BILL cosby

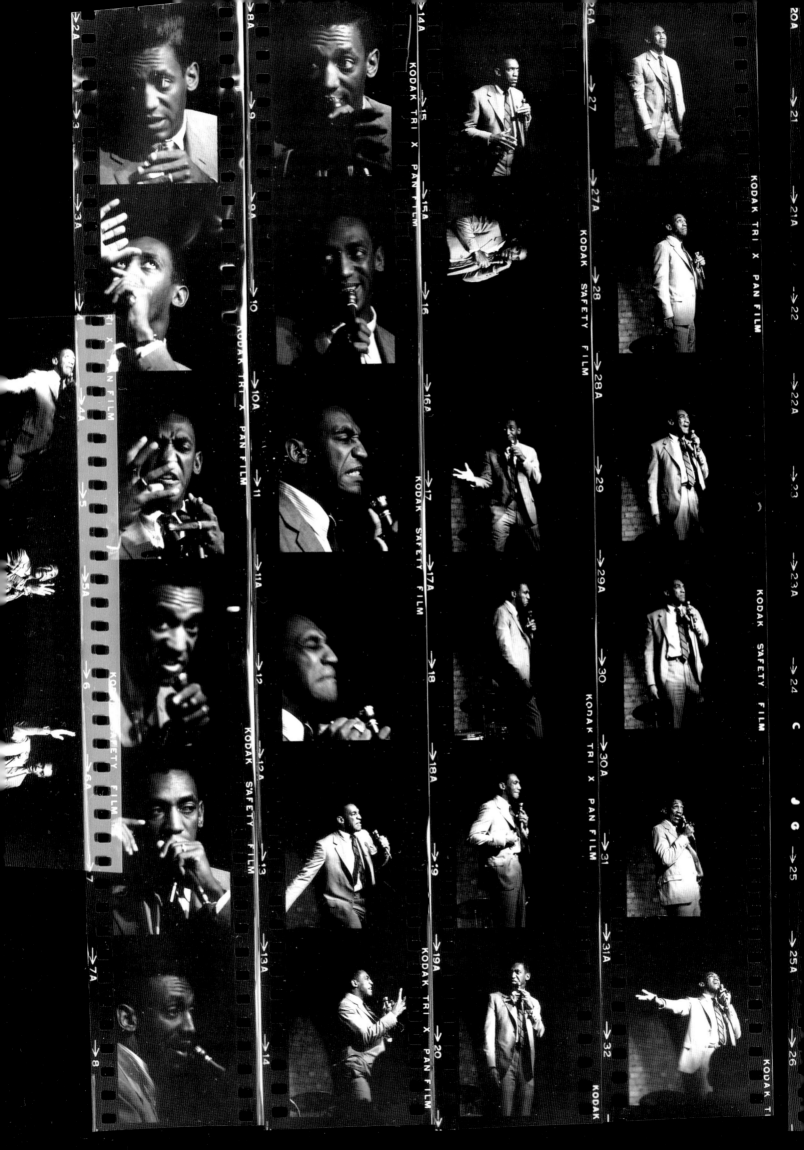

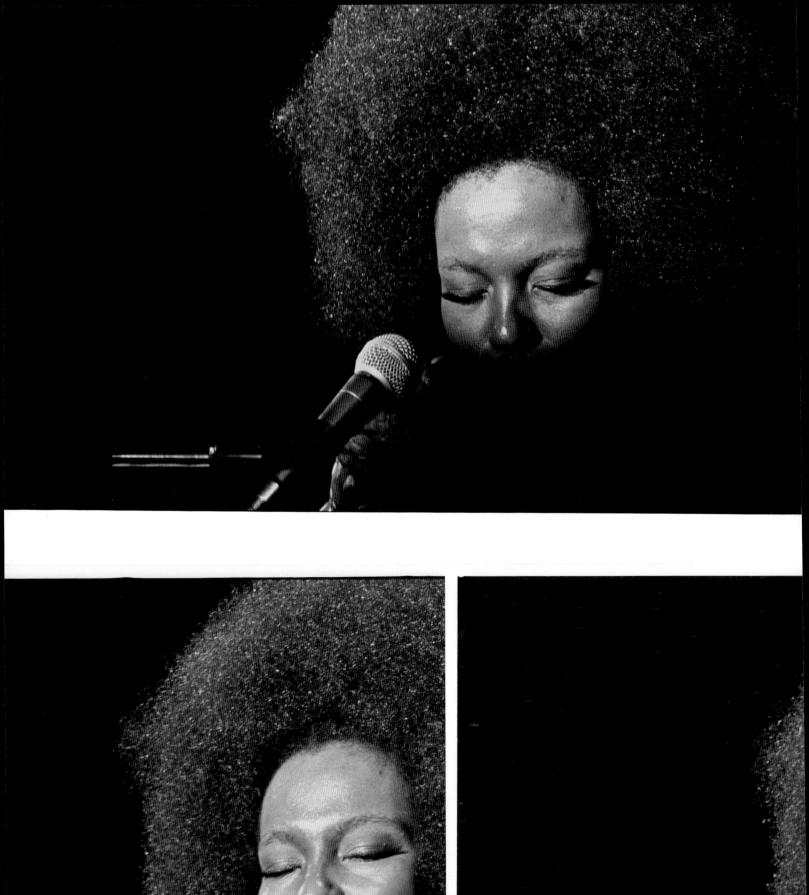

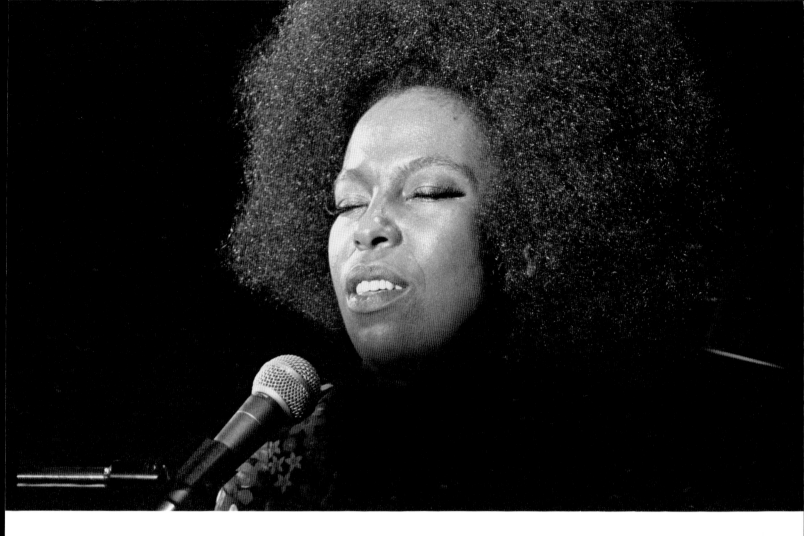

ROBERTA flack

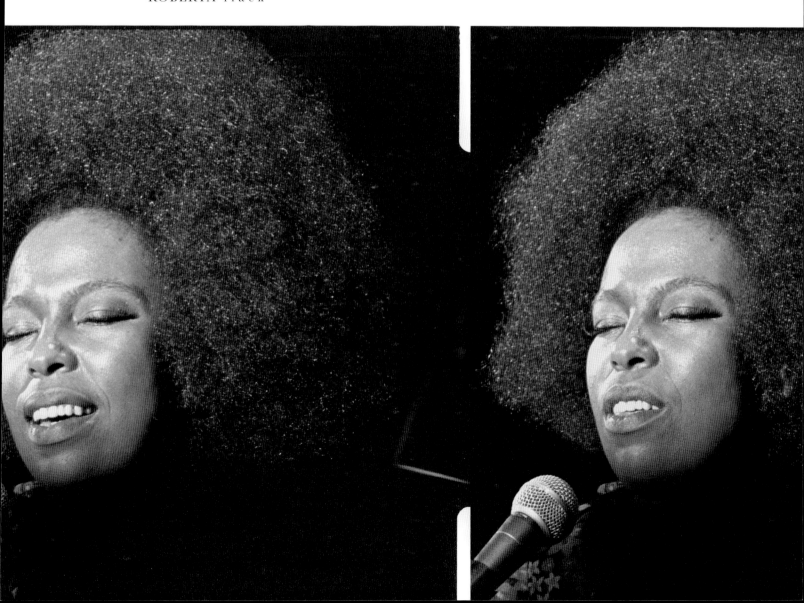

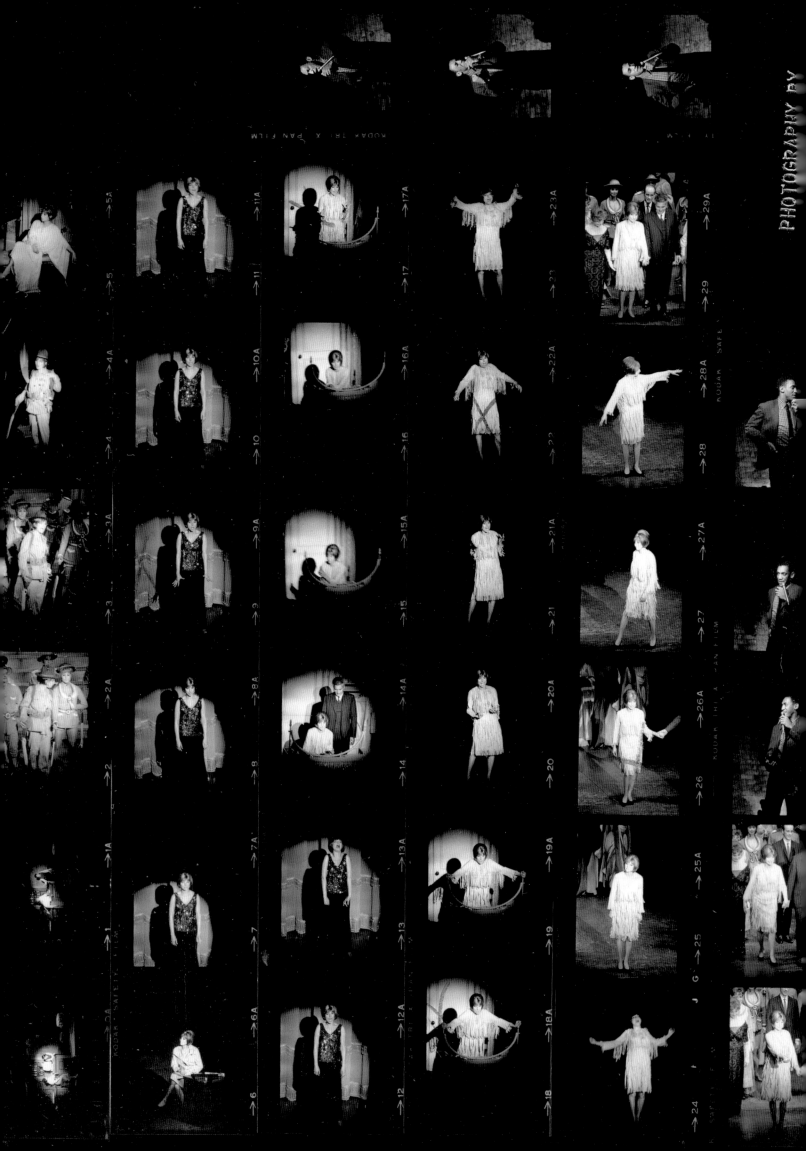

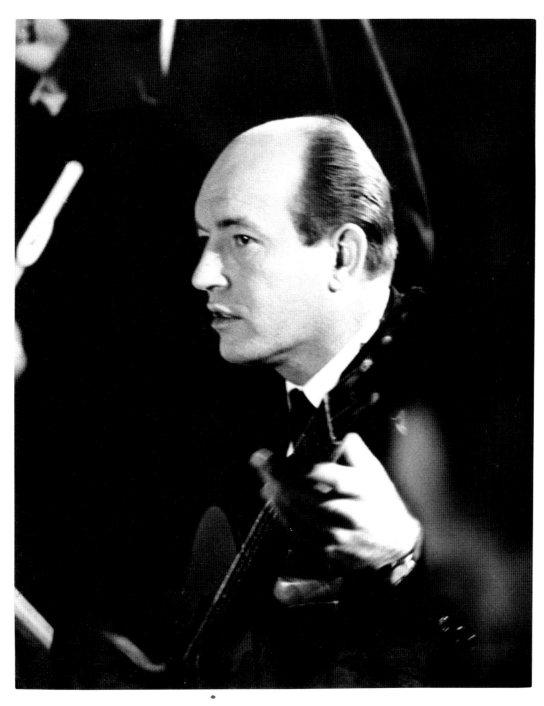

CHARLIE byrd

BARBRA streisand

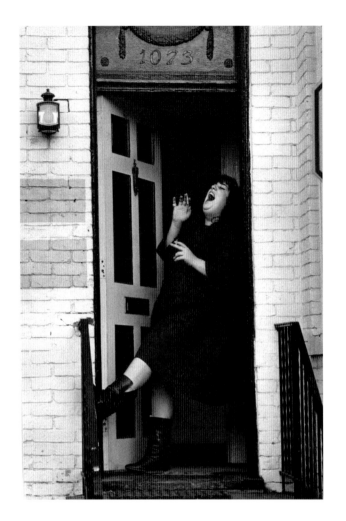

"MAMA" CASS elliot

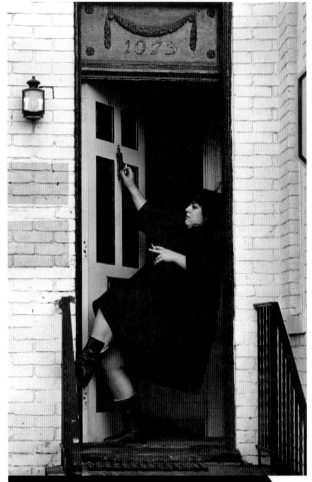

"Mama Cass was the funniest person I think I've ever known. Funniest woman I've ever known."

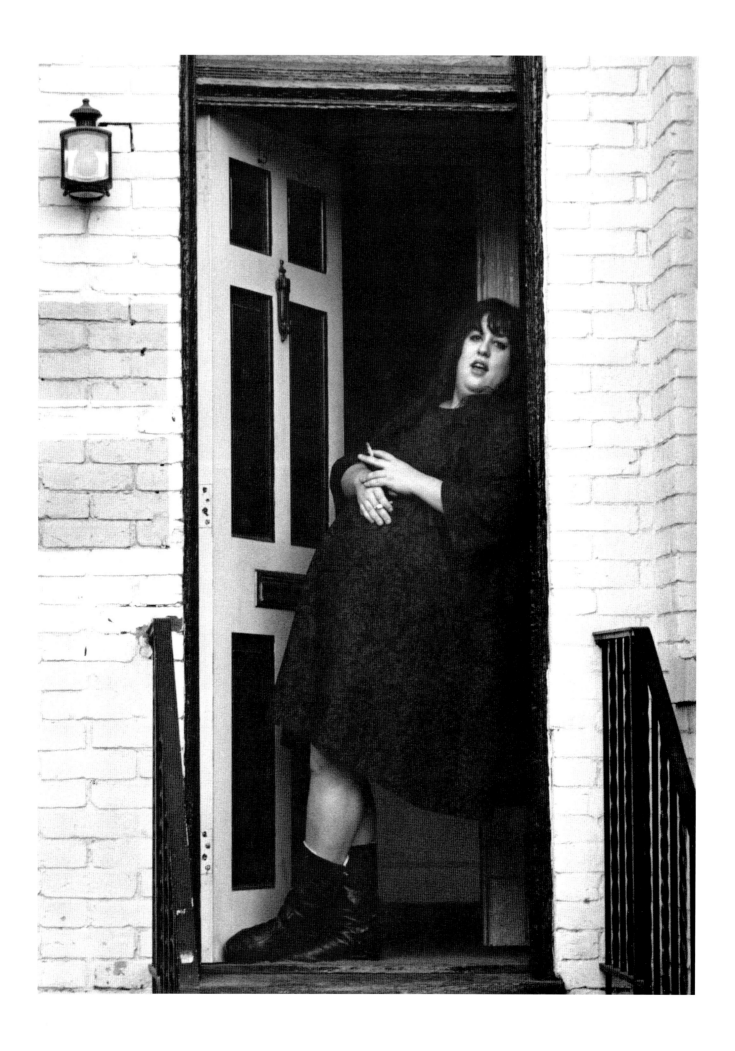

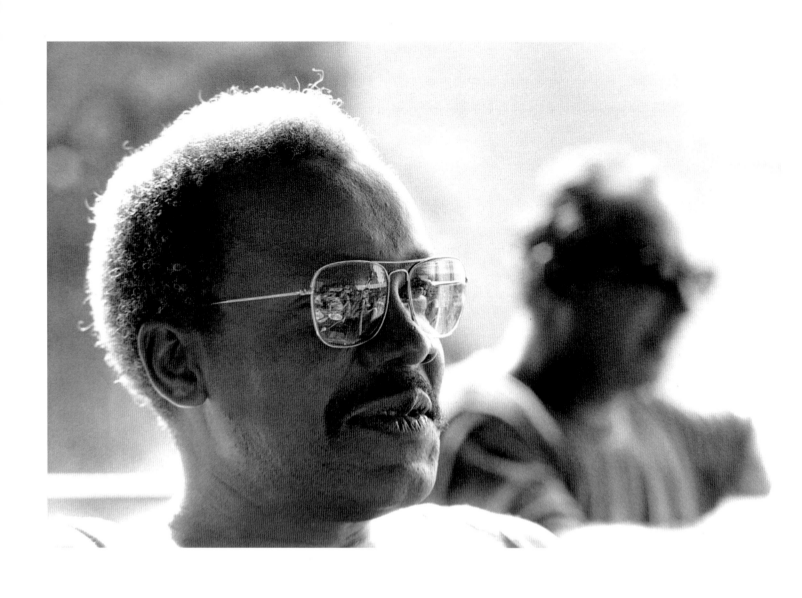

JIMMY rowser

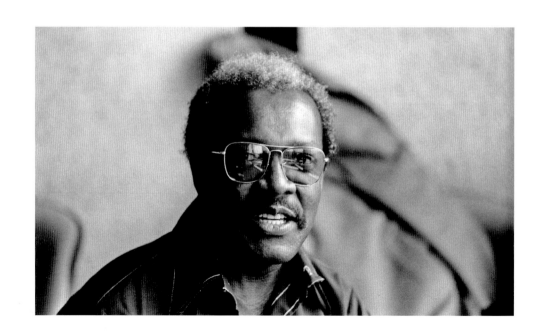

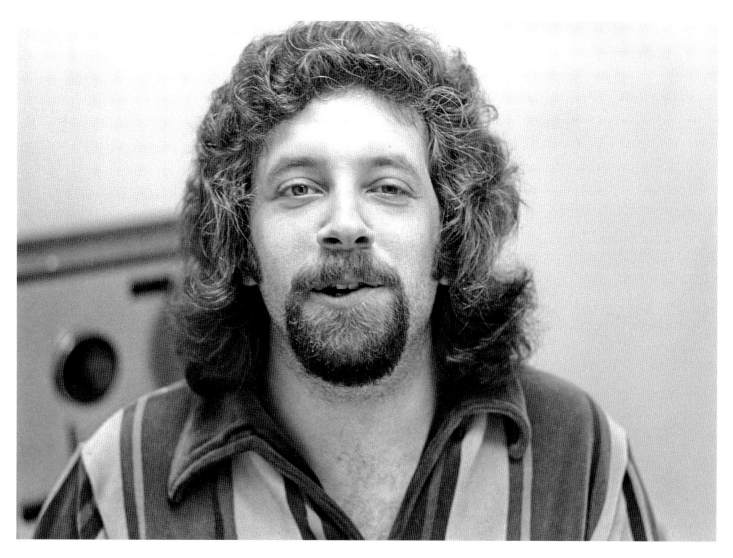

JOEL dorn

"*Joel would never tell a jazz musician what to play. Joel was the only producer
I ever met that never tried to tell you what to play, only how it felt, how to
sound, and if anybody was out of tune. Joel, very few people realize, couldn't
hear in one ear.* **Joel and I had one little disagreement in the beginning of
our relationship and when he brought it to my attention
I told him I didn't give a fuck and he said, 'Me neither, so
let's go on beyond it,' and that was it.** *From that point, it just went higher and higher and higher.*"

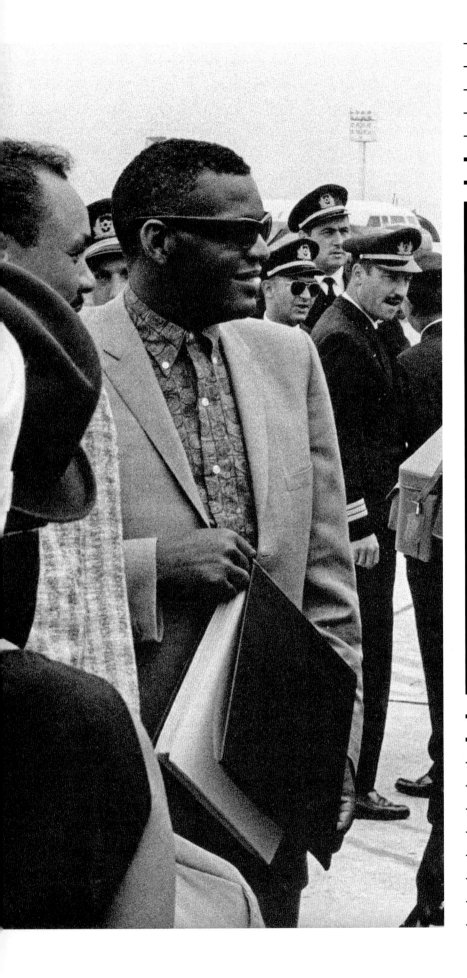

"From when I was very young, I remember Ray Charles. I don't know how old he was then but somehow I feel like he's always been around because his music was just like the church. Same chord structure, same vibe ... but the words were different. So, it was an automatic transition into him, you know? I've loved just about everything I've ever heard out of Ray Charles, and my father, who loved country music, was blown away when Ray made the country record."

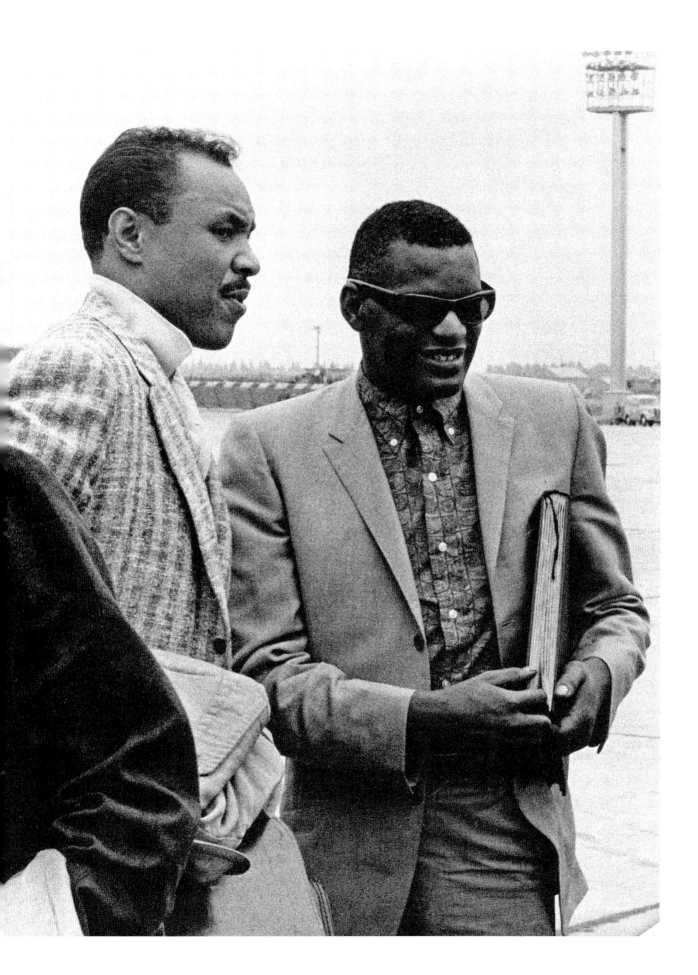

JOE adams + RAY charles

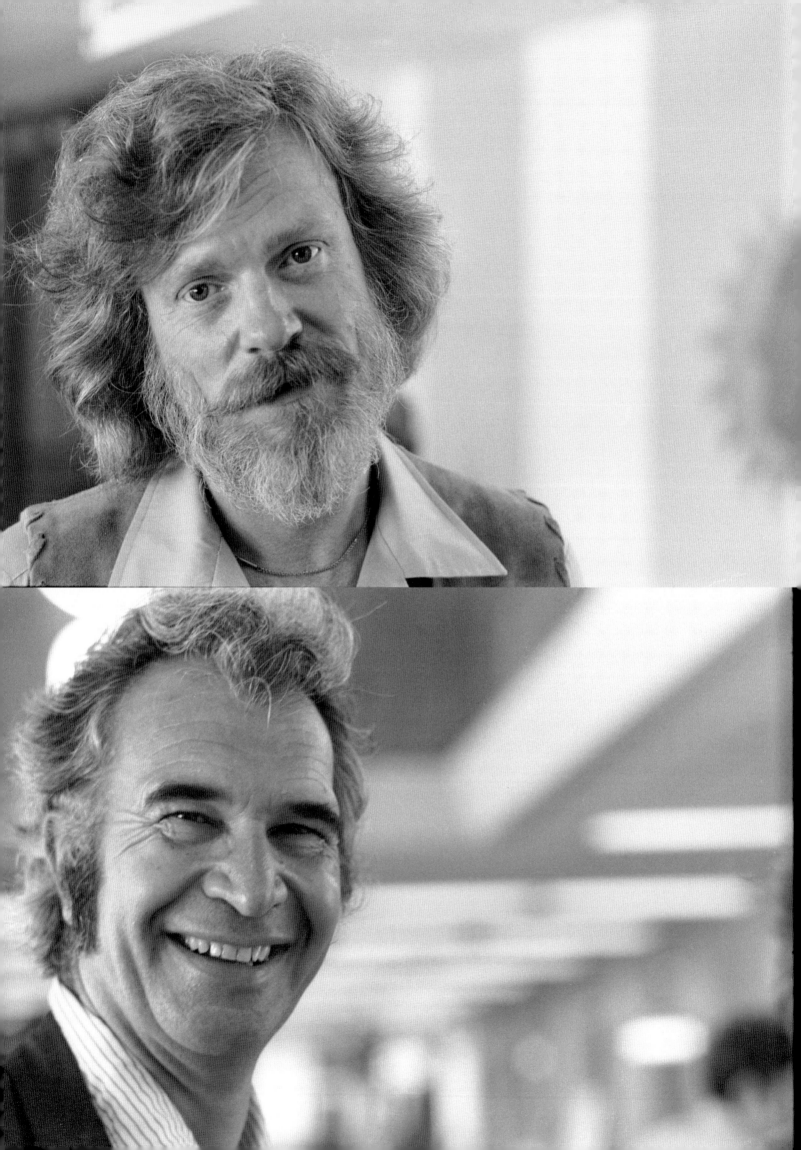

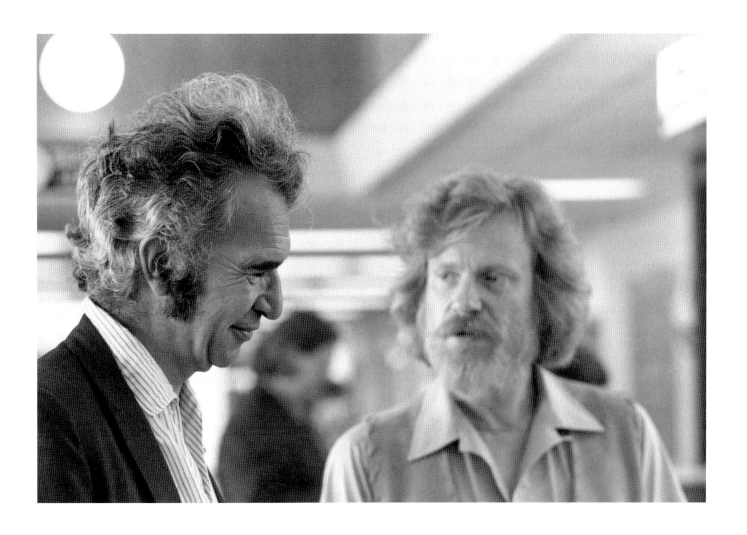

DAVE brubeck + GERRY mulligan

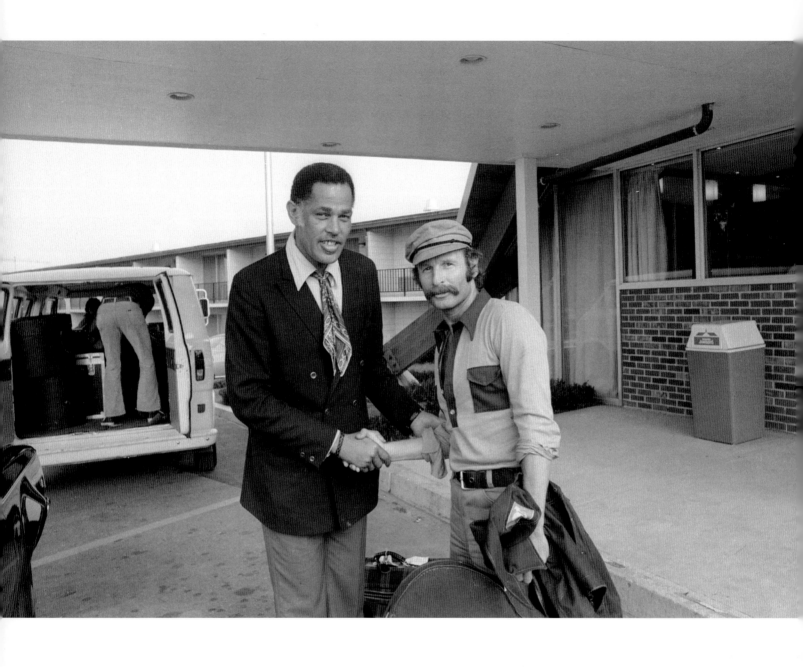

DEXTER gordon + JOE zawinul

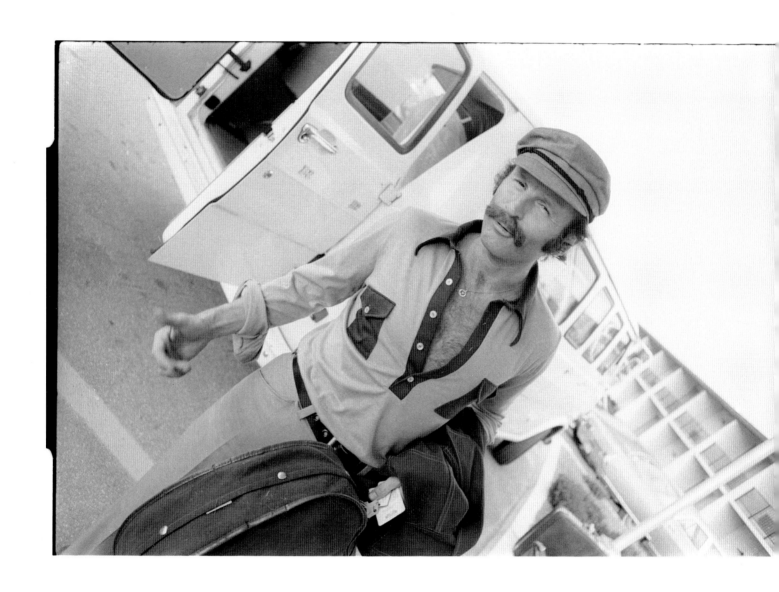

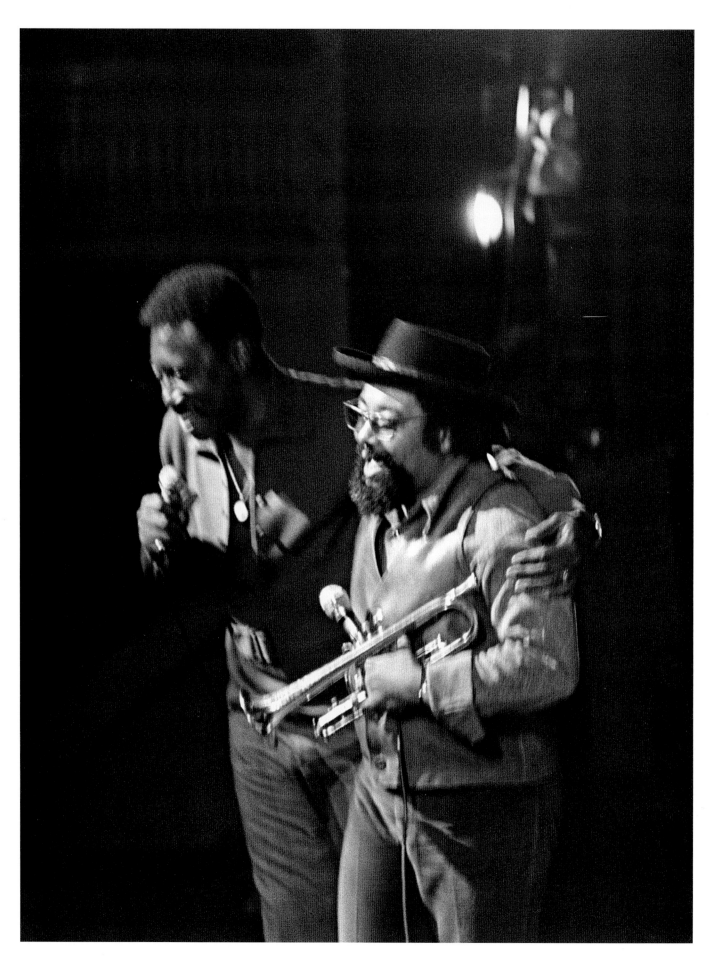

JOE williams + NAT adderley

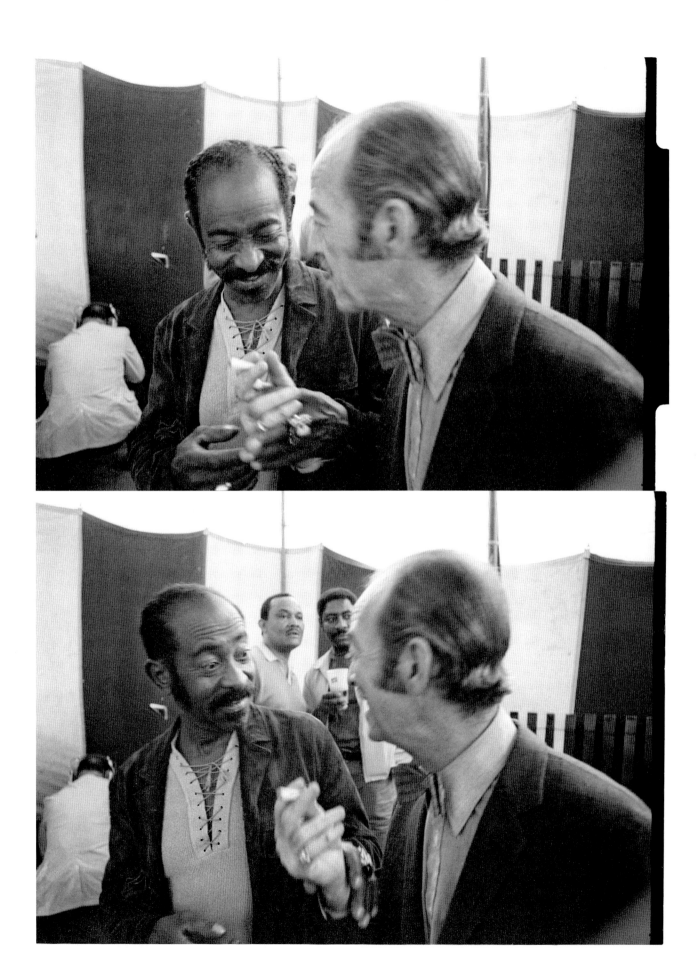

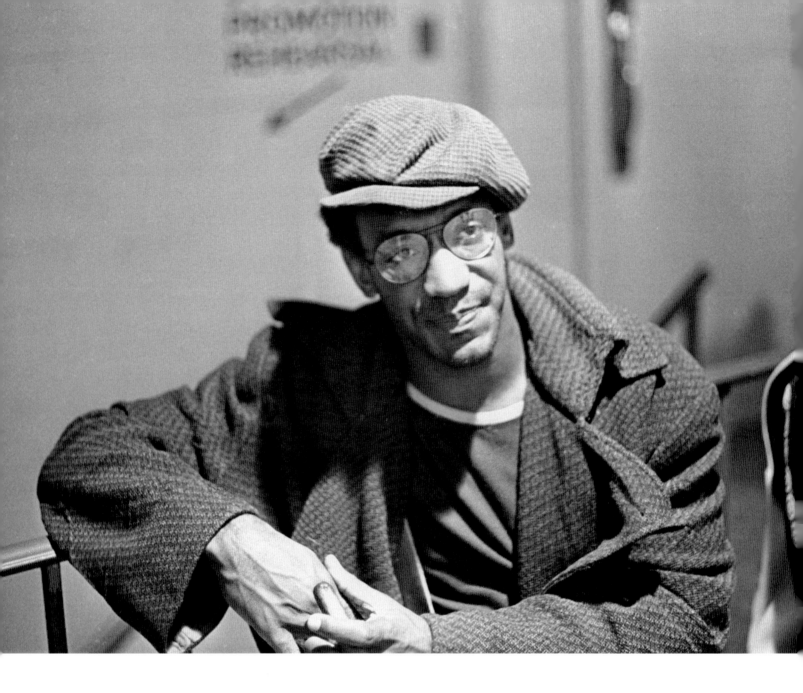

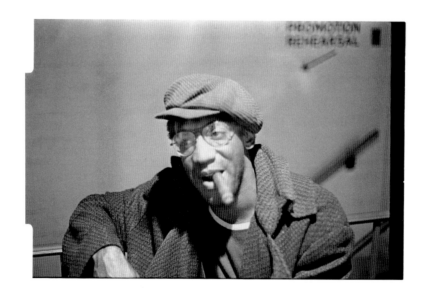

BILL cosby

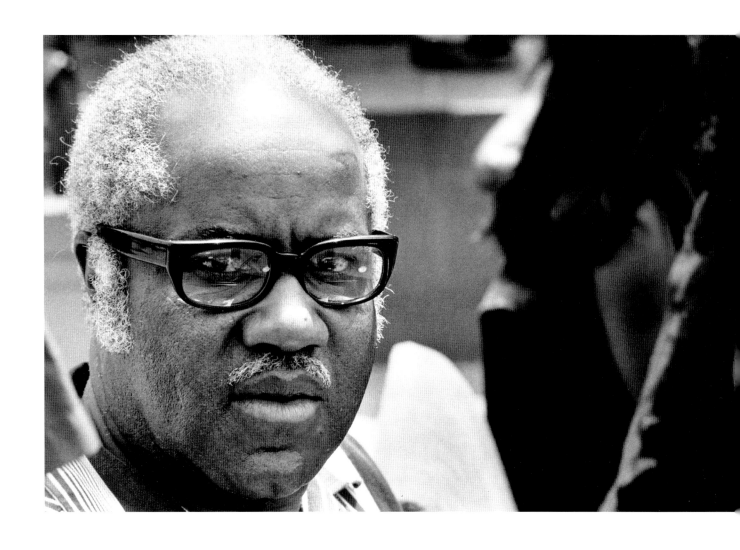

POPS staples in ghana

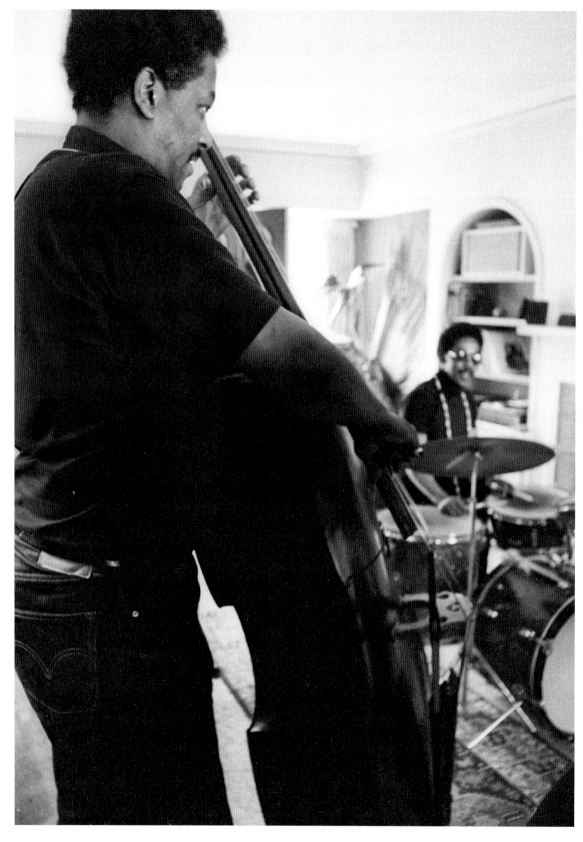

LEROY vinnegar DONALD dean

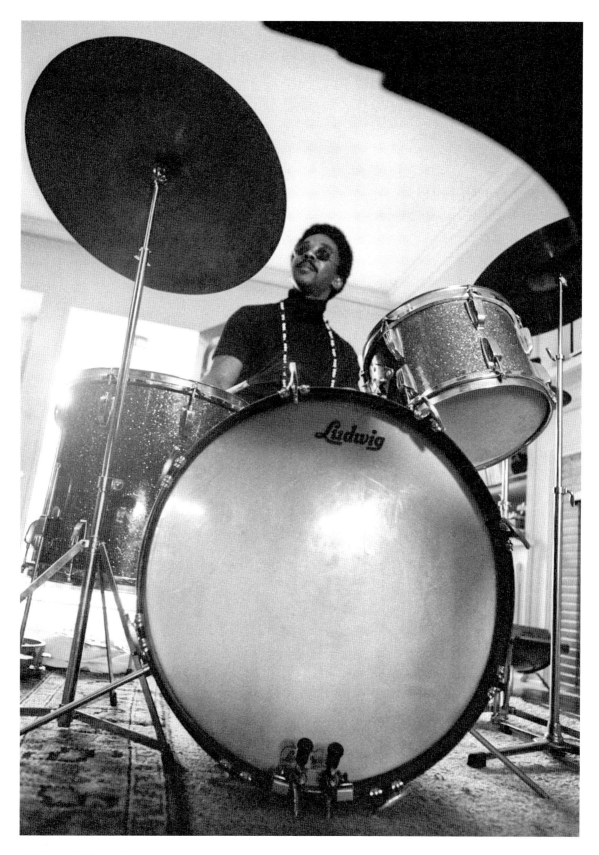

"Haaaa! The only person that could top Dizzy Gillespie with joy and fun is Donald Dean. I just talked to him for the first time in four years yesterday. 'Les! Happy birthday! I want to tell you I've never had as much fun in my whole life as when I was in your band. You're the best bandleader ever.'"

PAUL desmond + DAVE brubeck

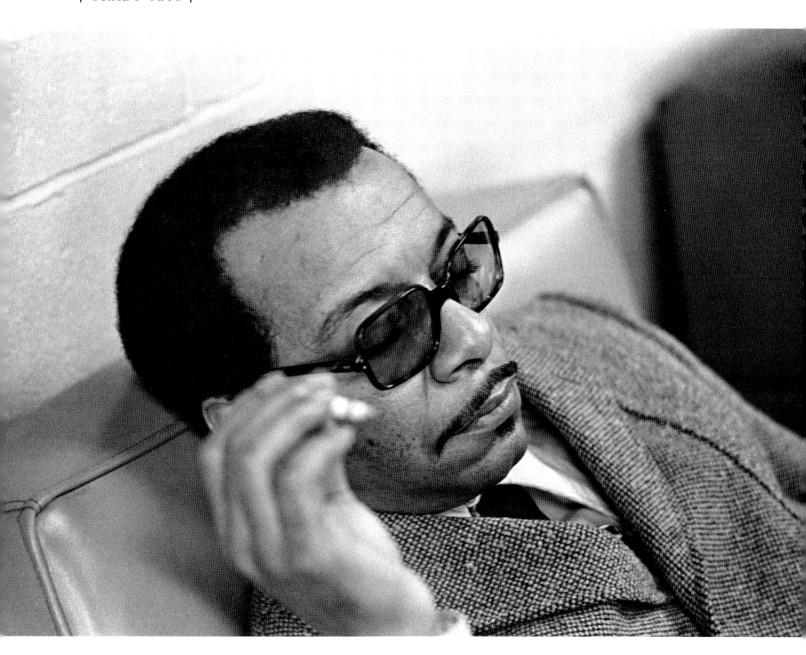

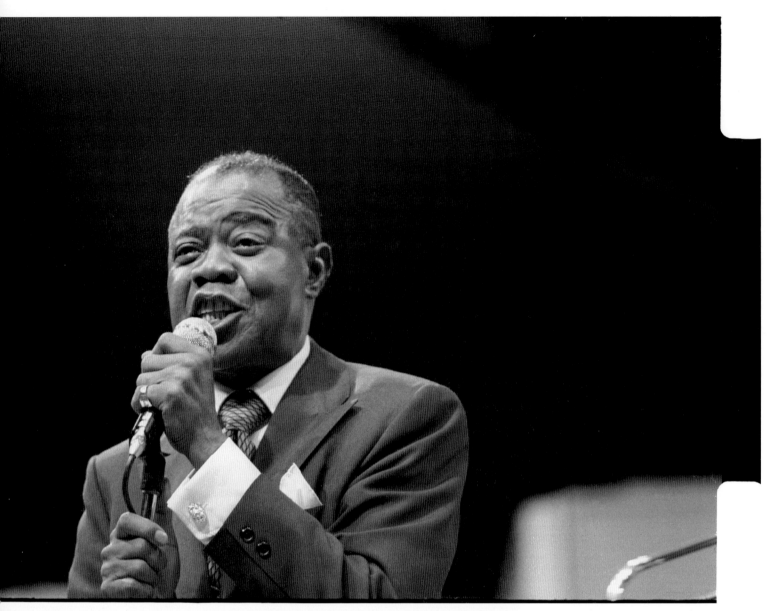

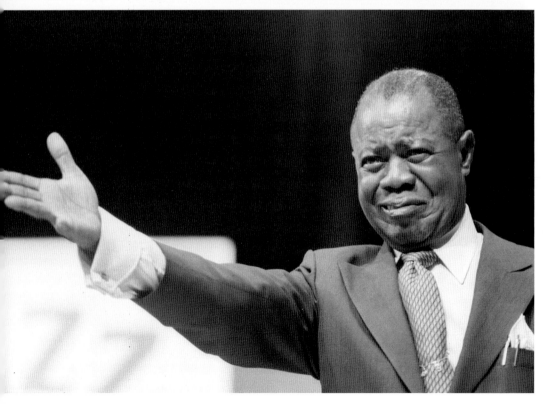

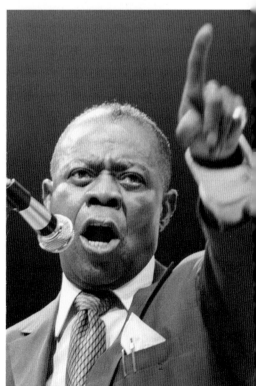

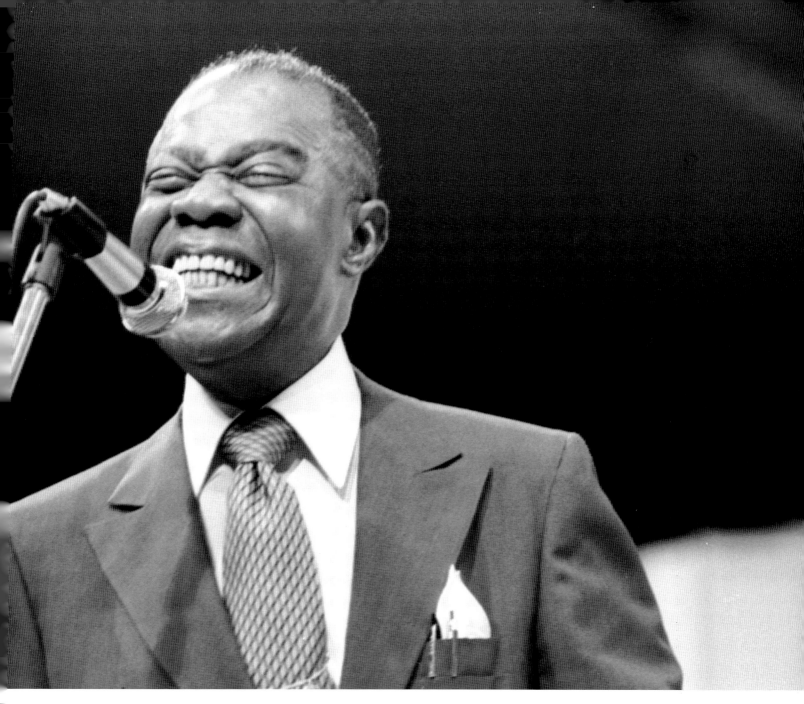

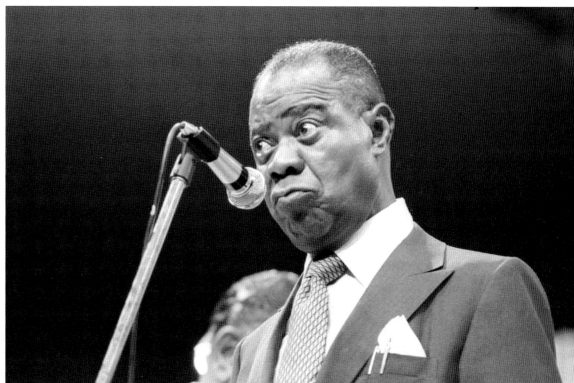

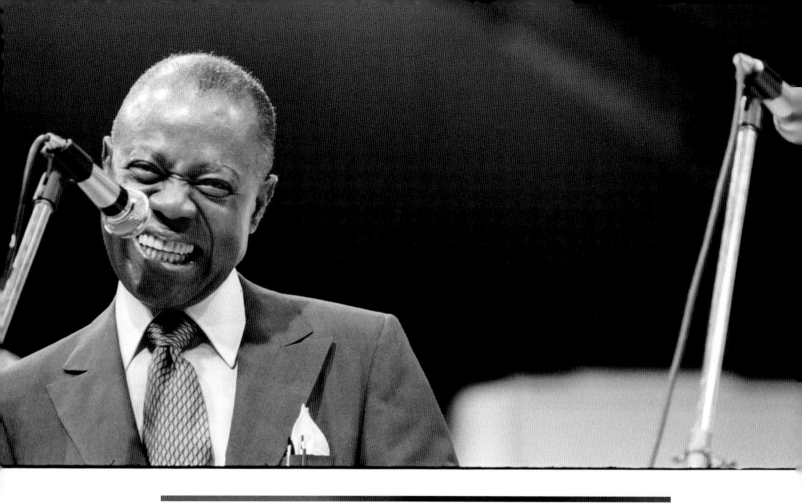

"When I was in the Navy, it was announced on the base that there was a big show in town: Louis Armstrong and Billy Eckstine. So, I went into town and I was fortunate enough to go backstage. It was beautiful. ████████████████████ I loved talking to him, the inspiration, 'cause I wasn't really into music then, but I loved his singing. But when I finally started listening to him more – I realized his contribution is monumental."

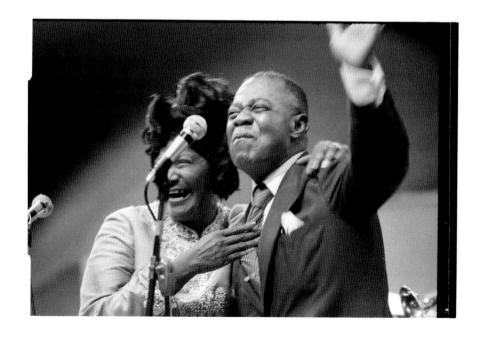

MAHALIA j a c k s o n

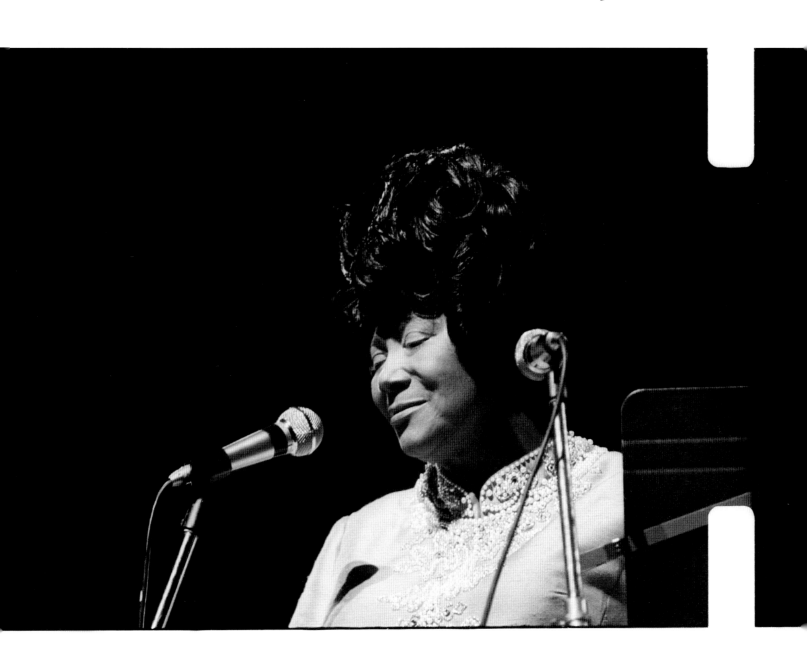

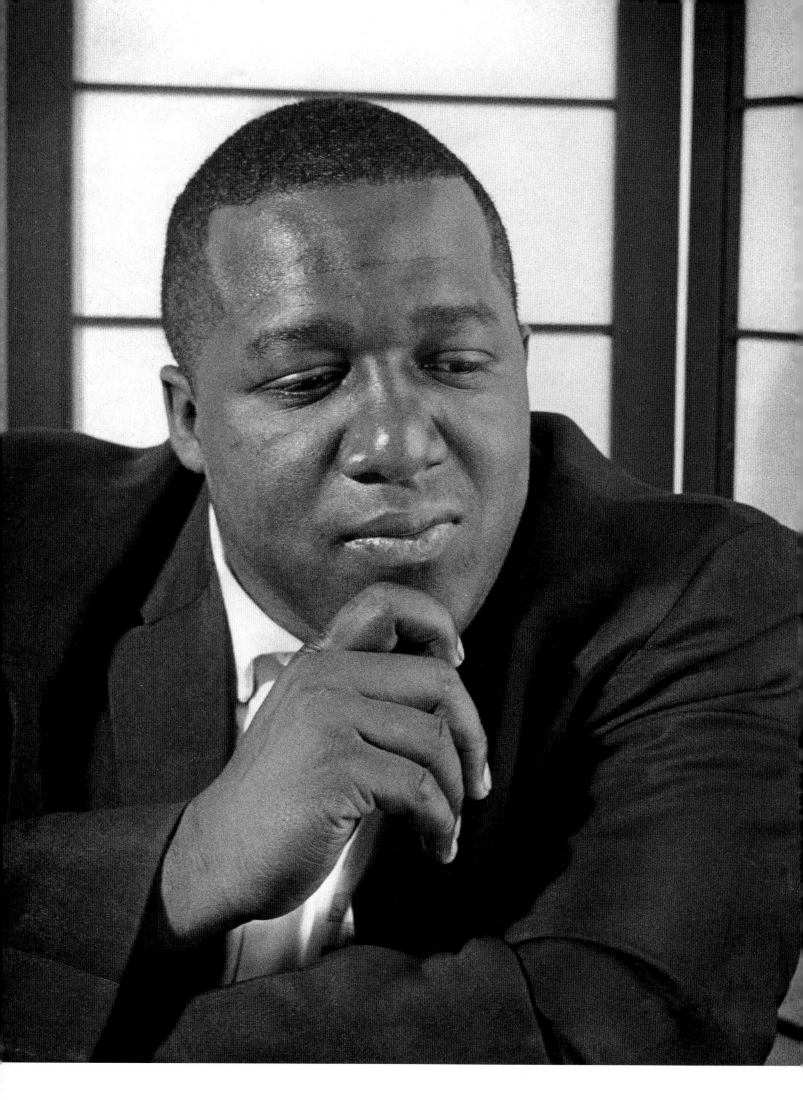

*"Damn! Biggest, blackest, fattest motherfucker ever!
I was in Pittsburgh, up in the Hill District – which was the hood of
Pittsburgh, then – and I went into a famous restaurant there, called
The Silver Pig. You know what that means: pork, corn bread, greens,
black-eyed peas, pies, and everything. As I walk into the restaurant, I
see this guy looking like he had the whole restaurant on his table. At
least ten different items and as I was walking by, he was asking the
lady for a Diet Coke and I bust out laughing, 'Diet Coke?! Are you
crazy?! With all that shit you got on there?!'"*

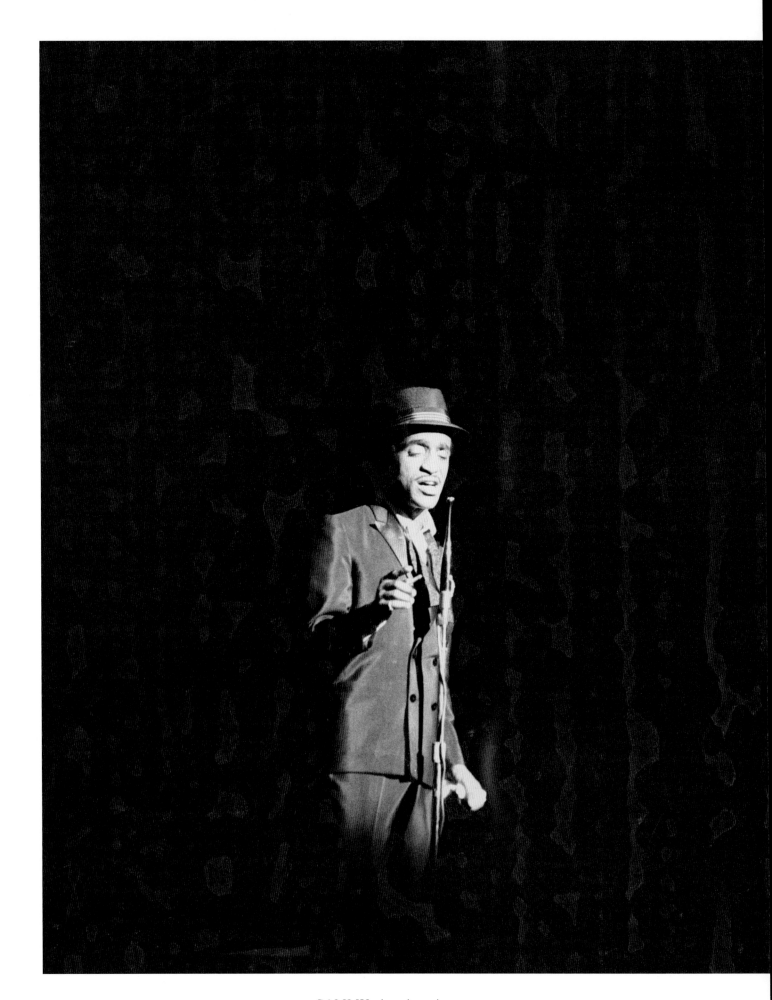

SAMMY davis, jr.

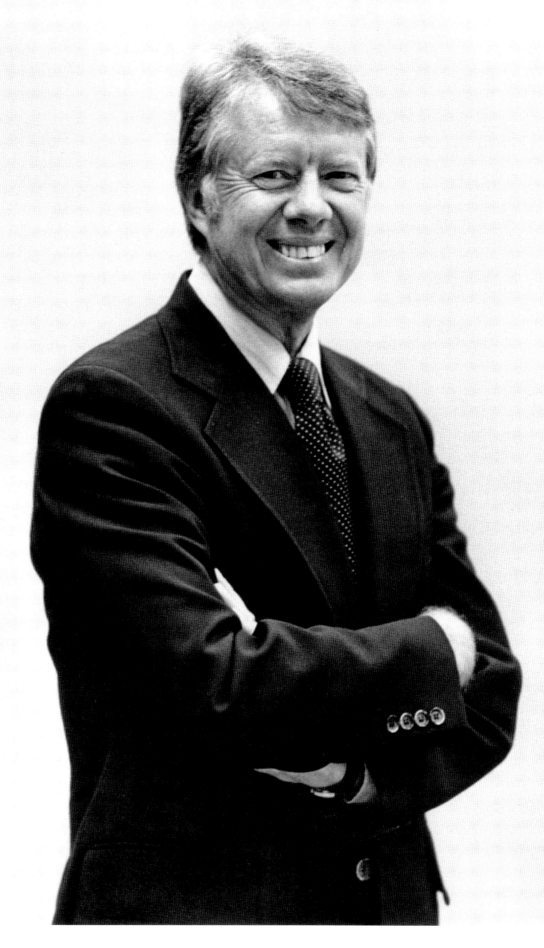

JIMMY carter

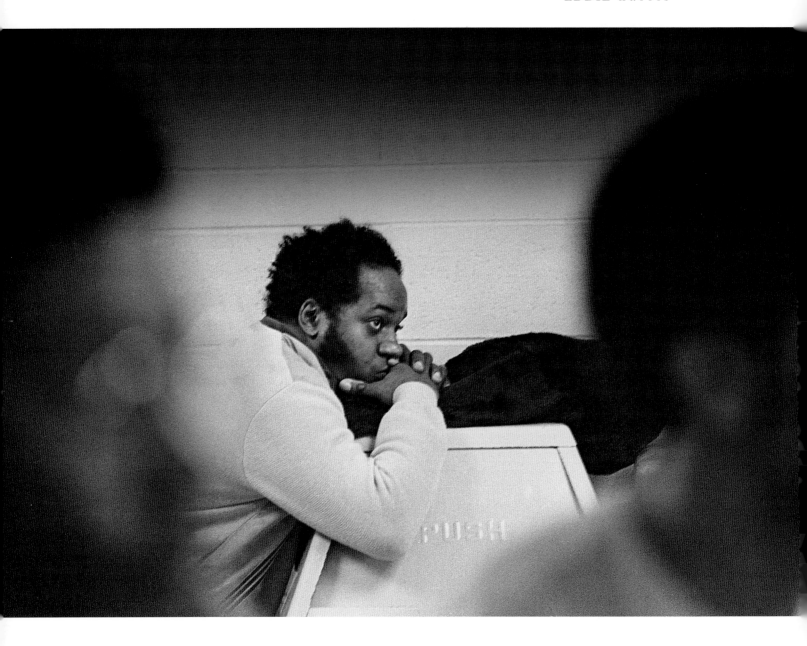

"*A possessed genius. To know Eddie Harris, you would love him, but to know him is probably harder than living. It takes all you can to crack the — I don't want to call it a wall, but — the door to Eddie. He's so versed in everything. You can't believe it when you see it. You don't want to hear it 'cause he talks too much. One thing I was just reading online was, 'Preach everywhere you go but only use words when necessary.' You see?*

Eddie and I went through every possible emotion that two guys could, as brothers almost, and it ended up in pure understanding and love."

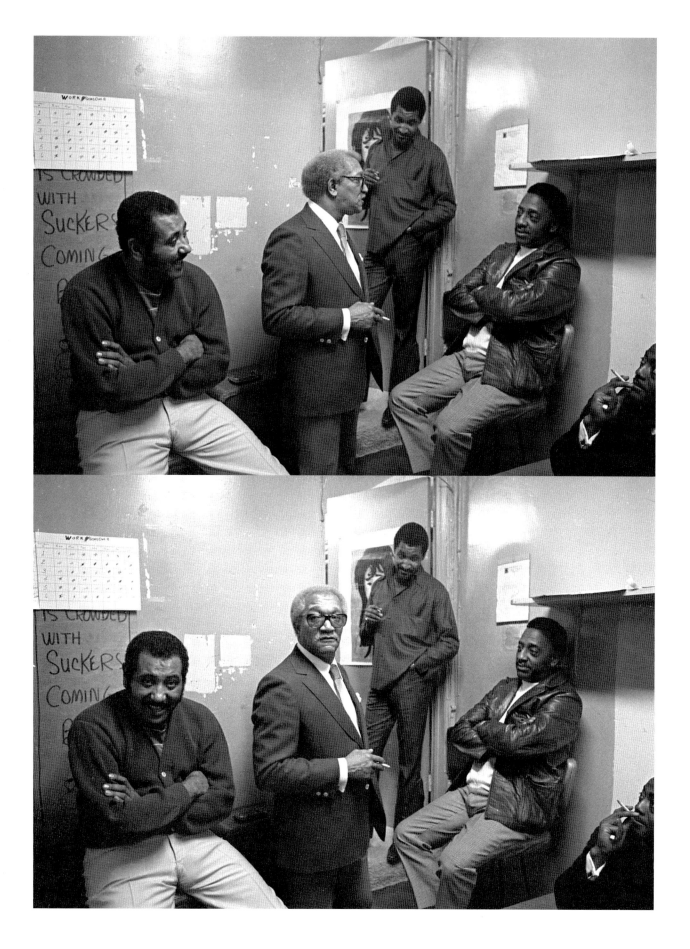

REDD foxx

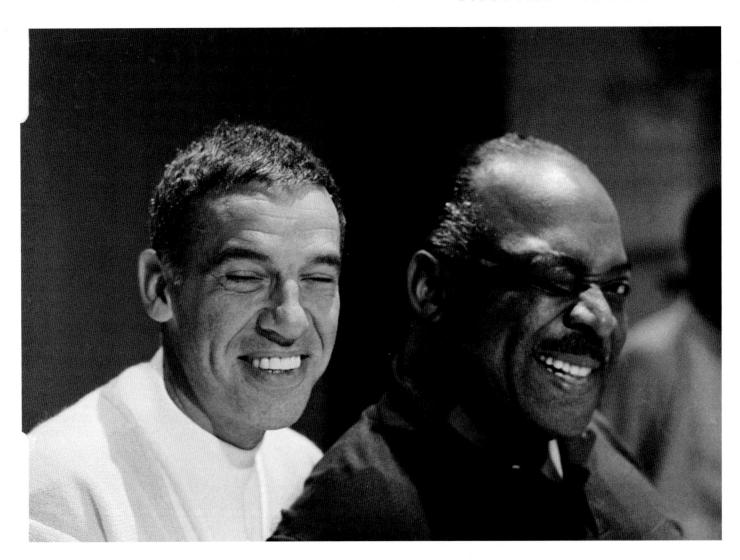

PLEASE GIVE PHOTO CREDIT TO
LES McCANN, LTD.
225 SANTA MONICA BLVD.
SUITE 1202
SANTA MONICA. CA. 90401

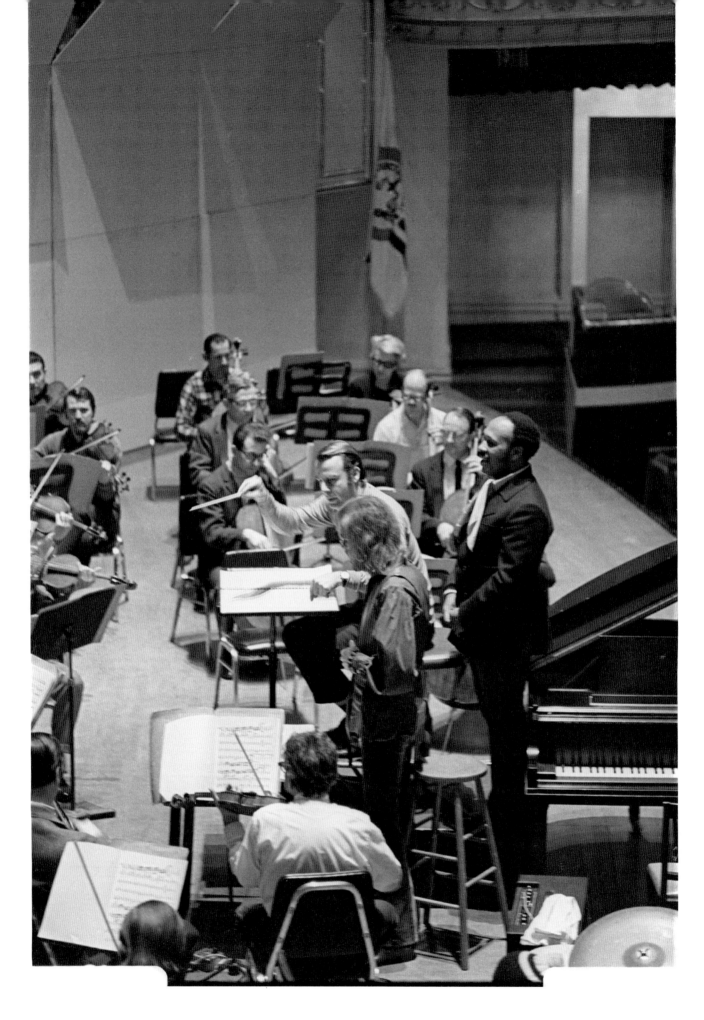

CINCINNATI SYMPHONY ORCHESTRA
conducted by ROGER kellaway
with LES mccann

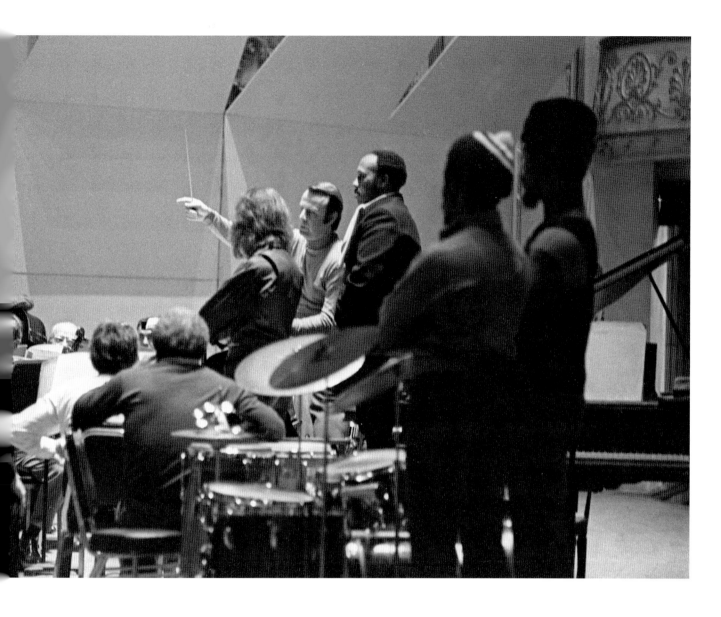

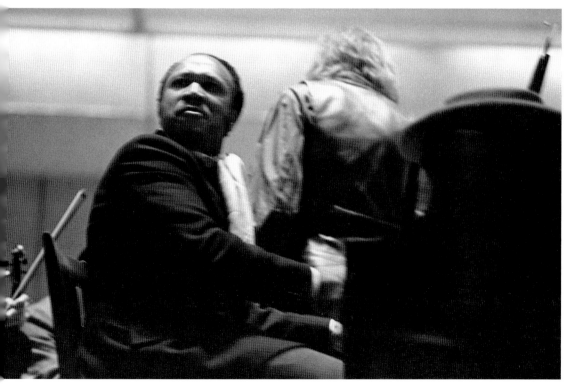

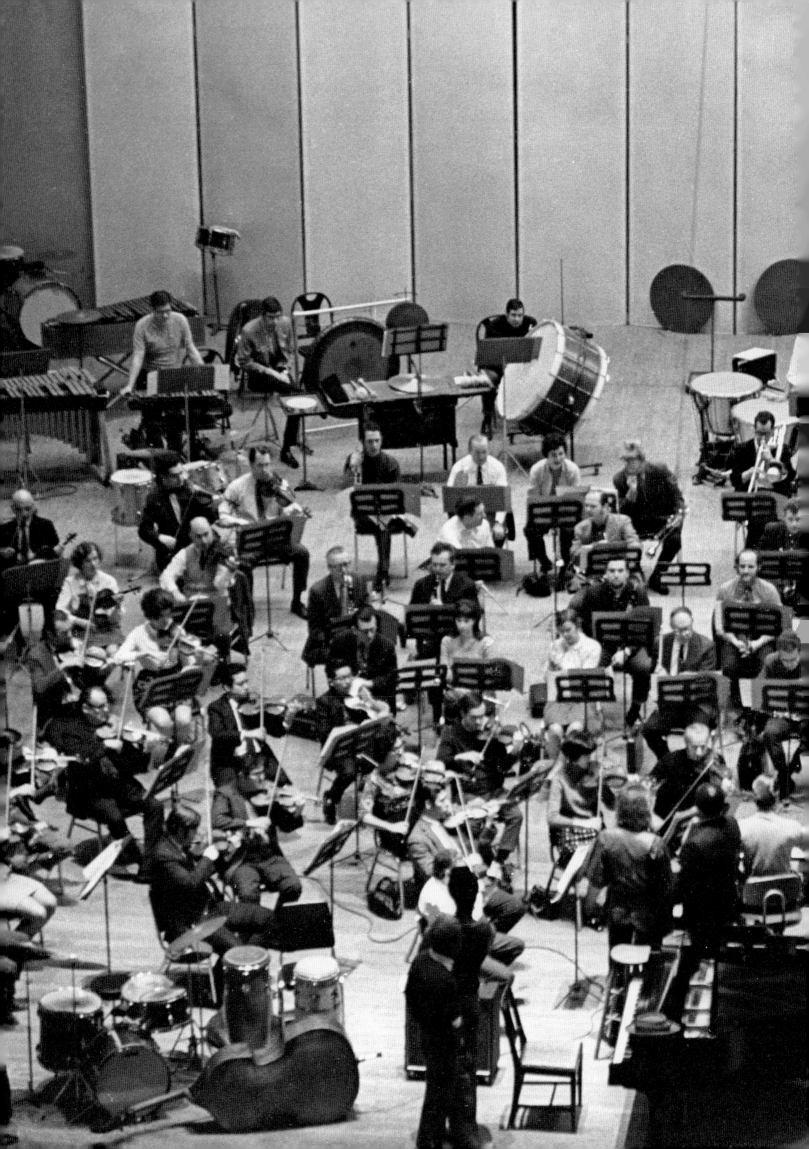

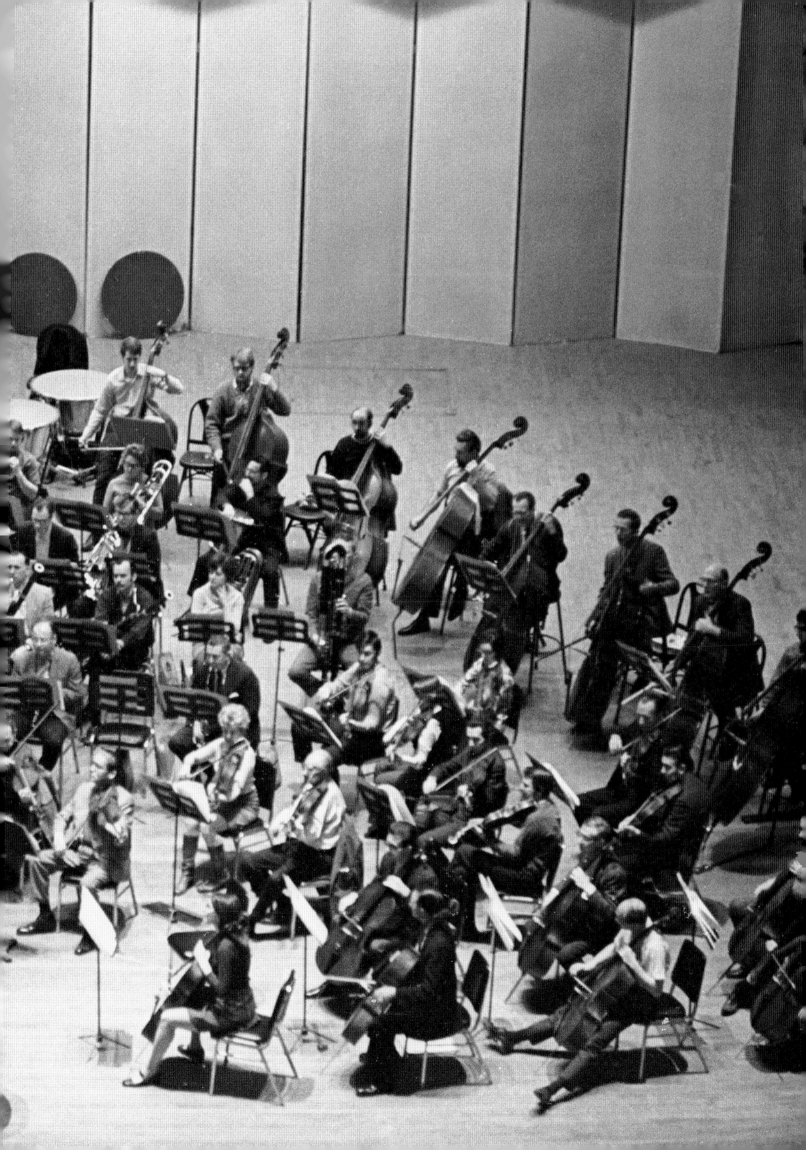

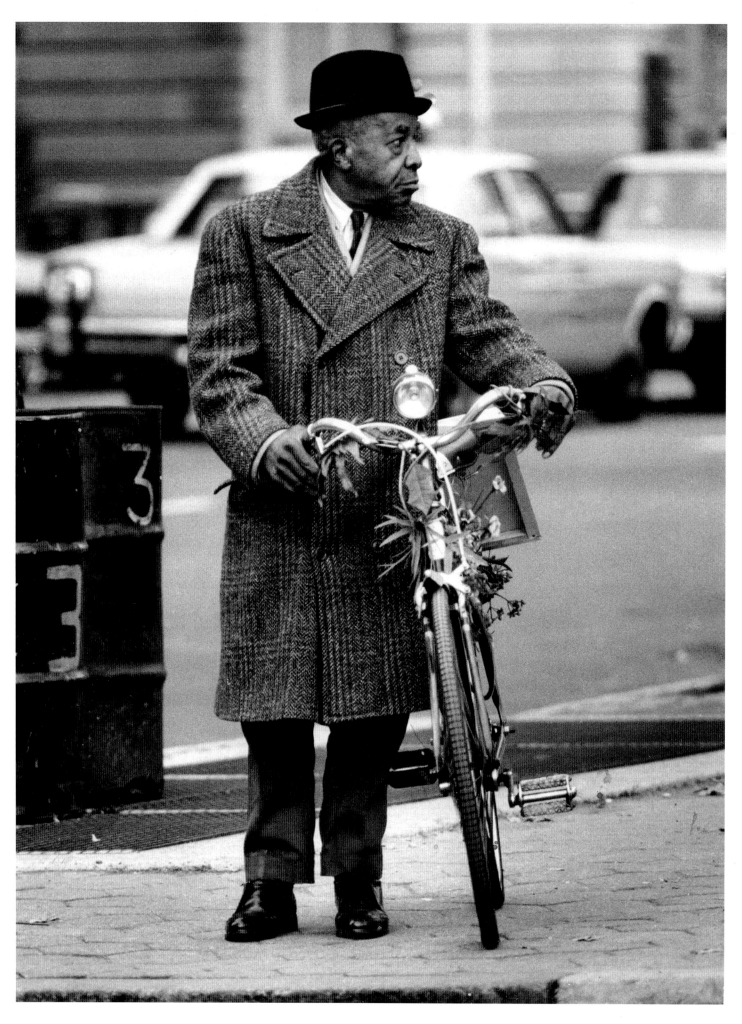

MAN with bicycle

WHEN ALAN ABRAHAMS AND I MET, it was love at first sight. We've done so much together down through the years. We speak honestly with each other, and there is nothing we can't talk about.

What touches me most about Alan is the great joy I always experience when I am with him. More than any soul on this Earth that I know, he is the ultimate. Alan is *that guy* I go to before I run it by God. He knows my heart and soul, he knows where I'm coming from, and he actually *listens* to me. He has my back and operates with no fear … I want to be like that.

Our recordings and our times in the studio together are some of the greatest moments of my life. I can't help but be in love with his wife (my "little sister," Margaret), his mom, and his sister, too.

Our relationship is then, now, and forevermore. We are one, our bond is as strong as stone — and I know when we're no longer on this plane that "Someday We'll Meet Again."

SEVERAL YEARS AGO MY DAUGHTER, the beautiful Rosie Lane McCann, said to me, "You've got to get your photography out to the world."

Shortly after that, I had a debilitating stroke while on tour in Europe, and I spent time recovering in a German hospital. Meanwhile, back home in L.A., Rosie went about the task of labeling my photos. She sorted everything, which made it easy for me to put things in place for Alan and Pat to review for this book. Without her organizational skills, perhaps this project would not have been possible. I thank Rosie from the depths of my heart. She is a unique soul.

After Rosie's work was completed, we realized that we needed some muscle. Dean Burt was instrumental in moving everything from storage so that I could view it all and so that Alan and Pat could start to edit. Now, every box is back in place for easy access for our next photo project. Thank you, Dean.

— Les McCann
Sherman Oaks, California
August 2014

PACIFIC JAZZ RECORDS · 8715 WEST THIRD STREET · LOS ANGELES, CALIFORNIA

"PRETTY LADY"
PJ-25 & STEREO-25
Stella By Starlight
Django
I'll Take Romance
Pretty Lady
Green Dolphin Street
Little Girl Blue
Dorene Don't Cry !

"IN SAN FRANCISCO"
PJ-16 & STEREO-16
Big Jim
Jeepers Creepers
Red Sails In The Sunset
I Am In Love
Oh, Them Golden Gaters
Gone On And Get
That Church
We'll See Yaw'll After While, Ya Heah

"THE SHOUT"
PJ-7 & STEREO-7
The Shout
But Not For Me
Jubilation
A Foggy Day
Cute
Night In Tunisia
C Jam Blues
Sonar

"THE TRUTH"
PJ-2 & STEREO-2
The Truth
I'll Remember April
Fish This Week
Vacushna
How High The Moon
For Carl Perkins
This Can't Be Love
A Little 3/4 For God & Co.

LES McCANN records exclusively for PACIFIC JAZZ RECORDS

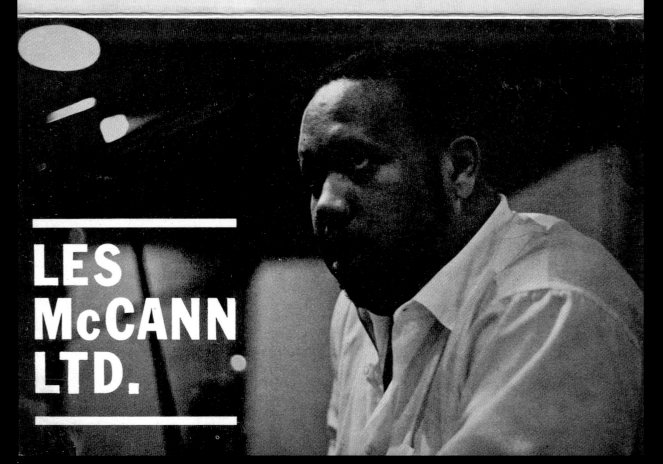

LES McCANN LTD.

MAJOR ALBUMS

Plays the Truth - Pacific Jazz, 1960
It's About Time with Teddy Edwards - Pacific Jazz, 1960
Plays the Shout - Pacific Jazz, 1960
In San Francisco - Pacific Jazz, 1961
Groove with Groove Holmes & Ben Webster -
 Pacific Jazz, 1961
Pretty Lady - Pacific Jazz, 1961
Les McCann Sings - Pacific Jazz, 1961
In New York with Stanley Turrentine & Blue Mitchell -
 Pacific Jazz, 1962
That's Where It's At with Stanley Turrentine -
 Blue Note, 1962
Stormy Monday with Lou Rawls - Capitol, 1962
Somethin' Special with Groove Holmes - Pacific Jazz, 1962
On Time with Joe Pass - Pacific Jazz, 1962
Plays the Shampoo - Pacific Jazz, 1963
Out Front with Clifford Scott & Joe Pass - Pacific Jazz, 1963
The Gospel Truth - Pacific Jazz, 1963
Soul Hits with Joe Pass - Pacific Jazz, 1963
Jazz Waltz with The Jazz Crusaders - Pacific Jazz, 1964
McCanna - Pacific Jazz, 1964
McCann Wilson with the Gerald Wilson Orchestra -
 Pacific Jazz, 1965
But Not Really - Limelight, 1965
Beaux J. Poo Boo - Limelight, 1965
Live at Shelly's Manne-Hole - Limelight, 1966
Plays the Hits - Limelight, 1966
Spanish Onions - Pacific Jazz, 1966
A Bag of Gold - Pacific Jazz, 1966
Bucket O' Grease - Limelight, 1967

Live at Bohemian Caverns - Limelight, 1967
From the Top of the Barrel - Pacific Jazz, 1967
More or Les McCann - World Pacific Jazz, 1969
Much Les - Atlantic, 1969
Swiss Movement with Eddie Harris - Atlantic, 1969
New from the Big City - World Pacific Jazz, 1970
Comment - Atlantic, 1970
Second Movement with Eddie Harris - Atlantic, 1971
Invitation to Openness - Atlantic, 1972
Talk to the People - Atlantic, 1972
Live at Montreux - Atlantic, 1973
Layers - Atlantic, 1974
Another Beginning - Atlantic, 1974
Hustle to Survive - Atlantic, 1975
River High, River Low - Atlantic, 1976
Music Lets Me Be - ABC, 1977
Change, Change, Change, Live at the Roxy - ABC, 1977
Les McCann the Man - A&M, 1978
Tall, Dark & Handsome - A&M, 1978
The Longer You Wait - Jam, 1983
Les McCann's Music Box - Jam, 1984
Road Warriors with Houston Person - Greene Street, 1984
Butterfly - Stone, 1988
Les Is More - Night, 1991
On the Soul Side - MusicMasters, 1994
Listen Up! - MusicMasters, 1996
Piano Jazz with Marian McPartland - The Jazz Alliance, 1996
Pacifique with Joja Wendt - nullviernull, 1997
How's Your Mother? - 32 Jazz, 1998
Pump It Up - ESC, 2002

SPECIAL GUEST APPEARANCES

Like Soul / Gloria Smyth; World-Pacific, 1960
This Is the Blues, Volume 1 / Various Artists; Pacific Jazz, 1960
This Is the Blues, Volume 2 / Various Artists; Pacific Jazz, 1961
Back in Town! / Bumble Bee Slim; Pacific Jazz, 1962
Tell It Like It 'Tis / Groove Holmes; Pacific Jazz, 1966
This Is the Blues, Volume 1 / Various Artists; World Pacific Jazz, 1968
Other Side of This Life / Fred Neil; Capitol, 1971
Soul to Soul / Various Artists; Atlantic, 1971
Newport in New York '72 / Various Artists; Atlantic, 1972
Doldinger Jubilee '75 / Passport; Atlantic, 1976
The Gap Band / The Gap Band; Tattoo, 1976
Marc Anthony Thompson / Marc Anthony Thompson;
 Warner Brothers, 1984
Straight Ahead / Stanley Turrentine; Blue Note, 1985
Cash Up Front / Cash McCall; Stone, 1988

My Pleasure / June Yamagishi; Meldac, 1988
Ahimsa / David T. Walker; Half Moon, 1989
Whatever Happened to the Blues / Phil Upchurch; Go Jazz, 1992
Deep Pocket / Herbie Mann; Kokopelli, 1994
Heavenly / Ladysmith Black Mambazo; Shanachie, 1997
Anthology / Lou Rawls; Capitol, 2000
Soul Insider / Bill Evans; ESC, 2000
Sketches of James / Various Artists; Koch, 2001
The Legacy Lives On II / Various Artists; Mack Avenue, 2002
Jazz Yule Love / Various Artists; Mack Avenue, 2002
Big Fun / Bill Evans; ESC, 2003
Go Tell It on the Mountain / The Blind Boys of Alabama;
 Real World, 2003
The Original Jam Sessions 1969 / Quincy Jones & Bill Cosby;
 Concord, 2004

SAMPLED WORKS

"Anticipation" from *Layers*
"Little Brother" by Lenzman
"Press Rewind" by Deda & Pete Rock
"Rather Unique" by AZ

"Baby, Baby" from *Comment*
"Demain Peut-être" by Oxmo Puccino
"Love Beat" by Musab

"Beaux J. Poo Boo" from *Invitation to Openness*
"Everything's Everything" by Freestyle Fellowship

"Before I Rest" from *Layers*
"For My Pa" by Godfather Don
"Head Eesti Asjad" by A-Rühm
"Long Island Degrees" by De La Soul

"Benjamin" from *Much Les*
"Basic Training" by All City
"C'est Donc a Ça Nos Vies" by IAM
"Interlude" by 2 Bal 2 Neg
"Monopol" by Rytmus
"Pain (Forever)" by Puff Daddy feat. G. Dep
"Right Back at You" by Mobb Deep

"Beyond Yesterday" from *Music Lets Me Be*
"Frankie and Johnny" by Traditional Folk
"Itz A Set Up" by GangStarr

"Cold Duck Time" from *Swiss Movement*
"You Flunked" by Casual

"Compared to What" from *Swiss Movement*
"Break It Up" by Cypress Hill

"Go On and Cry" from *Another Beginning*
"All Over Your Face" by H2O
"Allahu Akbar" by Infinite Allah
"California Dreamin'" by Dream Warriors
"Chicago Blues" by Add-2
"Cry" by Thad Reid
"Define Yourself" by Cormega feat. Tragedy Khadafi & Havoc
"Easy" by Fresh Daily
"Freestyle" by Funkmaster Flex
"Flawless" by Living Legends
"Go On" by Irealz feat. Kye
"Go On ... " by Prose
"Go On & Cry" by Mutt & Visionary
"Good Dwellas" by Cella Dwellas
"Growin' Up" by Trainspotters
"I Can Feel Everything" by Xtra Pleza
"Ich War So Gern???" by Nico Suave feat. Brumentoff
"Iso" by Futuristic
"Juicy Grub" by Pat D & Lady Paradox feat. Yousif
"Kodukandi Huligaanid" by Rijoint feat. Vesikas & Kristel Nael
"La Verità (Non Abita Più Qua)" by Ghemon

"Love Trippin'" by ADL
"Meil Oleme Meie" by Metsakutsu feat. Ülli
"Mr. Popular" by Jin
"No Pain" by Lords of the Underground
"Patrze Jak Idziesz" by Szad Akrobata
"Persephone" by Hannibal King
"Real Thugs" by Crooked I
"Runnin' wit' No Breaks" by Warren G
"SPL%T" by Adjaman
"Tap That" by French Montana & Chinx Drugz feat. Stack Bundles
"That's Why" by Snafu & Tuk
"The Jux" by Cyne
"Tha Next Episode" by Snoop Dog feat. Dr. Dre
"VII" by Cormega, Blaq Poet, Tragedy, Khadafi & Havoc

"Got to Hustle to Survive" from *Hustle to Survive*
"People's Choice" by Defari

"Interlude" from *Layers*
"Dysfunctional Family Song" by Sixtoo

"Kaftan" from *Swiss Movement*
"It Was Only a Song" by Jazz Liberatorz

"Kathleen's Theme" from *Swiss Movement*
"Autobiographical" by Black Sheep

"Loved You Full in Every Way" from *River High, River Low*
"Harlots" by K-Otix

"Music Lets Me Be" from *Music Lets Me Be*
"You Know My Steez" by GangStarr

"North Carolina" from *Talk to the People*
"#4 Disease" by Joe Beats
"After Hours" by A Tribe Called Quest
"Asia's Verse" by Lyrics Born
"Back to Hip Hop" by Troubleneck Brothers
"Checkmate" by Akinyele
"Cool City Slicker" by Dilated Peoples
"Decompression Chamber" by Dynospectrum
"Endless Railway" by DJ Krush
"Funk Is a Four Letter Word" by Bulldog Breaks
"Inglewood" by New Jack Hustle
"Let's Git It On" by Smif-N-Wessun
"Lots of Lovin'" by Pete Rock & C.L. Smooth
"Place to Be" by Ill Biskits
"Second to Nobody" by YZ
"Spüre Diesen Groove" by MC Rene
"The Infamous Date Rape" by A Tribe Called Quest
"The Rough Side of Town" by Organized Konfusion
"To Whom It May Concern" by Black Sheep
"What a Way to Go Out" by Souls of Mischief
"Word Em Up" by Robust
"Yo" by Akinyele
"You Got Shot" by Prince Paul

"Poo Pye McGoochie (and His Friends)" from *Invitation to Openness*
 "Disclaimer" by Sixtoo
 "Escapee" by DJ Krush
 "Jovial Costume" by Alias

"Roberta" from *Much Les*
 "Funky Piano" by E Bros
 "Let's Get Cozy" by Black Sheep
 "Whirlwind through Cities" by Afu-Ra

"Seems So Long" from *Talk to the People*
 "The World Is Yours" by Nas

"She's Here" from *Talk to the People*
 "10 Years" by Braille feat. Toni Hill
 "It's Your Life" by Head Toucha
 "Remember When (Salaam Remix Version)" by Da Bush Babies

"Shorty Rides Again" from *Second Movement*
 "Bronx Nigga" by Tim Dog
 "Hypnotic" by Eric B. & Rakim
 "Imma Gitz Mine" by Eric Sermon
 "Play It for Divine" by Divine Styler
 "Shorty" by Skoolbeats

"So Your Love Finally Ran Out for Me" from *Tall, Dark & Handsome*
 "Can't Hold Us Down" by Lost Boyz

"Soaring (at Dawn) Pt. 1" from *Layers*
 "No Doubt (Remix)" by Pos Neg

"Sometimes I Cry" from *Layers*
 "Behind Bars" by Slick Rick feat. Warren G
 "Bullet Boy" by Massive Attack
 "Liza" by Raekwon
 "N2U" by Eric Roberson feat. Marsha Ambrosius
 "Teardrop" by Massive Attack

"Sunny Pt. 1" from *Les McCann Plays the Hits*
 Hasta Hoy by Frainstrumentos feat. ChysteMc

"Talk to the People" from *Talk to the People*
 "Anger in the Nation" by Pete Rock
 "Overzicht" by Helberg

"The Dunbar High School Marching Band" from *Layers*
 "Save That Shit" by Lord Finesse
 "Sleep for Dinner" by Lords of the Underground
 "Streets of the Ghetto" by Ed OG

"The Generation Gap" from *Swiss Movement*
 "Loosifa" by *Juggernotz*

"The Harlem Buck Dance Strut" from *Layers*
 "Caught Up in the Game" by Bushwackass
 "Come Widdit" by Ahmad, Ras Kass & Saafir

"Do That (Lord Finesse Remix)" by Walkin' Large
"Dream and Imaginate" by The Wascals
"Flavor (Video Mix)" by The Jon Spencer Blues Explosion feat. Beck
"Gameplan" by Lord Finesse feat. Marquee
"Go for Yours ('Cause I'm Gonna Get Mine)" by MC Shan
"Hunnit$ & Fittie$" by $tan Ros$ & Thelonious Martin
"It's About That Time" by Pete Rock feat. Black Thought & Rob-O
"Lyrics" by Special Ed (Buckwild)
"My Place" by McGruff
"No More Worries" by Del the Funky Homosapien
"Out to Lunch" by Celph Titled feat. Treach
"Pressure (AK Nine Prophecy)" by Neffa feat. Soul Boy & Wardogs
"Prick Tat" by Luke Vibert
"Rock On (Buckwild Remix)" by Funkdoobiest
"Soul on Ice" by Ice T
"Speak Ya Peace" by Lord Finesse feat. Marquee, Diamond, & A.G.
"Summer Jam '95 (Diamond D Remix)" by Scha Dara Parr
"The Main Ingredient" by Pete Rock

"The Lovers" from *Invitation to Openness*
 "Escapee" by DJ Krush
 "Everything's Everything" by Freestyle Fellowship
 "Introspectrum" by Dynospectrum
 "Sideshow" by So-Called Artists

"The Morning Song" from *Another Beginning*
 "Bumpy Bring It Home" by Freddie Foxxx feat. M.O.P
 "Dirt All by My Lonely" by Naughty by Nature
 "Fire Water" by Fat Joe feat. Big Pun, Raekwon & Armageddon
 "Love and Life Intro" by Mary J. Blige feat. Diddy & Jigga
 "The Masha" by Capitol Tax
 "W Oceanie Zmysłów" by O.S.T.R.

"Vallarta" from *Music Lets Me Be*
 "Khaki's, T-Shirt, Chuccz" by South Central Cartel
 "Someone" by SWV
 "Ten Crack Commandments" by DJ Drama & Cookin' Soul
 "Ten Crack Commandments" by Notorious B.I.G.

"What's Going On" from *Talk to the People*
 "Bullshit" by Pharcyde
 "Erase Racism" by Kool G Rap
 "Second To Nobody" by YZ

"When It's Over" from *Another Beginning*
 "UV" by Frankenstein

"Why Is Now" from *Hustle to Survive*
 "Grannie" by Jay Dee

"Yours Is My Heart Alone" from *Comment*
 "Dreams" by Square One

PHOTOGRAPHY INDEX

PROTOGRAPHIC BI
LES McCANN, LTD.

PHOTOGRAPHY BY
LES McCANN, LTD.